ART NOUVEAU TILES

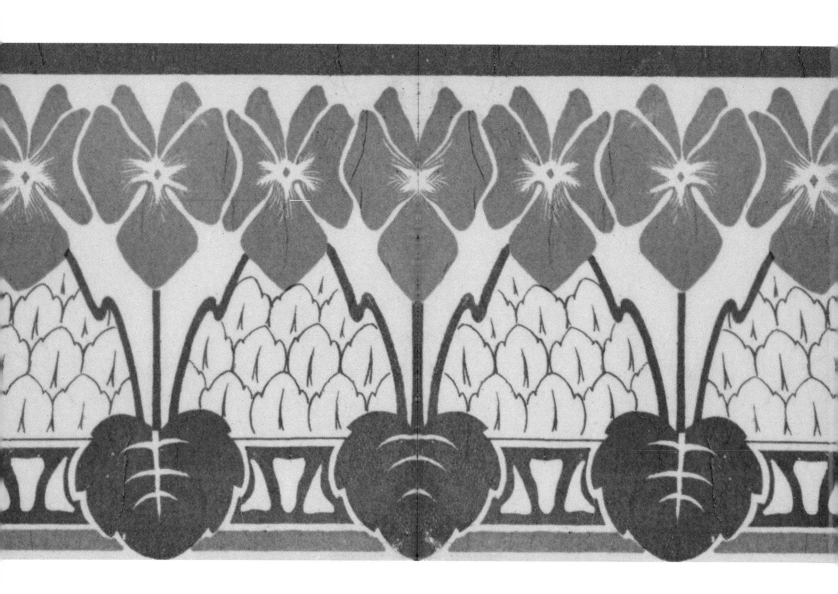

ART NOUVEAU TILES

Hans van Lemmen

Bart Verbrugge

LAURENCE KING

Published in 1999 by Laurence King Publishing
an imprint of Calmann & King Ltd
71 Great Russell Street
London WC1B 3BN

A catalogue record for this book is available from
the British Library.

ISBN I 85669 170 5

Designed by Price Watkins
Picture research by Mary Jane Gibson
Printed in Hong Kong

Frontispiece: Frontispiece: German Art Nouveau border
tiles by the firm Villeroy & Boch in Mettlach with a floral
design depicting violets.

CONTENTS

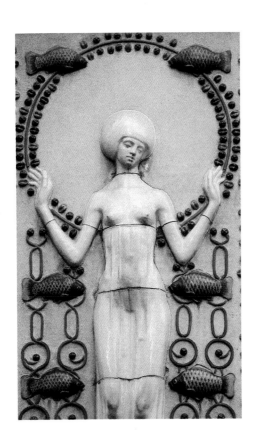

6 *Introduction*

16 *Arts and Crafts Inspirations*

34 *The Rise of Art Nouveau*

64 *Northern Europe*

110 *Central Europe*

130 *Southern Extravaganza*

154 *New World Experiments*

178 *Art Nouveau and Beyond*

194 *Collecting Art Nouveau Tiles*

208 *Glossary*

210 *Places to Visit*

213 *Bibliography*

216 *Credits*

218 *Index*

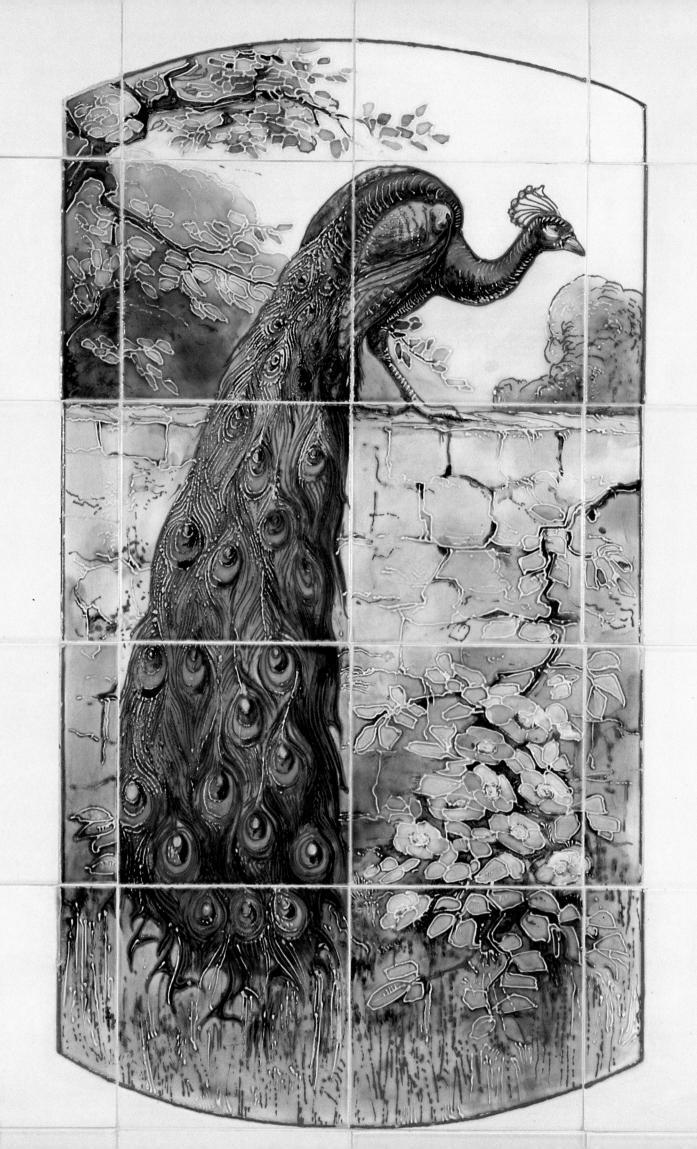

INTRODUCTION

ART NOUVEAU was a complex turn-of-the-century stylistic phenomenon that manifested itself in many aspects of art, architecture and design including tiles and architectural ceramics. The heyday of Art Nouveau was between 1890 and 1914 and a key moment was the establishment of the gallery called L'Art Nouveau by Siegfried Bing in Paris in 1895.

From a stylistic point of view Art Nouveau was characterized firstly by the dominant use of line. A second characteristic was the emphasis on flat areas of colour which added vitality to the linear design. Thirdly, these lines and flat colours were applied to organic design motifs, such as plants and flowers with slender, sinuous stems and tendrils, different varieties of water birds and young women with long flowing hair. Drawing on these themes, designers were able to create appealing images which can still be seen in many Art Nouveau tiles. Geometric Art Nouveau designs characterized by angular abstract forms became an important aspect of the work of a number of artists in Glasgow and Vienna at the beginning of the twentieth century.

However, though certain general design characteristics can be identified, Art Nouveau was not in any way a homogeneous style. It was an artistic movement that took different directions in each country and was also intertwined with the industrial, social, scientific and political developments of its time. New forms of industrial production, increasing urbanization, breakthroughs in science and technology, worldwide trade and the rise of nationalism as a political force, all contributed to a new world view marked by

Opposite: British tube lined tile panel made in 1928 by Maw & Co., Jackfield, Shropshire, with a late Art Nouveau design of a peacock.

Right: Business promotion tile by the Meissner Ofen und Porzellanfabrik vormals Carl Teichert, Meissen, around 1905. The tile bears the firm's name and shows a potter at his wheel.

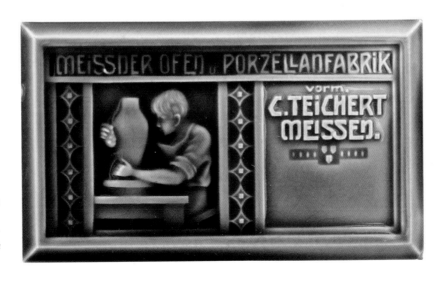

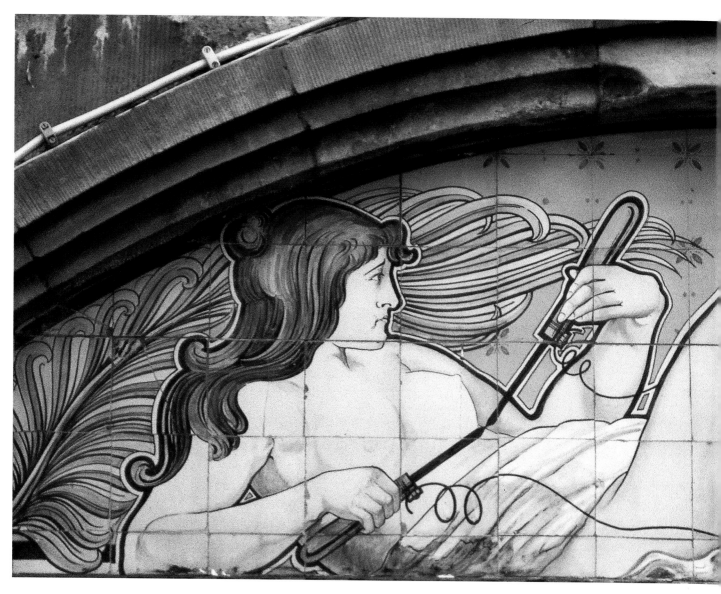

*Detail of a Dutch Art Nouveau panel above a former
electrical shop in the Lange Tiende, Gouda, showing
a woman holding an early Edison electric light bulb,
probably manufactured by the firm Holland in Utrecht,
around 1900.*

a sense of ever accelerating progress and change. Its very name, 'Art Nouveau', highlights the sense of 'renewal' as can be seen in other names for the phenomenon in different countries. In Holland it was called 'Nieuwe Kunst', in Germany 'Jugendstil', in Austria 'Sezession', in Spain 'Modernista', in Italy 'Stile Liberty' and in Portugal 'Arte Nova', names which all signify 'newness', 'novelty', 'youth' and 'modernity' and indicate a period poised on the threshold of a new era.

When the various Art Nouveau manifestations in different countries are examined more closely, it becomes evident that they were marked by dichotomies and contradictions. This is recognized by some Art Nouveau scholars as one of the positive characteristics of the movement. In his book *Art Nouveau: International and National Styles in Europe*, Jeremy Howard remarks that, 'In fact, Art Nouveau's strength and vitality derived from its diversity, complexity, ambiguity and pan-European manifestation. The struggle of forms it represented was a struggle of worldviews. It is chauvinism mixing with universalism, science co-mingling with art, the pagan with Christian. It can be both decadent and progressive, national and liberal, eastern and western, vernacular and international, urban and rural, imperial and social, natural and artificial, material and spiritual.'

Art Nouveau was an attempt to give a new direction to nineteenth century art, architecture and design and to replace the prevailing historical styles such as Gothic Revival, Neo-Classicism and Neo-Renaissance with a new idiom. This was to be based on fresh inspirations drawn directly from nature, from existing vernacular traditions and from design sources from outside Europe, such as the newly discovered art of Japan. Japanese porcelain and woodcuts, in particular, opened the eyes of European artists to the purely formalistic qualities of strong line and colour. Art Nouveau aimed to be 'new' in a world of progressive developments.

Britain features prominently in the history of Art Nouveau because it was here that many of the design elements that were to characterize the movement first emerged. A complex set of forces was at work in Britain in the field of art and design, ranging from the writings and designs of A.W.N. Pugin, through the formation of the Pre-Raphaelite Movement, to the emergence of the Arts and Crafts Movement and the Aesthetic Movement. Very important were the ideas of John Ruskin who urged artists and designers to return to nature and honest craftsmanship in reaction to industrialization. The Arts and Crafts Movement, led by outstanding artists and designers like William Morris, Edward Burne-Jones, Christopher Dresser, Walter Crane, Lewis F. Day and architects like C.F.A. Voysey, put many of Ruskin's ideas into practice. It was the work of this group, from the 1860s through to the 1890s, that became so inspirational for many designers and architects in Europe and America.

The dissemination of new ideas was aided by the publication of progressive art and design magazines, particularly *The Studio* which was founded in 1893. It carried articles on English designers like Morris, Voysey and De Morgan but also paid attention to what was happening on the Continent. *The Studio* had its counterparts in Europe, notably the German magazines *Innendekoration* and *Dekorative Vorbilder*, both founded in 1889, which helped to publicize the new style.

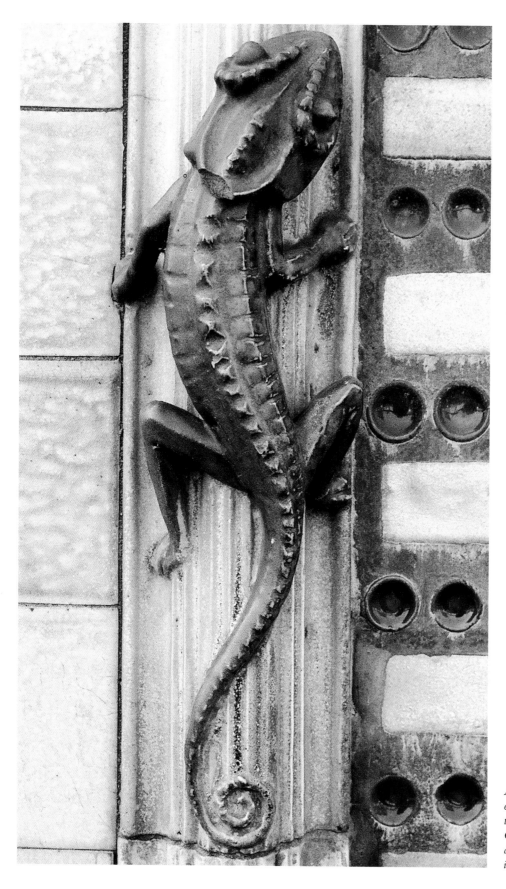

A ceramic lizard on the exterior of the workshop of the French manufacturer Charles Gréber at 63 Rue de Calais, Beauvais, built in 1911.

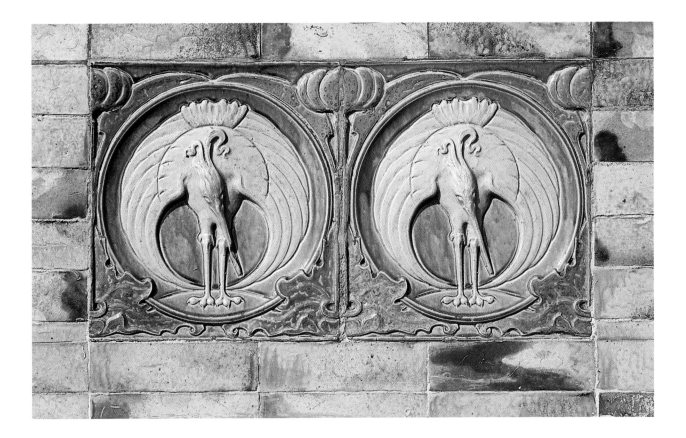

Two French grès flammé *tiles with birds by Charles Gréber, Beauvais, on a house at 2 Rue de Précy, Villers-sous-Saint-Leu (Oise), 1900.*

The spread of ideas and international contacts was taken further by the various World Fairs that had been organized in Europe and America since the Great Exhibition of 1851 in London. Here, manufacturers were able to show their wares as part of National Stands. These became important industrial showcases for a large range of products including tiles and architectural ceramics. For the participating countries it was also an opportunity to see what rival manufacturers were doing. International juries distributed highly coveted prizes and medals, and tile manufacturers' catalogues of the period often boast these awards.

Art Nouveau was also brought to the notice of the public by purely commercial enterprises, such as the shop opened in London in 1875 by the retailer Arthur Liberty. Liberty's sold all kind of merchandise from the Middle East, including carpets and pottery, as well as products by prominent British designers. Bing in Paris sold Art Nouveau furnishings, design products and textiles made by talented Belgian and French artists of the day. Among them were Henry van de Velde and Georges de Feure who helped to shape the taste of an affluent and progressive middle class.

Manufacturers throughout Europe responded to demands for new types of tiles and architectural ceramics, which in interiors would resist hard wear and when used on the exterior of buildings would be frost proof and pollution resistant. Minton in England developed dust pressed wall tiles as well as encaustic floor tiles, while Doulton made a frost and smoke resistant architectural ceramic called 'Doultonware'. In France Hachette & Gillet successfully manufactured *lave émaillée* for use on facades, while in Hungary

Zsolnay produced 'Pyrogranit' which could be utilized for all kinds of exterior ceramic decoration.

One particular manifestation of the fast developing world was an increasing awareness of the importance of durable and hygienic surfaces in public, commercial and domestic buildings. Tiles and architectural ceramics are easily cleaned and very hard-wearing, yet also highly decorative. It comes therefore as no surprise to see them in public buildings such as hospitals, railway stations, schools, libraries and hotels, and in commercial buildings such as offices, warehouses and shops; while in the domestic sphere they were ideal for cladding the walls in entrance porches, vestibules, kitchens and bathrooms.

Another aspect was the interest in the use of colour on the exterior of buildings for aesthetic effects as expressed in writings by such architects as Viollet-le-Duc, Paul Sédille and Halsey Ricardo, who favoured ceramic surfaces like glazed bricks and tiles rather than painted plaster and stucco which had been the norm until then.

The Art Nouveau style, essentially decorative in principle, was readily adapted to tile design. Factories copied each others' products, as there was little design protection at this period, and this led to a rapid proliferation of Art Nouveau throughout Europe. The style made its impact on flat tiles as well on the more sculptural architectural faience and terracotta decorations that were fashionable, particularly in America. One of the earliest manifestations of Art Nouveau design was Victor Horta's Tassel House in Brussels, of 1893. In France the architect Hector Guimard became an outstanding practitioner of the new movement. His famous Castel Béranger in Paris, constructed between 1894 and 1898, shows Art Nouveau tiles in combination with superb wrought iron and carved stone.

Soon Art Nouveau emerged everywhere in Europe and no country remained untouched. It became an important phase in the work of many architects, notably Hector Guimard in France, Charles Rennie Mackintosh in Britain, Hendrikus Berlage in Holland, Peter Behrens in Germany, Joseph Olbrich and Otto Wagner in Austria, Antonín Balšánek and Osvald Polívka in Bohemia, Ödön Lechner in Hungary, and Antoni Gaudí and Lluís Domènech in Spain. All used tiles and ceramics in their architecture. To this pan-European scene must be added the work of American architects Louis Sullivan and the brothers George and Edward Blum, who, like their European counterparts, incorporated Art Nouveau ceramic decorations in their buildings.

The purpose of this book is four fold. Firstly, it aims to provide a historical overview of the emergence of Art Nouveau tiles in Europe and America. The focus is on the main developments and therefore not every European country has been included. For reasons of space, Russia, Poland and the Scandinavian countries, for example, have had to be omitted. Secondly, it draws attention to prominent designers, manufacturers and architects, and to the diverse utilization of Art Nouveau tiles in architecture. Art Nouveau wall tiles occupy a central position in this account, but where relevant mention is made of architectural ceramics. Thirdly, it intends to encourage the conservation of Art Nouveau tiles in their original settings. Fourthly, it hopes to stimulate responsible collecting, and to advise collectors on what to collect and how to manage their collection.

*Tube lined Belgian Art
Nouveau tile with a squirrel
by Gilliot & Cie,
Hemiksem, around 1905.
Shown larger than actual
size (15 x 7.5 cm, 6 x 3 ins).*

ARTS AND CRAFTS INSPIRATIONS

THE emergence of Art Nouveau tiles can only be fully understood if one looks at what happened in British art and design during the period 1840–1900. The products on show at the Great Exhibition of 1851 had revealed the poor quality of industrial design and there were moral concerns about the effects of industrial capitalism. These concerns were first aired in the writings of the architect A.W.N. Pugin and later taken up more strongly by the critic John Ruskin, who advocated a return to medieval style craftsmanship as a reaction against the debasing industrial system. This inspired a number of socially conscious designers and artists to turn their backs on the machine and revert to hand production and sound design, a response that can be seen in the work of William Morris, Edward Burne-Jones, William De Morgan and Conrad Dressler. However, there were also artists and designers like Walter Crane, Christopher Dresser and Lewis F. Day, who took more realistic positions and strove to improve the quality of design through the available machine production methods. Progressive journals like *The Studio* and the *Magazine of Art* also played an important role by publishing articles on the work of influential designers, propagating their ideas and disseminating examples of their work. They thus helped to create a fertile design climate from which Art Nouveau design, and tiles, could emerge.

THE RISE AND EVOLUTION OF ARTS AND CRAFTS TILES

Opposite: Hand-painted bathroom tile panel from Membland Hall near Plymouth (demolished in 1928). The design is by William Morris and the panel was made by William De Morgan, around 1876. A splendid example of cooperative effort between two great Arts and Crafts designers.

Even before the Great Exhibition of 1851 the architect, designer and writer A.W.N. Pugin (1812-52) had in his own work revealed the debased nature of much early nineteenth century architecture and design. He considered it to be based on a repetitive and eclectic Classical design repertoire in the service of industry and commerce. As a staunch Roman Catholic, Pugin denounced Classical architecture and design as pagan. Instead, he advocated that buildings of all kinds, including churches, schools, hospitals, civic buildings and private homes, should be erected in the Gothic style which best expressed the religious and moral ideas of a Christian society. Pugin's own churches and houses in the Gothic style made liberal use of encaustic tiles on the floor and block printed tiles in fireplaces, which added a strong and colourful accent to his strikingly ornate interiors. The tiles and decorations

*Above: Block printed
tile decorated with a design
by A.W.N. Pugin based on a
motif on the front cover of
his book* Floriated
Ornament *(1849), made by
Minton's China Works,
Stoke-on-Trent,
around 1875.*

*Left: Block printed tile with
a snowdrop design by
A.W.N. Pugin for Minton's
China Works, Stoke-on-
Trent, around 1875.*

in the Palace of Westminster in London and the church for Lord Shrewsbury in Cheadle, Staffordshire, also his own church, St. Augustine's, and his house, The Grange, both in Ramsgate, Kent, are celebrated cases in point.

Pugin's designs for encaustic and block printed tiles show that he adapted studies made from nature and turned them into strikingly beautiful flat patterns. Some excellent examples of flat floral designs can be seen in his book *Floriated Ornament* published in 1849. The prime purpose of this book was to teach good principles of design based on the study of nature. He wrote in the introduction, 'The present work has been produced for the dissemination of these principles, and to assist in removing the reproach of mere servile imitation, so often cast on those who work after the antient manner. *Nature* supplied the medieval artists with all their forms and ideas; the same inexhaustible source is open to us: and if we go to the *fountain head*, we shall produce a multitude of beautiful designs treated in the same spirit as the old, but new in form.' But this must not be taken to mean that Pugin advocated the mere imitation of natural forms. He encouraged designers to represent and adapt their creations in such a way as not to destroy the flat surfaces that their designs were meant to decorate.

During the 1840s Pugin worked closely with the tile manufacturer Herbert Minton, who made all of Pugin's tiles. Minton, Hollins & Co. kept Pugin's floor tiles in production until the end of the nineteenth century, long after his death in 1852, while Minton's China Works continued manufacturing his block printed wall tiles. In one of the Minton's China Works catalogues of around 1885 it was still stated, 'The process for the decoration of Tiles was early favoured by the late Mr. A. Welby Pugin, "the great restorer of Gothic Art" in the Houses of Parliament and in many other places, and the patterns in that style of ornament in this book are all from his hand.' This clearly showed Pugin's continuing status as a designer and the enduring influence of his tile work during the second half of the nineteenth century.

Pugin's linking of the Gothic style to moral and religious values in society was of great importance to John Ruskin and later adherents of the Arts and Crafts Movement. Ruskin (1819-1900) was an outspoken critic of the effects of industrial capitalism on the lives of ordinary workers. In *The Stones of Venice*, published in 1851-3, he argued that men were debased by machines because they were enslaved by the division of labour and by mechanical forms of production. He wrote, 'It is not that men are ill fed, but that they have no pleasure in the work by which they make their bread and therefore look to wealth as the only means of pleasure.' In contrast, medieval craftsmen had joy in their labour as they were part of, and in control of, the whole manufacturing process from beginning to end. This gave them satisfaction in the things they made, not simply in the money they earned.

Ruskin's writing had an enormous influence on William Morris (1834-96). He was the son of a wealthy stockbroker and tried several careers (the church, painting, architecture) before he found his true vocation as a designer, craftsman, printer, writer and socialist. The idea of becoming a designer came to him when he furnished his own home, the Red House, in Bexleyheath, built by his friend the architect Philip Webb in 1859-60. More important, the Red House became a social hub for artists and poets such as Dante Gabriel Rossetti, Edward Burne-Jones, Charles Faulkner and his sisters Lucy and Kate,

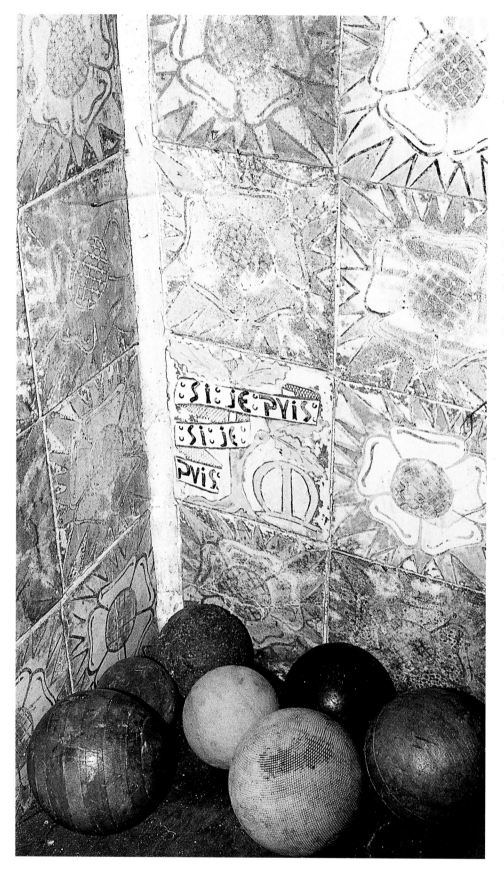

Left: Hand-painted tiles with on-glaze decoration in a porch at the Red House, Bexleyheath, showing William Morris's personal motto SI JE PUIS, early 1860s.

Opposite: Two versions of the Morris & Co. so-called 'Longden' tile pattern. Top: Dutch version made by the Utrecht firm Ravesteijn in an in-glaze technique, around 1880. It has kept its vibrant blue tones. Bottom: Morris & Co., London, on-glaze painted version, around 1870. This shows deterioration in the blue colour which has turned green.

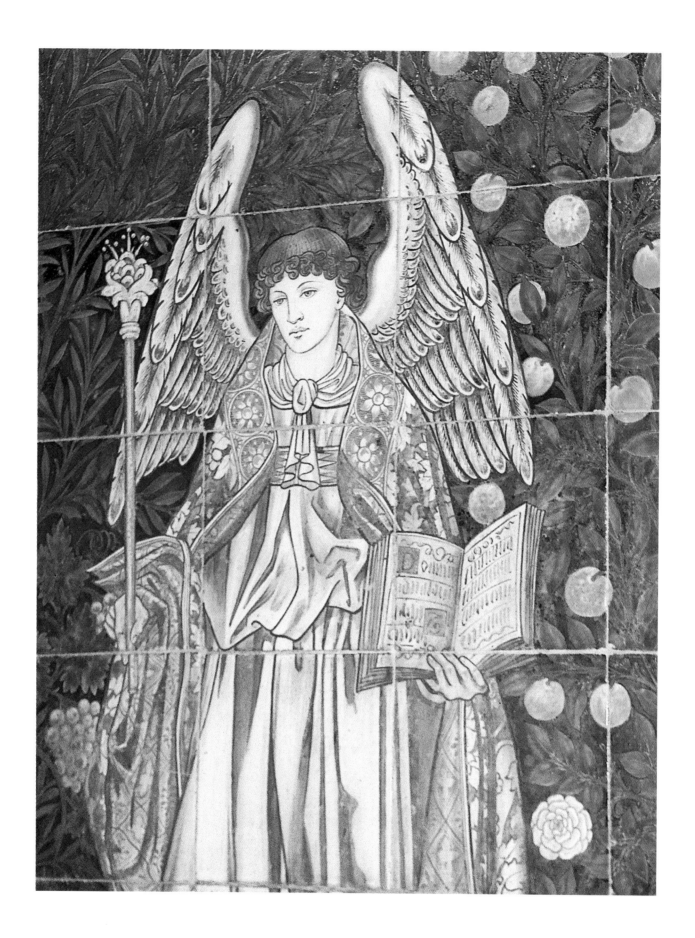

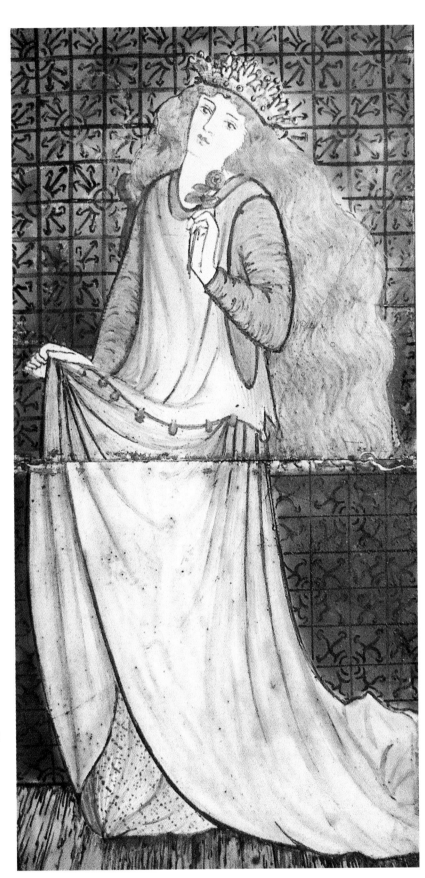

Opposite: Detail from the tiled reredos with on-glaze decoration made by Morris & Co., London, for Clapham Church, Clapham, Sussex, in 1873-4, depicting the four archangels.

Right: Tile panel with on-glaze decoration representing Cinderella as a queen designed by Edward Burne-Jones and painted by Lucy Faulkner for Morris & Co., London, around 1865.

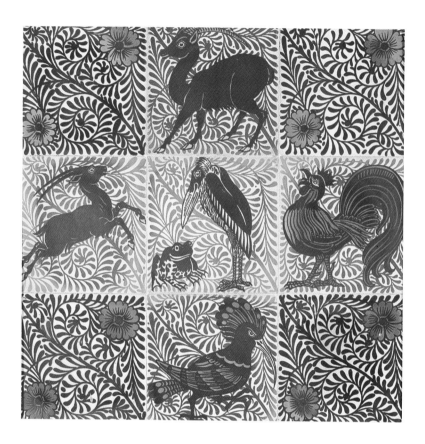

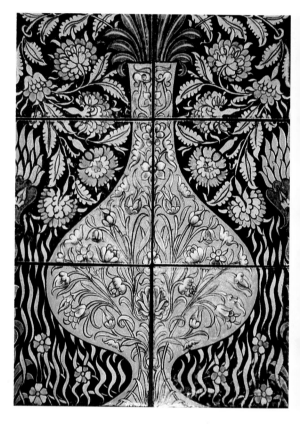

and Ford Maddox Brown. Morris and his friends set about designing and making many of the articles for the house by hand. These included tiles, and in one of the outside porches there are still tiles painted by Morris showing designs with Tudor roses, his father's coat-of-arms, and Morris's own motto *SI JE PUIS* (as I can).

The experience of the Red House led to the foundation of the firm Morris, Marshall, Faulkner & Co. in 1861. The firm produced such things as wallpaper, stained glass, textiles and tiles. All those actively involved with the firm, like Rossetti, Burne-Jones, Webb and Maddox Brown, contributed tile designs. The tile output consisted of patterned tiles and figurative tiles and panels. The patterned tiles showed design motifs such as daisies, sunflowers, floral scrolls and swans. The figurative tiles depicted fairy tales, Labours of the Month, saints, angels and minstrels. Rossetti, a founder of the Pre-Raphaelite Movement in 1848, was instrumental in introducing the languorous female with long, flowing red hair so characteristic of Pre-Raphaelite painting.

The style of painting on the tiles was simple, clear and direct, in line with Morris's view of medieval handiwork. He shunned the vogue for Victorian naturalism and was concerned that the figures, foliage and floral motifs should be in harmony with the flat surface for which they were designed. This is made clear in a lecture given at the Working Men's College, London, in 1881 entitled 'Some Hints on Pattern Designing', in which he argued: 'In pottery-painting we are more than ever in danger of falling into sham naturalistic platitude, since we have no longer to stamp our designs with a rough wood-block on paper or cotton, nor have we to build up our outlines by laying

Above, left: Panel of nine tiles, hand-painted in red lustre showing fantastic birds and animals on a foliated ground. Designed and decorated by William De Morgan on factory made, dust pressed blanks, around 1885.

Above, right: Tile panel made by William De Morgan with a flower vase arrangement inspired by Islamic design, around 1890.

Opposite, above: Sunflower tiles made by William De Morgan for a fireplace at Spring Bank, Headingley, Leeds, around 1880.

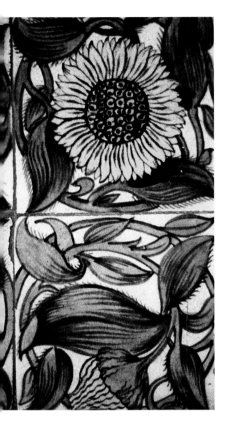

square by square of colour, but, pencil [brush] in hand, may do pretty much what we will. So we must be a law to ourselves, and when we get a tile or plate to ornament remember two things: first, the confined space or odd shape we have to work in; & second, the way in which the design has to be executed.'

Morris insisted that the firm's designs were painted on handmade tiles. Since these were unavailable in Britain, he used Dutch tin glazed tile blanks imported from Holland, where tile production had not as yet been industrialized. The designs were painted on the already fired glaze and fired again in a stained glass kiln. This procedure was far from satisfactory, which perhaps explains why the manufacture of the patterned tiles was soon franchised to the firm Ravesteijn in Utrecht. Not only did the Dutch workers make and decorate tiles by hand, but the delftware technique they employed consisted of an in-glaze method that was much more durable than the on-glaze technique of Morris & Co.

The link with Dutch tile firms was probably facilitated by Murray Marks, the son of a Dutch Jew who had settled in London. Marks ran a shop in Oxford Street, London, where he sold oriental blue-and-white porcelain and Dutch tiles to prominent members of the Aesthetic Movement, including the shipping magnate F.R. Leyland, the painter James McNeill Whistler, the artist Birket Foster and Dante Gabriel Rossetti himself. Marks therefore most certainly knew Morris personally. Morris must have approved of the Dutch versions of his firm's designs, as he used them not only in houses he was commissioned to decorate but even in his own rural retreat in Oxfordshire, Kelmscott Manor, where he, his wife Jane and Rossetti spent much time after 1871. The Dutch link is also significant for the emergence of the Arts and Crafts phenomenon in Holland. Tile designs by Morris & Co. became part of the standard repertoire in Ravesteijn's catalogues and were copied by other Dutch tile makers, and therefore they became visual examples of British Arts and Crafts design in Holland.

Morris & Co. tiles were used in houses, churches and educational institutions like Findon church in Sussex, the dining rooms of Queen's College and Peterhouse in Cambridge, and Stanmore Hall and Birket Foster's house, The Hill, in London. These commissions were carried out for an educated and well-to-do elite, who were part of the Aesthetic Movement that flourished during the second half of the nineteenth century. Their taste did not only extend to the medieval style craftsmanship of William Morris, but also to oriental design, particularly Japanese and Islamic ceramics. The latter were much favoured by the potter and tile maker William De Morgan, who drew freely on Iznik ceramics in the design of his own tiles and pottery.

William De Morgan (1839-1917) was a close friend of William Morris. He first became associated with Morris & Co. in 1862 as a designer of stained glass and tiles. By 1869 he decided to branch out on his own and specialize in the manufacture of tiles at his house at Fitzroy Square, London. Around 1872, after an accident which caused a fire, De Morgan moved to new premises at Cheyne Row, where he established himself as an important independent tile maker. It was here that some of his early lustre tiles were made which became such a major feature of his later output. Like Morris, he used Dutch blanks for some of his lustre tiles but also dust pressed blanks by Minton, Hollins & Co.,

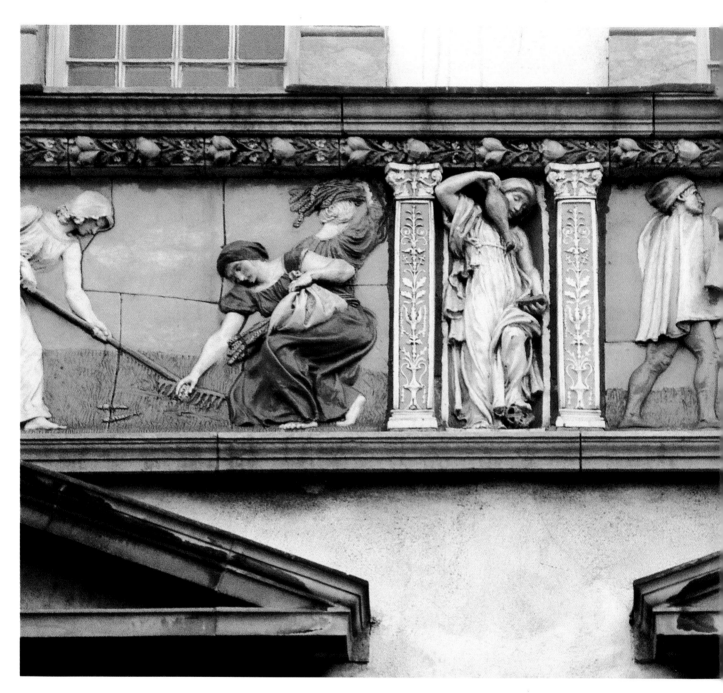

*Detail of the polychrome frieze on the facade of the
Sunlight Chambers, Dublin, built for the soap manufacturer
Lord Leverhulme in 1901. The frieze was made by the
Medmenham Pottery, Marlow Common, Buckinghamshire.*

Carter & Co. and Wedgwood, which indicates that he was less averse to employing machine products than Morris. However, he maintained good links with Morris and in some cases would execute his designs; Morris's panels made for Membland Hall in 1876 are a prime example. In return Morris & Co. stocked De Morgan tiles in their shop.

De Morgan's successes generated much business and soon bigger premises were needed. In 1882 he moved the workshops to Merton Abbey, Surrey, and a final move came in 1888 when the works were relocated to Sands End, Fulham, where he formed a partnership with the architect Halsey Ricardo. This partnership was dissolved in 1898 when a final phase began in cooperation with three employees – Frank Iles, and the brothers Charles and Fred Passenger – which lasted until 1907.

William De Morgan was a prolific designer whose range encompassed floral motifs, birds and animals, as well as medieval sailing boats. Many tiles were executed in ruby lustre, which was stencilled onto the surface of the tile before firing. This resulted in strong, bold, flat designs that shimmer with a metallic sheen when the light catches them at the right angle. However, the most glorious tiles are those painted in polychrome with exquisite blues, turquoises, greens, purples and yellows, which come most strikingly into their own in combination with Islamic motifs.

His tiles were used in fireplaces, bathrooms and sometimes P&O ocean liners. One of the most spectacular examples of De Morgan's work can still be seen at Debenham's House, Addison Road, London, designed by Halsey Ricardo in 1904-7. The exterior of the house is covered with green and blue glazed bricks, while De Morgan tiles were used on the wall of the outside passage leading to the front door and in the porch. Inside they decorate many fireplaces, walls on the first floor landings and several bathrooms. Ricardo was a leading advocate of polychromatic faience on and in buildings and Debenham's House is his tour-de-force.

An account of British Arts and Crafts tiles would not be complete without drawing attention to the Della Robbia Pottery at Birkenhead, near Liverpool, which was in existence between 1894 and 1906. It was founded by Harold Steward Rathbone, a pupil of the Pre-Raphaelite painter Ford Maddox Brown, who believed in the Arts and Crafts principles of William Morris. Pottery, tiles and plaques were made by hand using local clays. Conrad Dressler, a sculptor, joined the firm in 1894 and was put in charge of the architectural department. He left the Della Robbia Pottery in 1897 and set up his own workshop based on Arts and Crafts principles at Marlow Common. It became known as the Medmenham Pottery and one of the catalogues of the firm tells us that 'we place ourselves in conditions approximating those of the old potteries whose ware delighted and inspired us. We therefore established our pottery right away in the country. We use our Marlow materials as much as possible and employ village work people. These elements are to influence our work to the fullest possible extent.' One of the main commissions that came their way was to supply polychrome ceramic tiled friezes for the Sunlight Chambers in Dublin, built in 1901 for the soap manufacturer Lord Leverhulme by the architect Edward A. Ould. The friezes, which show the extraction of raw materials for soap and soap manufacturing processes, are an interesting example of the use of colour in architecture.

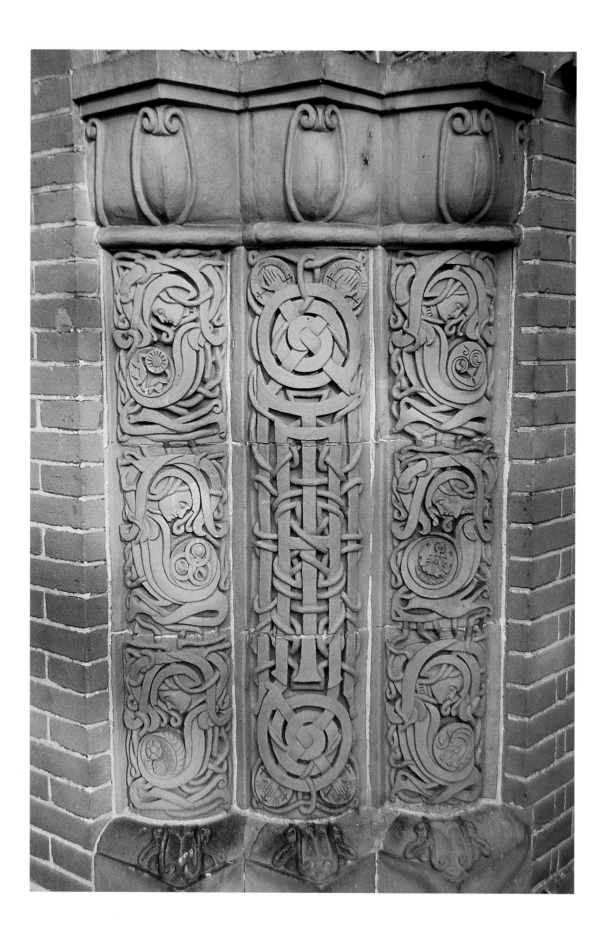

Above: Early dust pressed tile by Minton & Co., Stoke-on-Trent, decorated with an underglaze transfer printed decoration, around 1845. Prosser's 1840 patent is credited on the back.

Opposite: Detail of the Celtic inspired terracotta decoration by the Compton Pottery on the exterior of the mortuary chapel built in the honour of the painter George Frederick Watts at Compton, completed in 1898.

Another intriguing Arts and Crafts pottery venture was the establishment of the Compton Pottery at Compton near Guildford. It was set up in 1895 by Mary Watts, the widow of the artist George Frederick Watts, initially to make terracotta decorations for the mortuary chapel she was building in memory of her husband. With the aid of local villagers and using local red clays, extraordinary Celtic style terracotta ornaments were made for the exterior of the chapel. They show interlacing knots, angels and animals of intricate complexity decorated with sinuous lines reminiscent of Art Nouveau. After the completion of the chapel in 1898 the Compton Pottery specialized in making terracotta garden ornaments such as benches, sundials and garden vases.

William Morris, William De Morgan and, to a certain extent, Conrad Dressler and Mary Watts had retreated into an anti-industrial dream of romantic medievalism characterized by honest handiwork, community living and socialist ideals. Although it showed the world the beauty of craftwork and good design, doing things by hand resulted in limited production. This was expensive and ultimately could only be afforded by the rich; it was never within the grasp of the ordinary workmen the designers professed to champion. Their Arts and Crafts ventures could therefore not be a model for the world as it existed. In the real world of commerce, the problem of how to combine art and industry had to be addressed, and it fell to other tile designers and manufacturers to show the way.

ARTS AND CRAFTS TILES AND INDUSTRIAL MASS PRODUCTION

From the 1840s onwards the firm of Minton & Co. under the directorship of Herbert Minton was responsible for a series of important technical innovations without which the mass production of Art Nouveau tiles would not have been possible. The most crucial of these was the invention of dust pressing by Richard Prosser in 1840, a process that was first applied to the production of wall tiles by Minton & Co. In dust pressed tiles, designs with raised relief lines can be created on the surface of the tiles during the dust pressing process. The areas between the lines are then filled with colourful translucent glazes. At the beginning of the twentieth century this became the most used technique for the manufacture of mass produced Art Nouveau tiles in Britain, France, Germany and Belgium.

Another innovation was the development of transfer printing on tiles. The technique of transfer printing from engraved copper plates was first developed by John Sadler in Liverpool in 1756 as an on-glaze technique, but at Minton & Co. it was applied for the first time to dust pressed tiles in an underglaze technique. Herbert Minton also took advantage of an invention by two printers, Collins and Reynolds, in 1848, which made it possible to print areas of flat colour. Furthermore he was responsible for the development of encaustic floor tile production during the 1840s in cooperation with the architect Pugin. New glazes were also brought into operation, including the famous Minton opaque majolica glazes for pottery and tiles shown for the first time at the Great Exhibition of 1851.

Page from a Maw & Co. catalogue showing a range of Walter Crane designs depicting the Seasons and the Elements, around 1880.

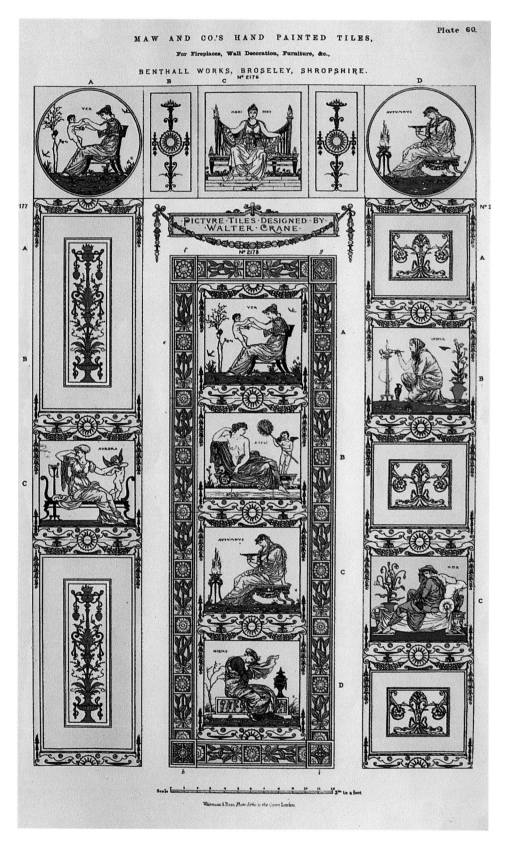

Tile designed by Walter Crane depicting Hiems (Winter) for Maw & Co. The outlines are transfer printed and the colours applied by hand, around 1880.

The lessons of the Great Exhibition and the need to improve the quality of industrial design were grappled with by men such as Richard Redgrave, Owen Jones and Walter Crane. This could partly be done through education in newly established schools of design, by the opening of new museums, through progressive art and design publications, and by examples of designers who forged successful partnerships with industry.

The present Victoria and Albert Museum was established in 1852 as a by-product of the Great Exhibition. It was called the Department of Practical Art and one of its main functions was to display objects of good design, the nucleus of which came from exhibits in the Great Exhibition itself and included tiles. Encaustic and block printed tiles which had been displayed by Minton were purchased 'for use of Students and Manufacturers' as good examples of how floral designs could be adapted to decorate floors and walls.

The raising of standards could also be achieved via publications like the *Journal of Design*, edited by Richard Redgrave between 1849 and 1851, in which examples of good design were discussed. A major impact was created by Owen Jones's *Grammar of Ornament* published in 1856. Showing colourful patterns and motifs from other periods, cultures and civilizations, it became an influential source of inspiration for many Victorian designers. Owen Jones's recommendation was not to copy these designs, but to employ them 'simply as guides to find the true path'.

Designers like Walter Crane, Christopher Dresser and Lewis F. Day worked as freelancers for a number of large tile companies, including Maw & Co., Minton & Co. and Pilkington's Tile & Pottery Co. They demonstrated that high quality tile design worked just as well on dust pressed tiles as on handmade ones. More important, some designers like Crane and Dresser showed that their work could also be executed with the aid of mechanical decoration processes, notably transfer printing and block printing, something that would have been anathema to William Morris and his circle.

Walter Crane (1845-1915) was an important book illustrator, designer, painter and writer. He was also a leading arts administrator in his role as president of the Arts and Crafts Exhibition Society between 1888 and 1890 and a prominent teacher in his capacity as the principal of the Royal College of Art. He was interested in tiles and executed several series on the subject of nursery rhymes, the Seasons and the Elements for Maw & Co. in the mid 1870s. In particular one of the designs for *The Seasons*, showing a female figure draped in a billowing cloak to personify Hiems (Winter), indicates a restlessness of line that can be seen as a precursor to the Art Nouveau style. It too proved that it was possible to achieve a successful combination between mechanical, transfer printed outlines and hand painting.

A similar design philosophy underpinned the work of Christopher Dresser (1834-1904). Dresser undertook some tile commissions for Minton's China Works between 1871 and 1875, when he became involved with Minton's Art Pottery Studio in London. Most of these designs were block printed, with colours sometimes added by hand, a mechanical process that suited Dresser's sensitive but strictly disciplined and flat designs. Dresser was also instrumental in the craze for Japanese art by designing blue-and-white, block printed tiles with flying cranes. The influence of artists such as Crane and Dresser extended to other tile manufacturers such as Craven Dunnill & Co. in Shropshire, who

during the 1890s produced some stunning block printed tiles with flat, bold, floral designs echoing those of the Arts and Crafts Movement.

The designer Lewis F. Day (1845-1910) became through his work and writing an important contributor to the world of British design during the last two decades of the nineteenth century. He favoured careful study of nature and then went on to produce sensitively abstracted and unpretentious flat designs suitable for tiles and wallpapers. This approach is amply illustrated in his *Every-Day-Art: Short Essays on the Arts not Fine*, published in 1882. He designed some floral and animal lustre tiles for the firms Maw & Co. and J.C. Edwards, which were executed on dust pressed blanks. A particularly interesting design of a peony was created by Day for J.C. Edwards, both as a lustre tile and as an underglaze painted tile. The latter was copied by the Dutch firm Van Hulst in Harlingen, but instead of using lustre or underglaze painting it was executed in a tin glaze technique and painted in a vivid green and pink/red in a special 15 centimetre (six inch) format for the British market.

The architect and designer C.F.A. Voysey (1857-1941) was active during the later phase of the Arts and Crafts Movement, in the 1880s and 1890s. Between 1875 and 1879 he studied in the office of the architect J.P. Seddon, who was himself a prolific designer of encaustic floor tiles. Besides his architectural work Voysey became an influential designer of wallpaper and his curvilinear, flat patterns inspired many artists in Britain and on the Continent. In 1895, one entitled *Elaine* was used in Victor Horta's Tassel House, a building that is regarded by many as the architectural birthplace of Art Nouveau. Another, called *Bird and Tulip*, was illustrated in *The Studio* of 1896 with the prophetic comment, 'The very beautiful wall paper (the Bird and Tulip) here reproduced, one of Messrs. Essex's new patterns for this season, is probably destined to be the progenitor for a long series of illegitimate descendants.' Proving the point, the Dutch tile designer Jac. van den Bosch drew heavily on this model for his own design *Waterkip* (waterhen) of 1900 for the tile manufacturer Holland in Utrecht. Voysey himself became involved with tiles at the turn of the century when he began to design for Pilkington's Tile & Pottery Co., a cooperation that firmly links him to the early developments of Art Nouveau tiles in Britain.

The significance of the new art journals like *The Studio* and the *Magazine of Art* cannot be overestimated because they became major showcases for the work of leading British designers. They published well illustrated articles devoted to the work of progressives such as Morris, De Morgan, Dresser and Voysey. This exposure helped to disseminate Arts and Crafts ideas widely, not only in Britain, but also on the Continent and in the United States. There is therefore no doubt that the ideas and products of the British Arts and Crafts Movement inspired many artists and tile makers abroad. The transmission of Arts and Crafts theory and practice therefore became one of the principal sources from which Art Nouveau would develop.

THE RISE OF ART NOUVEAU

PARIS and Brussels are regarded by many as the birthplace of Art Nouveau. Here architects, artists and designers, reacting against the dead hand of Classical art, created a new, progressive style based on fresh inspiration from nature. These endeavours were encouraged by art dealers in Brussels and Paris who commissioned work and helped to create a receptive climate for it. Art Nouveau was also actively propagated through various World Fairs in Paris during the second half of the nineteenth century. Architects began to show a marked interest in the use of external colour in buildings and this influenced the production and application of tiles and architectural ceramics. The use of tiles was further stimulated by functional needs in shops and public buildings. To meet these requirements many factories in France and Belgium began to manufacture mass produced dust pressed Art Nouveau tiles, as well as earthenware tiles, handmade panels and architectural ceramics for special commissions.

The first signs of the emerging new style could already be recognized in the 1880s. In Brussels, in 1881, the lawyer Octave Maus and the art dealer Edmond Picard published the first issue of *L'Art moderne*, a platform for avant garde artists, who after 1884 were to call themselves 'The believers in Art Nouveau'. From this the name 'Art Nouveau' originated. *L'Art moderne* also led to the founding of the avant garde group Les Vingt (The Twenty) in Brussels in 1883, with the Belgian artists James Ensor and Fernand Khnopff as prominent members. They held their first exhibition in Brussels in 1884. Another element was the growing interest in oriental art. Many artefacts from China, Japan and Indonesia were brought together at the World Fairs in Paris in 1867, 1878 and 1889. Ceramics and prints from Japan especially created an impact and many artists and collectors started to acquire Japanese art. In 1888 the art dealer Siegfried Bing (1838-1905) published the first issue of *Le Japon artistique*, a collection of Japanese prints and decorations that appeared in French, German and English. This 'Japonism' was an important influence on the Art Nouveau style in western Europe. The free treatment of the flat plane is a characteristic of Art Nouveau that is literally copied from Japanese art.

In 1894 Edmond Picard opened his art gallery 'Maison d'Art' in Brussels, intending mainly to exhibit the work of avant garde artists in painting and the applied arts. The German art dealer Siegfried Bing borrowed this idea for his own 'Galerie de l'Art Nouveau' in Paris, which opened in December 1895.

Opposite: Abstract Art Nouveau tiles in the washroom of the toilet at the Chinese Pavilion in the Domains Royal de Laeken, near Brussels, built in 1903 to designs by the architect Alexandre Marcel. The tiles were made by Helman in Sint-Agatha-Berchem, near Brussels.

This combination of fine art and applied art was also the central idea behind the first exhibition of La Libre Esthétique (The Free Aesthetic), which took place in Antwerp in 1894 and where the majority of the design objects, such as pottery, glass, jewellery and book bindings were in the new Art Nouveau style.

Another important aspect of the new movement was its experimentation with new materials and construction techniques. In Brussels the architect Victor Horta deliberately made use of external iron girders as visible elements in the houses he designed for a group of liberal, well-to-do clients. Another Belgian Art Nouveau pioneer, Henry van de Velde (1863-1957), started his career as a painter and had his first major exhibition with Les Vingt in 1889. In 1893 he built his own house in Uccle, on the outskirts of Brussels, designing all the furniture and household objects himself. From then on he continued his career as a designer as well as an architect. The designer Serrurier Bovy, who had his furniture workshop in Liège, also shows the direct influence of Arts and Crafts ideas in his work. The Parisian architect Hector Guimard was strongly influenced by the work of Horta and Van de Velde, and took over their sinuous interlacing lines and the use of pure metal construction in his own designs for houses in Paris.

During this period, Belgian and French Art Nouveau shared the same decorative elements, especially elegantly bending flowers with curving stems. The favourites were irises, sunflowers, thistles, waterlilies, daisies, anemones, red poppies and roses. Elegant, slender birds such as flamingos, herons and peacocks were also popular. In contrast to the English designers, who in their following of Owen Jones stressed the stylization of nature, the Belgian and French designers excelled in elegant compositions of plants and animals with predominant naturalistic detail. Félix Bracquemond had already expressed the main characteristics of French Art Nouveau in his *Du Dessin et de la couleur* (On Design and Colour), published 1885, as follows: 'The works which are most artistic are those which are closest to nature whatever their purpose may be.' However a new period of Art Nouveau, with more abstract forms soon followed. This was already visible in the two interiors and several objects designed by Henry van de Velde that were exhibited in the Galerie de l'Art Nouveau in Paris in 1889. In these designs the stress is more on abstract stylization, with free flowing whiplash lines and undulating movement. At the World Fair in 1900 both the more naturalistic and the more abstract, stylized designs were exhibited side by side.

Typical of Belgian and French Art Nouveau was the use of rather sweet, soft pastel colours, and a common theme in graphic design and tile panels was the use of female allegorical figures. These women, elegantly posed, might represent one of the Muses (usually Architecture or Painting), or symbolize a modern utility - Electricity, the Telegraph or the Telephone. Without doubt the designs of the Czech artist Alphonse Mucha, who worked in Paris at the turn of the century, were the most important inspiration. In 1894 Mucha became world famous for his poster design of the well known actress Sarah Bernhardt as Gismonda. The Belgian artist Privat Livemont also designed many posters in this style.

Relief moulded tiles with sunflowers on the facade of a
villa in Avenue Victor Hugo in Beauvais, depicted as a
frieze (design no. 143) in the catalogue of the firm
La Manufacture de Grès – Gréber, Tabary & Commien,
Beauvais, around 1900.

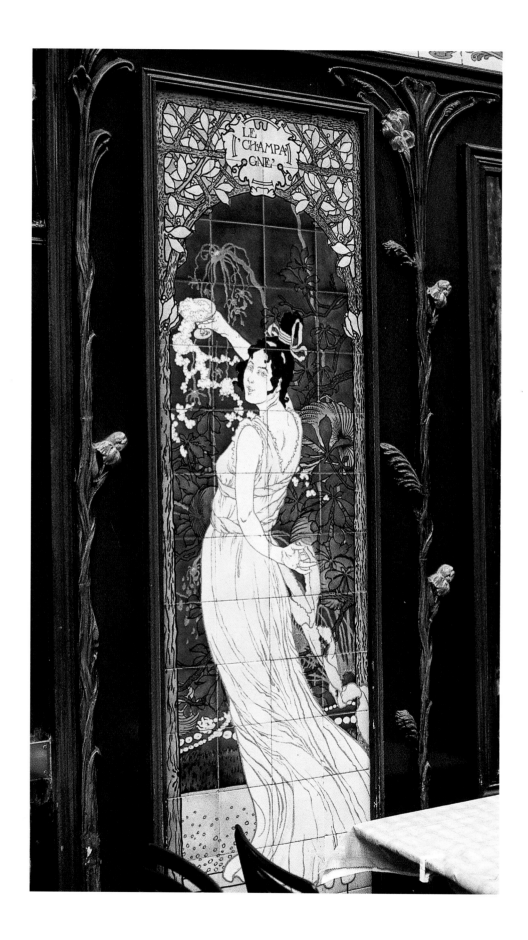

Above: A cuerda seca Art Nouveau tile by J. Loebnitz of Paris, around 1895.

Opposite: Panel of a female figure representing the region of Champagne on the exterior of the restaurant Le Petit Zinc, Rue Saint Benoit, Paris, made by Utzschneider-Jaunez, Sarreguemines, around 1900.

FRANCE

In nineteenth century France, various factors stimulated the use of tiles in architecture, particularly the rediscovery of external colour in ancient buildings and the revival of the production of medieval tiles. Another strong stimulus was the need for hygiene in food shops, bars, restaurants and public buildings. By 1900 the use of tiles had reached a peak and the diversity of available tileware was enormous. The output at this time can be divided into two categories. Firstly, the mass production of dust pressed tiles (*faience fine*) by large factories and, secondly, the manufacture on a craft basis of earthenware tiles and ceramic stoneware (*grès*) by smaller tile factories and workshops. Various World Fairs held in Paris between 1878 and 1900 were instrumental in promoting the use of tiles in architecture.

Technical advances had been made without which Art Nouveau tile production would not have been possible. Around 1840 Pichenot, since 1834 the owner of a small ceramic stove factory in Paris, deposited a patent for frost resistant ceramic. It was first brought to the notice of the public in the book *Traité des arts céramiques* (Treatise on Ceramic Art) by Alexandre Brongniard, managing director of the famous ceramic works of Sèvres. From 1844 Pichenot produced faience plaques and stoves in a Neo-Renaissance style or made copies based on the work of Della Robbia. Soon the production was extended with architectural wares. In 1857 the firm was taken over by his grandson Jules Loebnitz (1836-95) who expanded the firm and was successful in the production of large ceramic tiles and panels. Work for restoration projects was also undertaken for the architect Viollet-le-Duc.

Another ceramic material with similar frost resistant qualities was the so-called *lave émaillée* that was a combination of crushed volcanic rock with clay, fired at a high temperature. The result was a dense, dark brown material that had a good reputation when used in facades. It was invented around 1830 by Joseph Mortelèque, originally a glass painter, and from around 1850 was produced by the firm Hachette & Gillet in Paris. In 1882 François Gillet took out a patent for the new material. Théodore Deck (1823-91) was one of the first ceramic artists to explore the possibilities of painting very fine pictures on white ceramic tiles. He was also one of the first to use cloisonné techniques to obtain the necessary division between different glaze areas. The secret was to apply thin lines of slip that would keep the coloured glazes separate. This technique was used for one-off tiles, special tile panels and limited-edition series. For a large run of tiles, relief lines were created by the dust pressing process. From 1870 Deck became well known for the quality of his work. The free arrangement of his compositions and their two dimensional effect were inspired by Japanese prints and with this approach he paved the way for the Art Nouveau style. In 1887 Deck became director of the Manufacture de Sèvres. Tile panels were also produced by leading ceramic artists, such as Ernest Chaplet and Auguste Delaherche.

Any fashion trend is always most clearly displayed in the capital cities of the world. The same is true of Art Nouveau in Paris. From around 1870 the architect Paul Sédille was already encouraging his friend Jules Loebnitz to concentrate on the production of architectural ceramics. At the 1878 World Fair Sédille designed the monumental entrance to the Pavillon des Beaux-Arts,

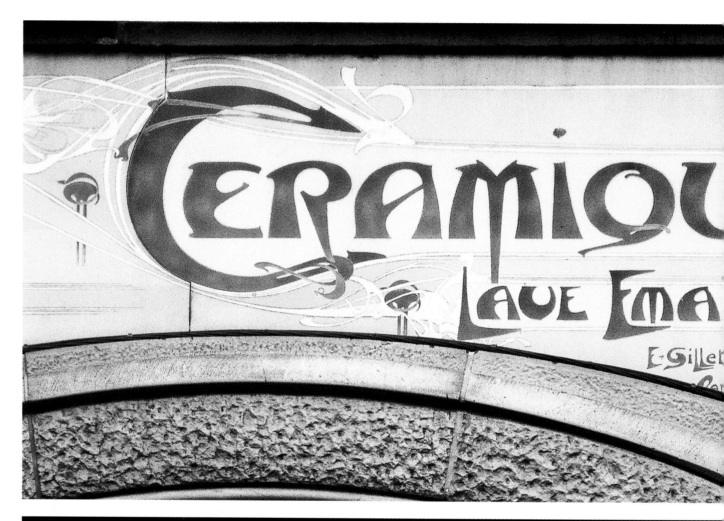

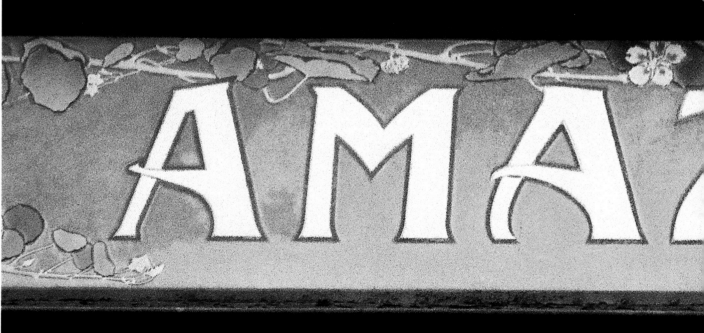

Above: Detail of the facade designed by the architect Paul Sédille with green glazed bricks and a frieze of polychrome tiles showing lemons amongst green foliage at 32 Rue Eugène Flachat, Paris, 1892.

Left: Detail of the lave émaillée *panel made by Gillet for the exterior of Louis Coilliot's ceramics showroom at 14 Rue de Fleurus, Lille. The shop was designed by Hector Guimard and built between 1898 and 1900.*

Below: Detail of a lave émaillée *panel with the name* Amazone *on the Samaritaine department store designed by François Jourdain between 1905 and 1907 at Rue de Monnaie, Paris. The facade was decorated with* grès flammé *panels by Bigot and brightly coloured name panels in* lave émaillée *by the Gillet workshop.*

for which some large tile panels were executed by Loebnitz. One of these is still to be seen as part of the facade of Loebnitz's workshop at 14 Rue de la Pierre in Paris. The front of this building, designed by Sédille between 1880 and 1884, is decorated with large ceramic panels designed by Emile Lévy which show an allegorical representation of Ceramic Art. Also at the World Fair of 1878, decorations with polychrome tiles and mosaics were included in the facade of the Trocadéro building, designed by the architects Davioud, in the Galerie des Machines and in the Palais du Champ-de-Mars. Architects like Anatole de Baudot and Paul Sédille had produced several publications on the use of colour in architecture. The most influential was Sédille's book, *Etude sur la renaissance de la polychromie monumentale en France* (Study on the Revival of Architectural Polychromy in France), an ardent plea for the use of colour in architecture.

Detail of the floral tiles on the Manufacture de Sèvres pavilion for the World Fair of 1900, reerected at Place Félix Desruelles, Boulevard Saint Germain, Paris.

The World Fair in 1889 was a triumph for architectural ceramics. Several new tile factories had been established in and around Paris during this period, including those of Boulenger in Choisy-le-Roi and Vitry-sur-Seine. Boulenger and the factory of La Grande Tuilerie d'Ivry-sur-Seine, which had been owned since 1854 by Emile Müller, produced a large amount of decorative ceramics for the Fair. Most of the important buildings in the exhibition sparkled with the extensive use of glazed ceramics. A large gate, the Porte de la Céramique, was designed by the architect M. Deslignières and executed in collaboration with the factories of Loebnitz and Boulenger. In the large pavilions, ceramic panels were used in combination with an iron skeleton, in order to give the construction more 'body'. The two side pavilions of the central Palais des Expositions Diverses had cupolas covered with blue glazed tiles. Some tile panels of this building were rescued and reused elsewhere in Paris: work by Emile Müller can still be seen at the Place Paul Langevin and a tile panel by Paul Loebnitz in the inner court of the Ministère de l'Industrie at Rue de Grenelle.

At the World Fair in 1900 tiles were also used in many pavilions since by then glazed faience had become a fashion. One of the most important examples was the grand pavilion of the Manufacture de Sèvres designed by the architect Ch. Risler with ceramic decorations by the sculptor J. Coutan. A section of this pavilion was reerected on a wall at the Place Félix Desruelles, beside the Boulevard Saint Germain in Paris. The Müller factory executed the spectacular *Frise du Travail*, designed by the artist Guillot, for the monumental gateway.

The Niermans brothers were successful interior designers or decorators. From around 1890 they created many spectacular schemes for restaurants and theatres. They worked in a number of historical and exotic styles, but also in the modern Art Nouveau manner. A good example of their work is the Brasserie Mollard, which opened around 1895 opposite the Saint-Lazare railway station. The interior was decorated with nine large tile panels, depicting French landscapes alongside rail routes. Executed by the Sarreguemines factory and designed by the factory designer E.M. Simas, these panels already have the characteristic open composition and bright colours of Art Nouveau design.

In the fin-de-siècle period, a fashionable interior became a must for all expanding new businesses, especially food shops, brasseries, cafés, hotels,

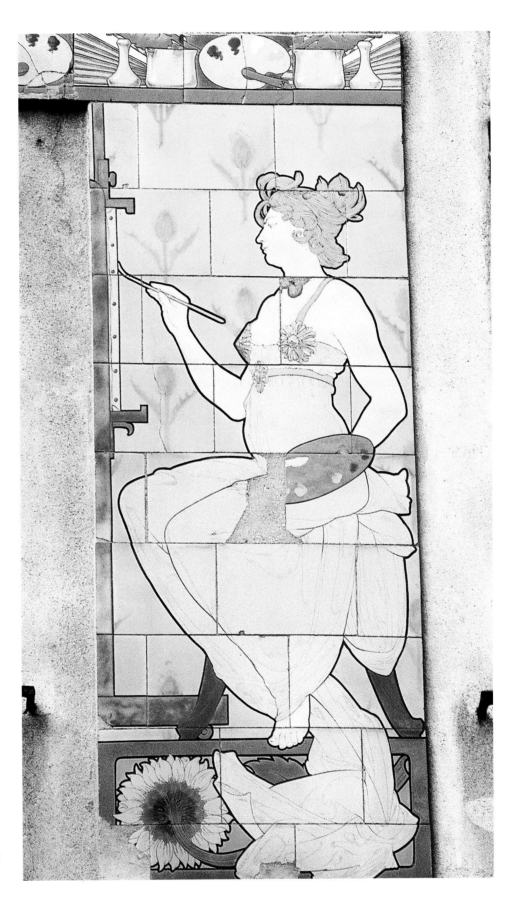

Mucha style panel showing a woman behind an easel on the facade of an artists' supply shop at 8 Boulevard Saint Martin, Paris.

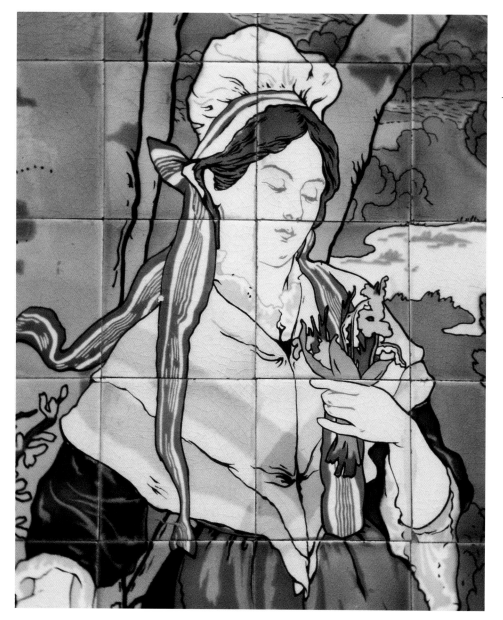

Left: Panel of a female figure in French rural dress on the exterior of the restaurant, Le Petit Zinc, Rue Saint Benoit, Paris, made by the firm Sarreguemines, around 1900.

Below: Detail of an entrance to one of the Métro stations in Paris with a trade tile of the Boulenger firm who supplied most of the tiles for the Métro.

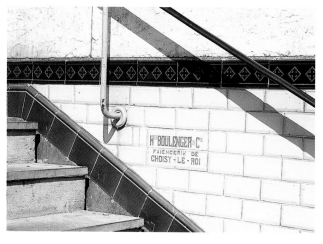

restaurants and department stores. Here tiles were used mainly for their easy maintenance and because they were hygienic. Fishmongers, dairies and butchers had tile panels with subjects usually directly connected to the business. An example can be seen in the famous Samaritaine department store at Rue de Monnaie, built between 1905 and 1907 to the design of François Jourdain. The ceramic decorations are made of *grès flammé* relief panels produced by Bigot, and there are also brightly coloured name panels and other panels in *lave émaillée* made by the Gillet workshop. The work of Alphonse Mucha was the inspiration for the large tile panels in a striking Art Nouveau style on the facade of 8 Boulevard Saint Martin (10e arr.), one female figure personifies Sculpture, the other Painting. Several interiors with tiled walls have survived the changes in fashion that have followed. Many of them were executed by the Sarreguemines factory: the café restaurant La Table en Aquitaine, 176 Rue du Faubourg Saint Denis (10e arr.), with four large panels signed by the painter A.J. Arnoux, representing hunting scenes; the famous restaurant L'Assiette au Beurre, now the restaurant Le Petit Zinc in Rue Saint Benoit (6e arr.); and the Royal Bar at 143 Rue Saint Denis (2e arr.) dating from 1915. The Boulenger factory made the tiles in the Palace Bar at 146 Rue de Rivoli (1r arr.), dating from 1910. In the Lux Bar at 12 Rue Lepic (18e arr.), the Art Nouveau tile panels, one of them dated 1910, are by Gilardoni; the tile panels in the Aviatic Bar at 354 Rue de Vaurigard (15e arr.) are from Gilliot in Belgium and by G. Martin.

All the important tile factories had their showrooms in the capital and many were located in the Rue de Paradis (10e arr.). At no. 28 was the showroom of the firm Sarreguemines, at no. 38 Gilardoni Fils & Cie, and at no. 18 Hippolyte Boulenger, whose showroom was built in 1889. For commercial purposes Boulenger decorated the front of his building with a variety of large tile panels, acting as kind of catalogue of what his factory could produce. During the years many more tile panels were added inside the showrooms, where they are still in situ. Several of them are signed 'Arnoux et Guidetti'. A.J. Arnoux was director of the decoration department during this period. His research into glazing techniques resulted in the vibrant colours for which the Boulenger factory was famous, especially bright red, pink and orange, colours that are most difficult to produce in glazes. Another designer who worked for Boulenger was a certain Lovatelli-Colombo. The production of the Boulenger factories was probably limited to wall tiles; for floor tiles they acted as agents for S.A. (Société Anonyme) des Carrelages Céramiques de Paray-le-Monial.

1899 saw the start of the Métro project in Paris. The entrance pavilions were designed by the young architect Hector Guimard with standardized panels in *lave émaillée* executed by the Gillet factory. But even more important was the commission for the vast tiled surfaces of the underground tunnels and stations. Six manufacturers applied for this commission, and Boulenger and Faiencerie de Gien were awarded the main part of the contract. A special tile, called *carreau-métro* was developed, for which Boulenger used special rubber moulds. The Gentil & Bordet tile factory made the famous Art Nouveau entrances of the Porte de la Chapelle-Mairie d'Issy line.

Besides Bigot, Boulenger and Müller, there were several smaller firms in and around Paris that concentrated on the making of luxury Art Nouveau tile

panels for a wealthy clientele, notably Théodore Deck, Ebel & Gazet, Gilardoni Fils & Cie, Janin & Guérineau, Lamare & Jurlin, Mazzioli, Gentil & Bourdet.

Several Parisian avant garde architects, such as Anatole de Baudot, Paul Guadet, Hector Guimard, Jules Lavirotte, Auguste Perret and Henri Sauvage experimented with Art Nouveau ceramic stoneware for the decoration of entire facades, some of which were made of concrete. In 1893 the Müller factory produced the glazed ceramic panels and roof tiles for the Hôtel Jassedé in Paris, its first important commission for Hector Guimard. The panels with a decoration of sunflowers were fitted into several window arches, accompanied by other colourful materials, such as polychrome bricks, painted iron and stone. In 1897-8 Guimard used stoneware decorations in his famous apartment block Castel Béranger at 14 Rue La Fontaine in Paris, executed by Bigot and Müller. In the entrance hall he applied large *grès flammé* panels by Bigot, as well as *lave émaillée* by the Gillet factory. The architect Jules Lavirotte designed three apartment buildings with facades in *grès flammé* by Bigot, at 3 Square Rapp (1899), 29 Avenue Rapp (1901) and 34 Avenue de Wagram (1903), later converted to the Ceramic Hotel. Bigot was the owner of the apartment block at 29 Avenue Rapp and here he took the opportunity to display his craftsmanship. The whole facade above the ground floor is covered with *grès flammé* attached to a reinforced concrete structure. For the decorations on the facade Bigot gave free rein to the architect, who indulged in erotic symbolism. The sculptures around the entrance door represent two naked children, symbolizing the 'source of youth', that was also popular in German Jugendstil ('Jungbrunnen'). The design of the door suggests the male organ, the upper part the testicles, the lower the penis. At 34 Avenue Wagram, there are one metre (three foot) high vases from which grow tall vines that spread across the entire facade. Bunches of grapes and the occasional beetles adorn the building. These last two buildings won the first prize in 1901 and 1905 in the annual competition for the design of facades held by the city municipal council. In 1903 the architect Auguste Perret used small glazed 'pastilles' and flowers in *grès de Bigot* for the entire facade of the apartment building at 25 Rue Franklin, which is famous for its early use of a reinforced concrete. The ceramic pieces are in many different pale colours, and used in such a way that the effect can be compared with an Impressionist or Pointillist painting.

In France, sculptural ceramic stoneware decorations represented the spirit of the Art Nouveau perhaps even more than the normal flat decorated tiles. The most important manufacturers of this product, called *grès* in French, were Emile Müller, Alexandre Bigot and Charles Gréber.

Emile Müller (1823-88) was an engineer who established his own factory, La Grande Tuilerie d'Ivry-sur-Seine, in 1854 for the production of bricks and other ceramic products. It was situated in Ivry, near Paris. He worked together with Loebnitz on the Asile du Vésinet Building in 1859. In 1872 Müller produced the glazed bricks and ceramic ornaments for the famous Menier chocolate factory at Noisiel, designed by Jules Saulnier. The walls of this building consisted of flat brick planes between an iron framework. The architect, not wanting to use plaster, decided that colour was the right solution for their decoration. To lessen the impact of the red bricks, he interspersed them with white glazed ones. Around the windows he placed black and buff bricks as borders for tiled roundels in shades of green, with the letter M for

Above: Detail of the facade of the Ceramic Hotel at 34 Avenue de Wagram in Paris, decorated with grès flammé *by Alexandre Bigot of Paris, 1903.*

Opposite: Main entrance of 29 Avenue Rapp in Paris, extravagantly decorated with grès flammé *ceramics by Alexandre Bigot of Paris, 1901.*

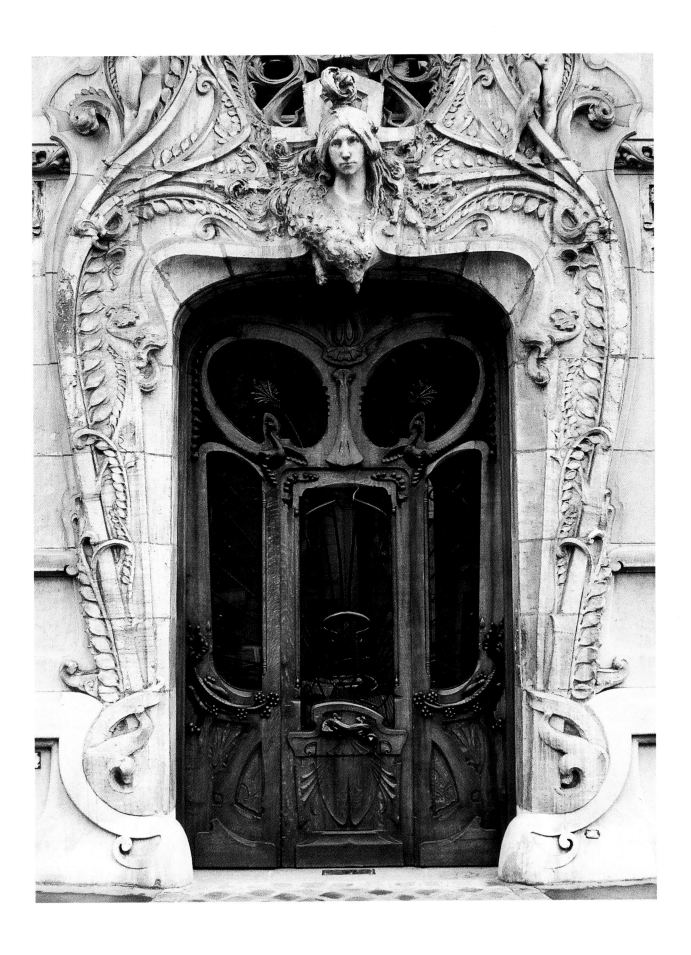

Above: Detail of grès flammé *panels by Alexandre Bigot, in the entrance of Hector Guimard's Castel Bérenger, 14 Rue de la Fontaine, Paris, 1897-8.*

Left: Panel with Art Nouveau lettering advertizing grès de Bigot *on the exterior of the Ceramic Hotel at 34 Avenue de Wagram in Paris, 1903.*

Menier, as well as green and white glazed rose ornaments. For the roof special ridge tiles were designed with flowers, cloves and cocoa tree leaves, with metal rods that served as lightning conductors. One of Müller's goals was to produce special tiles for monumental decoration, in contrast to the standard tiles of 15 by 15 centimetres (six by six inches), and to enable architects to have their own designs made to order. Müller was awarded a grand prize for his contribution to ceramics at the World Fair in 1889. However, he died in the same year and his son Louis took over the factory, continuing it under the name Emile Müller & Cie. Louis succeeded in enlarging the factory to one of the largest ceramic works in France which in 1900 provided work for about 400 employees.

At the World Fair in 1889, Alexandre Bigot (1862-1927), a 27-year-old chemist, discovered the beautiful glaze effects of oriental ceramics. He decided to become a ceramic chemist and to perfect the various techniques necessary to make ceramics a reliable decorative material. In his laboratory at the Ecole des Mines, he had kilns at his disposal that could be fired to very high temperatures of about 1600°C. At that time most kilns, fired with oak bark or oak wood, had a limit of about 900°C. For all his architectural products Bigot used a porcelain body that he covered with the special coloured glaze which he called *grès flammé*. He established his own ceramic factory in Mer, in the Cher-et-Loir district, where, at the turn of the century, some 150 workers were employed. Besides being a scientist, Bigot also developed as an artist. At the Salon in 1894 he showed cups, vases, flower pots and inkstands of his own design. In 1897 he exhibited for the first time with Siegfried Bing in his Galerie de l'Art Nouveau. Bigot received a Grand Prix and the Legion d'Honneur for his work at the World Fair in 1900. A large number of the pieces he exhibited were purchased by the National Hungarian Museum of Applied Arts in Budapest, where they can still be seen. The objects, mostly friezes and tiles, are by different designers such as P. Roche, Halou and A. de Baudot. Another piece of work at the 1900 exhibition was an Art Nouveau frieze with animals for the monumental entrance, based on a design by the sculptor Paul Jouvé. A smaller version of this frieze was used by Bigot in the facade of his atelier in Paris at 13 Rue des Petites Ecuries.

Following the example of Emile Müller, Bigot specialized in the production of architectural ceramics, such as bricks, tiles, friezes and decorative panels. Besides pieces designed by himself, Bigot offered for sale Art Nouveau tile friezes designed by architects and artists like Guimard, Sauvage, Van de Velde, Roche, Jouvé, Majorelle, De Baudot, Formigé and Lavirotte. He received his first commission for architectural ceramics from Anatole de Baudot in 1898, for the theatre in Tulle which was faced with small colourful 'pastilles' of two to four centimetres (one to two inches) in diameter. The same pastilles were used at the innovative church of Saint Jean in Montmartre (1897-1904), in combination with small pellets of *pâte de verre*. For this building Baudot experimented with the use of reinforced concrete (the Cottancin system), which was then so controversial that Baudot was taken to court by the church authorities because they feared the building would collapse. The work had to be suspended for nearly three years before the building could finally be completed. Bigot's ceramic tiles were craft products and not the result of mass production. This meant that in principle they could be made in all sorts of

dimensions, and that Bigot *grès* could be commissioned to individual
specifications, sizes and colours. An example is the chimney piece designed
by Jean Prouvé in the Majorelle House in the Rue Majorelle in Nancy.
This project was built between 1898 and 1900 after the design of the young
Parisian architect Henri Sauvage and decorated with *grès* ceramics made by
Bigot. The firm of Bigot stayed in business until 1914, when the outbreak of
the First World War forced its closure.

The most important large wall tile factories in France were not located in
Paris but in the northern and eastern parts of the country, close to the raw
materials. Examples are the tile works in Saint Amand, the S.A. des Carreaux &
Revêtements Céramiques du Nord in Orchies, owned by E.L. Herminé, and
the Huart Frères factory in Longwy, the Fourmaintraux-Délassus factory in
Desvres and the Utzschneider (later: Utzschneider-Jaunez) factories in
Sarreguemines and Digoin. Tile factories were also located in the central
regions of France, such as in Sèvres, Creil, Montereau, Ponchon, Rambervillers
and Toul. In Gien, on the river Loire, there was the Faiencerie de Gien,
Geoffroy & Cie where tiles were produced alongside tableware. In and around
Limoges, another centre of ceramic manufacture, several factories produced
architectural ceramics, such as the famous Haviland factory. Tiles were also
made in the south of France, in Toulouse and Marseilles. Most of these firms
began with the production of faience or *grès* wall tiles in and around 1890, but
some were long established, with a continued production since the eighteenth
century or earlier, like the Fourmaintraux-Délassus works and the factories in
the Saint Amand region.

A major factory in Art Nouveau tile production outside Paris was
Utzschneider in Sarreguemines, an old firm, where production of pottery
started around 1770. At the end of the nineteenth century the company came
to prosperity under the direction of Baron de Geiger and by 1900 it employed
around 3000 workers. Sarreguemines was actually on German territory until
1918, the German name of the town being Saargemünd, but the factory was
strongly orientated towards Paris and the rest of France. To escape from German
integration a large branch was founded in Digoin, in the Sâone-et-Loire
département, where production on a large scale was started in 1879 and where
most of the employees went to work. In 1895 another branch was opened in
Vitry-le-François, near Paris. Sarreguemines Art Nouveau tiles can be found all
over France, especially in Paris. At the World Fair in 1900 the firm introduced a
new frost proof ceramic product called *grès de Riverney* for use on facades. The
oriental flavour of some of their Art Nouveau tile panels can be explained by
the fact that the factories' designers were inspired by such illustrated books as
Hundred Views of Mount Fuji-Yama by the Japanese artist Hokusai and *Japanische
motive* by the German Keneken. One of their most important designers was
E.M. Simas. Several others worked for the firm including Jules Chéret and
Théophile Steinlen. Simas already worked for Sarreguemines in 1895 and
continued as late as 1921, because in a catalogue of that date two large tile
panels are illustrated with his name as designer. The Sarreguemines showrooms
in Paris were located at 28 Rue de Paradis, but all the tile panels there were
dismantled and sold by auction in 1987.

Another important region for tile manufacturing was the area south west
of Beauvais, due to the existence of a large clay vein in this area. Around 1900

*Ceramic pastilles by
Alexandre Bigot of Paris on
the facade of the church of
Saint Jean in Montmartre,
Paris, designed by the
architect Anatole de Baudot
and built between 1897 and
1904.*

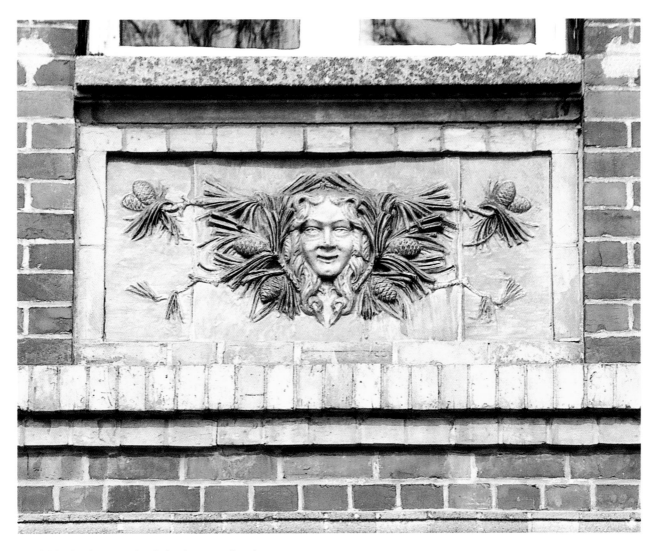

*Moulded tiles showing a female head amongst branches
with pine cones manufactured by the firm Charles Gréber
around 1910, on a house in Avenue Victor Hugo,
Beauvais, France.*

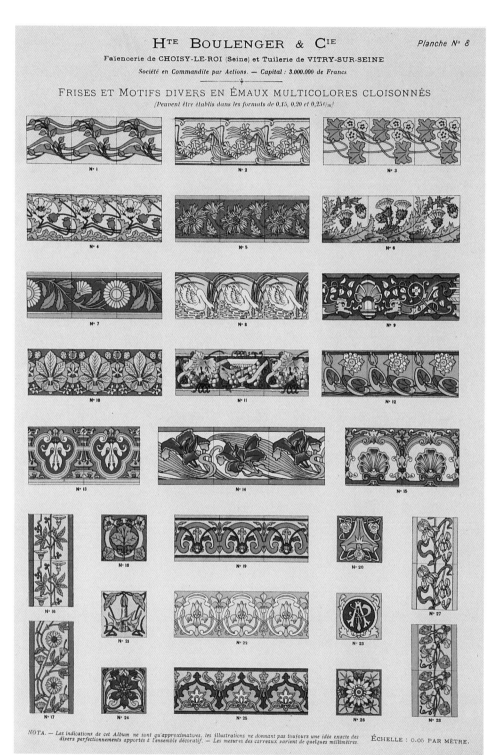

HTE BOULENGER & CIE

Faïencerie de CHOISY-LE-ROI (Seine) et Tuilerie de VITRY-SUR-SEINE

Société en Commandite par Actions. — Capital : 3.000.000 de Francs

Planche N° 8

FRISES ET MOTIFS DIVERS EN ÉMAUX MULTICOLORES CLOISONNÉS

(Peuvent être établis dans les formats de 0,15, 0,20 et 0,25 c/m)

NOTA. — *Les indications de cet Album ne sont qu'approximatives, les illustrations ne donnant pas toujours une idée exacte des divers perfectionnements apportés à l'ensemble décoratif. — Les mesures des carreaux varient de quelques millimètres.* ÉCHELLE : 0.05 PAR MÈTRE.

Left: Catalogue page from the firm Boulenger showing a range of standard Art Nouveau tiles.

Opposite, top: Facade of the Charles Gréber workshop at 63 Rue de Calais, Beauvais, built in 1911, depicting a potter at his wheel.

Opposite, bottom: Tile panel in a Japanese style with seagulls flying above stormy waves in the vestibule of 103 Rue Jouffroy, Paris, by Janin & Guérineau, around 1905.

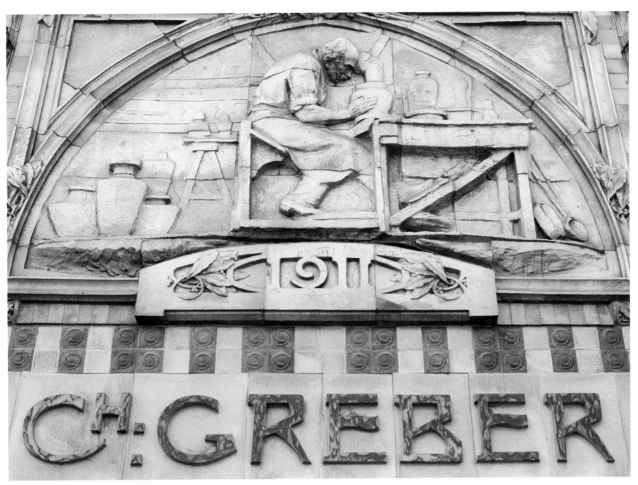

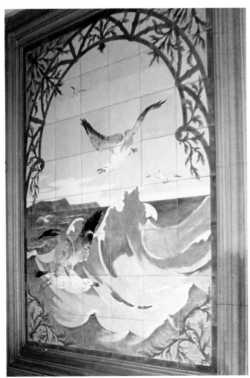

the most important firms were Boulenger in Auneuil, established around 1850, and Colozier established in 1889 in Saint Just-des-Marais, near Beauvais. The Boulenger brothers were amongst the first in France to produce encaustic tiles (which in French are known as *carreaux de grès incrustés*) in the spirit of Minton encaustic tiles in England, and like Minton most of their encaustic tiles were decorated with medieval or sometimes Classical designs. However, of more interest for the history of Art Nouveau is Charles Gréber (1853-1935) who established a small factory for tiles in Beauvais. Around 1890 he was making panels with rather traditional designs for his own house in 14 Rue Bossuet, but more in keeping with Art Nouveau is the facade of his small factory, dated 1911, at 63 Rue de Calais in Beauvais. It has several relief panels depicting a potter at work, and vertical bands with small sculptural creatures such as lizards. Although Gréber's highly individual work was received very positively at several international exhibitions, most of it is only to be seen in and around Beauvais, such as in the Avenue Victor Hugo, where several houses and villas are decorated with his ceramic ornaments.

BELGIUM

Although Belgium was one of the first industrialized countries in Europe, large scale production of tiles did not begin until the end of the nineteenth century. When it did begin its expansion was rapid and between 1895 and 1910 more than ten wall tile factories were established. Floor tiles were even more in demand with 50 factories being set up between 1900 and 1914. Apart from the large factories there were also small workshops where tile panels were produced for special orders. All this coincided with the emergence of the Art Nouveau style in Belgium. Brussels was an important centre of artistic innovation where artists, designers and architects found a willing and affluent clientele. All these developments made Belgium one of the major Art Nouveau tile manufacturing countries in Europe and explains why there are still so many tile installations to be seen throughout Belgium today.

Leading Art Nouveau architects such as Victor Horta and Paul Hankar only used tiles on a few occasions. However, Hankar was involved with the Compagnie Générale d'Architecture in Namur, for which he created some tile designs. Artists such as Adolphe Crespin, Paul Hankar, Jean Baes and Privat Livemont taught at the Belgian schools of arts and crafts where they spread the dynamic, free flowing Art Nouveau style created by Horta, Van de Velde and others. From these institutions future tile designers like Jacques Madiol and Joseph Roelants emerged. At the end of the century competitions for the best facade design in Antwerp and Brussels were a stimulus to creativity and the use of colour in architecture. In 1897, Henri Baudoux, co-founder of the tile factories Hasselt and Helman, expressed in a lecture to the Société Centrale d'Architecture the changing attitude of architects towards the use of colour in facades, and therefore to the use of tiles: 'For some time there has been a certain aesthetic preoccupation amongst modern builders. They no longer wish to see around them the sombre and monotonous streets, and they are looking for ways to bring in gaiety. In my opinion ceramics will play a very important

Opposite: The tiled conservatory of a house at Korte Meer in Ghent, around 1905. The floral scene and landscape act as an illusionary extension of the conservatory.

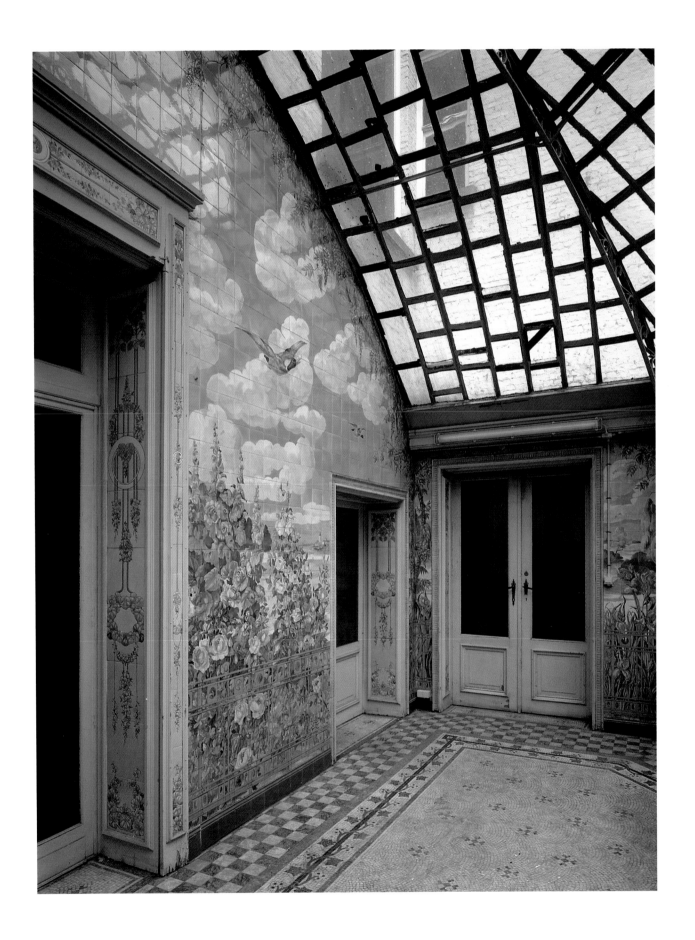

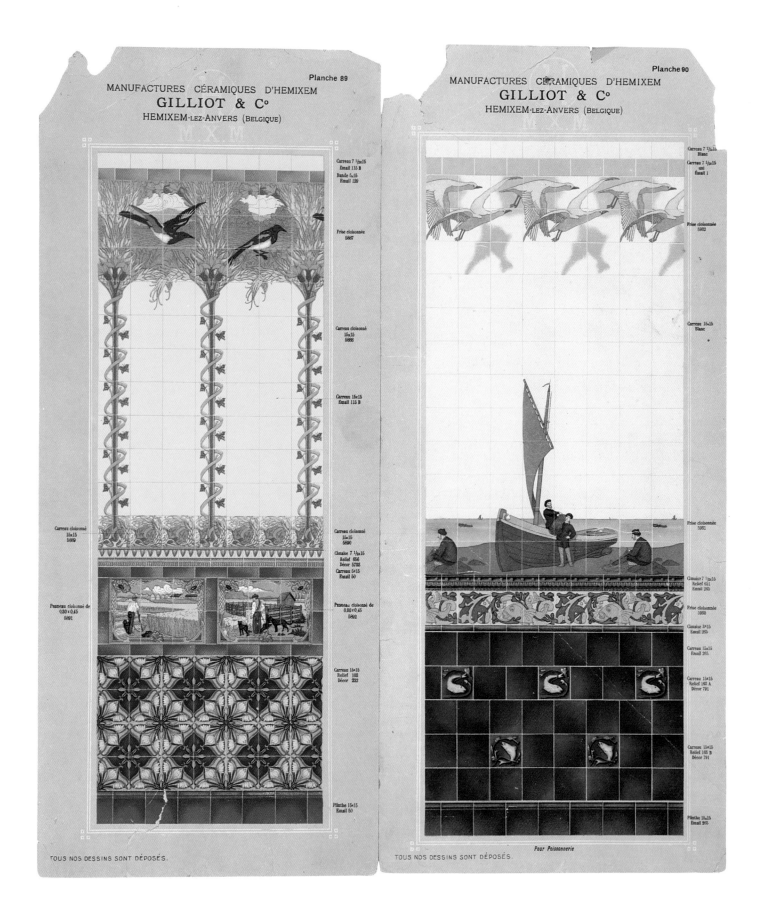

Above: Name panel dated 1897 on one of the office buildings of the tile manufacturer Gilliot & Cie in Hemiksem.

Opposite: Two pages from a Gilliot & Cie catalogue showing tiled dados in the Art Nouveau style, around 1905.

role in the making of architectural panels. What other product could create harmonious and colourful designs, with colours that shine brightly in the sunshine? With ceramics everything is possible, all your dreams can be realized.' In some designs the influence of the abstract designs of Mackintosh or the Viennese Sezession group can be recognized as there were contacts between Vienna and Glasgow that went via Brussels. The tiles in the wash room of the Chinese pavilion at the Domains Royal de Laeken, near Brussels, built in 1903, are an example of this trend.

When at the end of the century Belgian cities began to expand, a new market for architectural ceramics emerged. In the years 1895-7 the three most important tile manufacturers were established, namely the Manufacture de Céramiques Décoratives (also named Les Majoliques de Hasselt) in Hasselt; the Manufactures Céramiques d'Hemixem, Gilliot & Cie in Hemiksem (the Flemish name for Hemixem) near Antwerp; and Helman Céramique in Sint-Agatha-Berchem, in the suburbs of Brussels.

Georges Gilliot, founder of the new tile factory in Hemiksem, was a relative of Charles Gilliot, who had been, since 1859, one of the main shareholders of the Société Céramique factory in Maastricht in Holland. There must have been major financial resources in this family, making it possible to start such a large tile factory. From the beginning business prospered. The technical development was in the hands of an experienced scientist, the Englishman John Salt who became technical director. In 1898 the first tiles were sold and by 1900 the firm had 50 employees. Ten years later there were 900 workers. In 1913 the 46 kilns were capable of producing around 300,000 square metres (360,000 square yards) of wall tiles per year. Tile production at Hemiksem came finally to an end in 1977 and its archival material, including a number of tile catalogues, is now preserved in a small museum devoted to the history of the firm. These sales catalogues from the period between 1900 and 1914 offer an overwhelming variety of designs, for wall and floor tiles. For most of these tiles the name of the designer is unknown. Only a number of special tile panels are signed with the name of the designer H. Bonnerot.

The Helman factory was founded by the architect Célestin-Joseph Helman in 1895, with Henri Baudoux as the general manager of the factory during the early years, and from the start only tiles and architectural ceramics were produced. These two men were also involved with the establishment of the Hasselt factory in 1896, where Helman became co-director and shareholder with Baudoux until Baudoux became director of the Servais Werke in Ehrang in Germany in 1898. The tile factory in Hasselt started on a large basis, with around 130 workers, but did not expand as much as the Hemiksem factory. Its ceramic production consisted of pottery, architectural ceramics of all sorts, and tiles. These were not only produced by dust pressing, but also by hand moulding. Probably the Helman and Hasselt factories worked closely together as they shared the same showrooms in Brussels. They also shared the same designers, for example Jacques Madiol. During the first years many Art Nouveau tile panels were made to special designs, for a variety of purposes: 'Décorations de verandahs, terrasses, salles à manger, salons, cafés, restaurants, brasseries, salles de billiard, vestibules, halls, salles de bains, boucheries, charcuteries, etc'. Only in a few instances is the name of a designer known. Designers moved around. Joseph Roelants started working for Helman in 1911.

*Panel of six Art Nouveau tiles with cyclamen on the facade
of a house at 35 Nieuwstraat, Hemiksem.*

Then during the First World War he made a series of tile designs for the Poole factory in England, and at the end of the war he became chief designer of the Hemiksem factory. The Helman factory also collaborated with the Norddeutsche Steingutfabrik (N.S.T.G.) in Bremen-Grohn in Germany, with the result that several relief tiles with stylized Art Nouveau designs were produced by both factories. This has led to some confusion as not all tile back marks give a clear indication of origin.

The Boch Frères factory, named Kéramis, had been established by René Boch as early as 1841 near La Louvière and was the first major tile factory in Belgium. Their designs were mostly rather traditional, though they also made some products in the Art Nouveau style. Amongst their first Art Nouveau tiles were the designs *Lily* and *Thistle* by Maurice P. Verneuil, from his book *La Plante et ses applications ornamentales* (Plants and Their Ornamental Applications), published in 1897. These tiles were printed by a lithographic technique. In the 1880s and 1890s some interesting tile pictures were designed and painted by Anna Boch, who was a member of Les Vingt and La Libre Esthétique. She was responsible for attracting other avant garde artists to the factory, such as Charles Catteau and William Finch. It is also known that Emile Diffloth and Georges De Geetere painted special tile panels at the Boch factory, mostly for special occasions. One example was the large panel *La Chasse de Diane*, made for the World Fair in Antwerp in 1894. Some years later De Geetere painted a series of tile panels after designs by Privat Livemont for the facade of the commercial building Grande Maison du Blanc at the Kiekenmarkt in Brussels, which was constructed in 1897. Although these panels are rather dirty and damaged, it is still worth the trouble to go and see them.

By 1910 there were around 20 other firms producing Art Nouveau wall tiles besides Boch, Hasselt, Helman and Hemixem. One of them was the famous porcelain factory Vermeren Coché in Brussels (from 1901 the name was Demeuldre Coché), where panels in *grès cérame* technique were produced for the Old England store at the Kunstberg in Brussels, built in 1899. The porcelain and ceramics shop that belonged to this firm, at 144 Waversesteenweg in Brussels, is still there but the factory which was located behind the shop no longer exists. The interior is quite well preserved, especially the Art Nouveau panels representing *Dance*, *Colour* and *Music* in *grès cérame* by the artist Isidore De Rudder and the specially designed dado with iris flowers and swans in white in green.

Other factories of interest at that time were the N.V. Ceramiekprodukten De Dyle which started production in Flanders in 1908, with the trademark Belga. In the southern part of Belgium there were many factories producing encaustic floor tiles, while others produced mainly wall tiles, such as the S.A. Faiencerie de Bouffioulx, with the back mark *FB*; the S.A. des Pavillions, with the back mark *P*; and the Société Générale de Produits Réfractaires et Céramiques de Morialmé, with the back mark *S.M.* (Société Morialmé). In 1906 total production in Belgium amounted to 20 million wall tiles. Besides these tile factories, there were at least 20 small ateliers specializing in tile panels and other tile decorations.

The firm Maison Guillaume Janssens' most spectacular creation is without doubt the director's own house Villa Marie-Mirande at 11 De Selliers de

Detail of hand-painted tile panel in cuerda seca *technique with a yellow lizard crawling through high grass, probably designed by the Dutch artist Nienhuis, using factory tile blanks of the Boch Frères factory in La Louvière, Belgium. Shown larger than actual size (22 x 15 cm, 9 x 6 ins).*

MᵒⁿG.JANSSENS
BERCHEM Sᵗᵉ AGATHE

Above: Tile panel with a woman playing a harp on the facade of a house built in 1910 at 25 Avenue Jean Dubrucq, Brussels. The name and address of the manufacturer, Maison Guillaume Janssens, can be seen at the bottom of the panel.

Left: Panel of a woman holding lilies on the facade of one of the houses in the Prinses Clementinalaan, Ghent, around 1910, probably made at the Helman factory in Brussels.

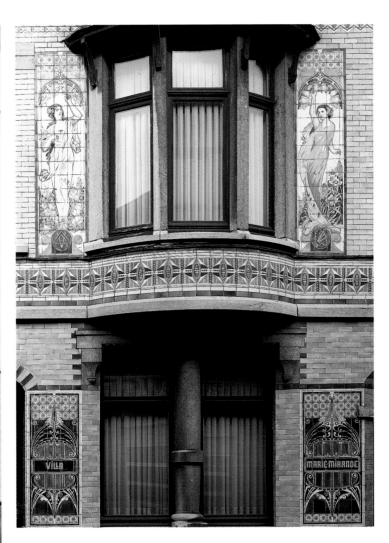

Above, right: Part of the elaborately tiled facade of Villa Marie-Mirande, 11 De Selliers de Moranvillelaan, Sint-Agatha-Berchem, Brussels, built for the owner of the tile firm Maison Guillaume Janssens in 1912. The elegant female figures on the first floor represent Architecture and Painting.

Moranvillelaan in the Sint-Agatha-Berchem area of Brussels, close to where the Helman factory was located. The entire facade of the house, built in 1912, is covered with tiles, with elegant female figures and colourful flowers. Another impressive example of this firm's work can be found at 23 and 25 Avenue Jean Dubrucq in Brussels. The facades of both these houses, built in 1910, are covered with numerous Art Nouveau panels decorated with female heads, birds and other motifs. At the top of the facade of no. 23 is an impressive panel showing the Goddess Diana as a huntress. But there is more to be seen in Brussels, such as the completely tiled interior of the Rôtisserie Vincent at 10 Predikheerenstraat. All the walls, as well as the ceiling and floors, are covered with tiles, made to special design at the Helman factory. Next to the entrance door a tile with the name of the factory is bricked in. This interior dates from 1913, but although rather late for an Art Nouveau interior, it is still a convincing example. In the back room there are large tile paintings with landscapes and seaside scenes. Ghent is another town where Art Nouveau tiles can be seen, particularly in the areas around Sint Pieters railway station where houses in the Prinses Clementinalaan show a great variety of different Art Nouveau tile panels.

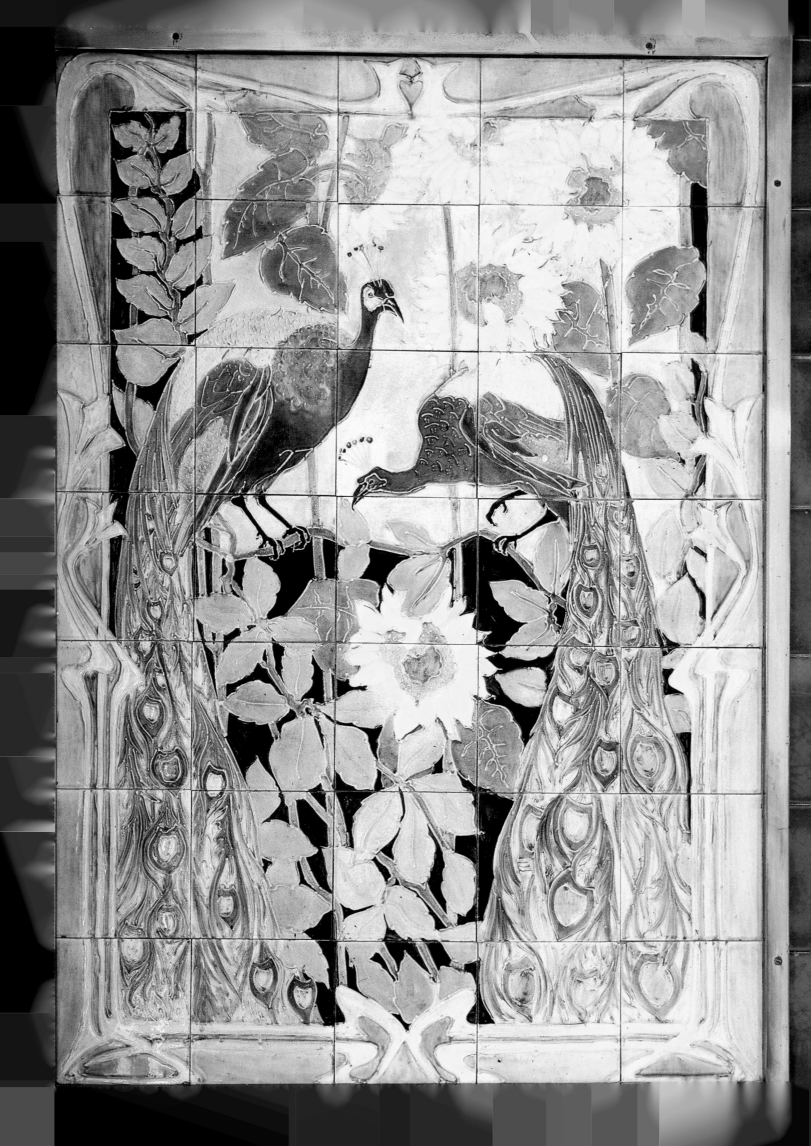

NORTHERN EUROPE

ART NOUVEAU manifested itself in Britain, Holland and Germany in different ways. It never became a strong phenomenon in England because of the legacy of the Arts and Crafts Movement, but instead it flourished in Scotland where Charles Rennie Mackintosh and others created some remarkable buildings, furniture and objects in the Art Nouveau style, some of which showed a distinctly geometric tendency. Holland was a crossroad for many conflicting influences, not only those of the British Arts and Crafts Movement, but also Art Nouveau vibrations from Belgium and Germany and exotic imports from its own colonies. However, in certain instances it did manage to assimilate these diverse influences and create its own distinct contribution to Art Nouveau. This took the form of the 'Nieuwe Kunst' movement as can be seen in the work of H.P. Berlage and Jac. van den Bosch. Germany developed another variant known as 'Jugendstil'. Although it could boast of its own high calibre designers and architects like Otto Eckmann and Peter Behrens, it also depended greatly on foreign artists like the Belgian Henry van de Velde who came to work in Germany and influenced the development of Jugendstil.

BRITAIN

In Britain, Art Nouveau manifested itself most strongly in Scotland where the work of the so-called Glasgow Four (Charles Rennie Mackintosh, Herbert MacNair and the two sisters Frances and Margaret Macdonald) had a considerable impact on architecture and design in Glasgow at the turn of the century. Scottish Art Nouveau had two distinct sides. On the one hand there was the more feminine and organically inspired work of the Macdonald sisters, on the other hand the abstract and geometric work of the architect Mackintosh, whose designs became well known on the Continent and found an appreciative audience in such places as Vienna and Darmstadt.

Although Charles Rennie Mackintosh is now considered to be the most outstanding Scottish Art Nouveau architect, tiles do not feature prominently in many of his buildings. The important exception is Scotland Street School built in Glasgow between 1903 and 1906. Here functional requirements made it necessary for tiles to be used on a large scale. The entrance hall and

Opposite: Tube lined tile panel with peacocks among sunflowers in the entrance of Hotel Jan Luyken, 58 Jan Luykenstraat, Amsterdam, made by De Distel in Amsterdam, around 1905.

staircases are tiled throughout with plain white, green and blue tiles. The most striking feature is the square, blue tiled columns with green tiled capitals near the staircases on the first floor. On the exterior, green and blue tiles have been used as insets as part of carved curvilinear Art Nouveau stone decorations.

However, in England the attitude to both Scottish and Continental Art Nouveau was more ambivalent because here the more conservative ideas of the Arts and Crafts Movement were still dominant. At the beginning of the twentieth century artists and designers such as C.F.A. Voysey, Walter Crane and Lewis F. Day were still very active, but although they are now regarded as precursors to Art Nouveau, they then viewed the whole phenomenon with considerable reservation. This ambivalence can clearly be seen in the *Magazine of Art*, which in 1904 sought the views of a number of British designers, artists and architects to the question: 'L'Art Nouveau: What is it and what is thought of it.' A set of very mixed responses emerged. The sculptor Alfred Gilbert called it, 'Absolute nonsense', the architect C.F.A. Voysey thought it, 'Not worthy to be called a style', the artist Walter Crane felt it to be, 'A phase rather than a craze', while the designer George C. Haité maintained it to be, 'A perverted sense of the Beautiful'. A more charitable view was expressed by F.S. Blizard, the author of the article in question, who said that 'L'Art Nouveau is replete with beauty of line, grace of form, and freedom, and is a sympathetic style.'

Despite these mixed reactions, a more positive attitude to Art Nouveau was taken by Liberty's in London who helped to commercialize the style via the products and furnishings sold in their shop in Regent Street. Arthur Liberty had been selling oriental goods since 1875, to a clientele whose taste had been shaped by the Aesthetic Movement. By 1900 Liberty's had begun to promote the fashion for Art Nouveau, helping to create a more receptive mood for it in Britain. They encouraged the revived interest in Celtic art, with its sinuous, interlacing line that is exemplified in the work of Archibald Knox, who worked for Liberty's. This promotion of Art Nouveau was so successful abroad that in Italy the style became known as 'Stile Liberty'.

Between 1890 and 1914 Art Nouveau also made its influence felt on the design of ceramic tiles. Several manufacturers, such as Minton's China Works, Doulton & Co., Pilkington's Pottery and Tile Co. and Maw & Co., produced panels and individual tiles in the Art Nouveau style. They were designed either by the companies' in-house artists or by outside freelancers. These designers had often been trained at the Government Schools of Design, which had been set up during the 1840s in most large manufacturing towns with the support of local industry. In Stoke-on-Trent, the Burslem School of Art was an important training ground for young designers who wanted to work in the local pottery and tile industry. A similar function was served by the Coalbrookdale School of Art in Shropshire, where the tile firms Maw & Co. and Craven Dunnill & Co. were located. The students were encouraged to study books on ornament and design: A.W.N. Pugin's *Floriated Ornament* (1849), Owen Jones's *Grammar of Ornament* (1856), Christopher Dresser's *Principles of Decorative Design* (1873), James Ward's *Elementary Principles of Ornament* (1890), and Gleeson White's *Practical Designing* (1893), which contained a special chapter on tiles.

*Square tiled columns on the first floor of Scotland Street
School, Scotland Street, Glasgow, built by Charles Rennie
Mackintosh between 1903 and 1906.*

Left: Tube lined Art Nouveau tile by the firm Lee & Boulton, Stoke-on-Trent, around 1905. Shown larger than actual size (7.5 x 15 cm, 3 x 6 ins).

Opposite: Dust pressed Art Nouveau tile by Minton, Hollins & Co., Stoke-on-Trent, around 1905. Shown larger than actual size (7.5 x 15 cm, 3 x 6 ins).

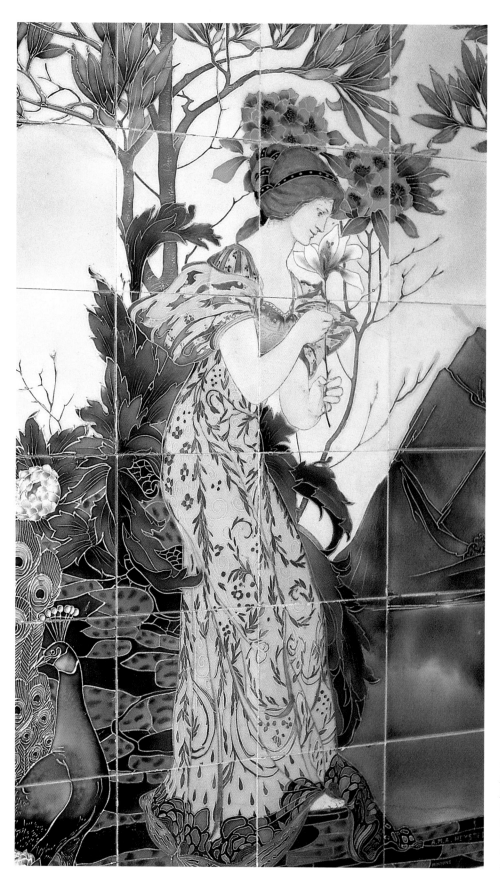

An exquisite tube lined tile panel with a woman and peacock, designed by Léon V. Solon. The panel bears the name Mintons Ltd and was made for the tile supplier A.M.A. Heystee in Amsterdam around 1905.

After the death in 1858 of Herbert Minton, the celebrated firm of Minton &
Co. was run by Colin Minton Campbell and Michael Daintry Hollins. In 1868
they dissolved their partnership. Campbell became the proprietor of Minton's
China Works and Hollins established a new tile factory under the name Minton,
Hollins & Co., but he continued to market encaustic tiles under the original
name of Minton & Co., to which he had a legal claim. Although Minton,
Hollins & Co. produced a large range of dust pressed, transfer printed tiles and
dust pressed, relief moulded ones, including some Art Nouveau examples, they
never managed to attract the high calibre designers and famous names that were
so plentiful at Minton's China Works. There we find artists like Christopher
Dresser, William Wise and John Moyr Smith, as well as French designers such as
Joseph François Léon Arnoux and the celebrated Louis Marc Solon. Having left
the imperial manufactory at Sèvres in 1870 to come to England and work for
Minton's China Works, Solon became a highly esteemed decorator of the
exquisite French technique of slip painting known as *pâte-sur-pâte*.

His son Léon V. Solon also became an outstanding designer. First he trained
at Hanley School of Art and in 1893 he became a student at the South
Kensington School in London. He joined Minton in 1895 where he was
responsible for the design of some fine Art Nouveau plaques and tiles with
floral designs and female figures. *The Studio* had followed Solon's career both as
a student and as a young professional designer and in 1895 (vol. 8) wrote:

> There are not many South Kensington students who make a reputation as
> designers before they complete their course in the Schools. But the name
> Léon V. Solon, although he ceased to be a student but a few months,
> attached to work of considerable promise, has frequently appeared in the
> Studio The tile designs which we are permitted to illustrate, deprived of
> their colour, must need lose much of their true effect, yet the plan and
> arrangement of their decoration is good and fresh. The manner in which
> the naturalistic detail of the lilies is subordinated to the architectural lines,
> and the harmonious convention in the other panels of the flowers, reveal a
> distinctly accomplished mastery of the material.

Solon's designs were executed painstakingly by hand in a slip-trail
technique and painted with colourful glazes, sometimes enhanced with gold
lustre. At Minton's China Works he worked together with John Wadsworth,
who had joined the firm in 1901 and was responsible for the design of some
beautiful slip-trailed Art Nouveau fireplace panels. While working at Minton's
China Works, Solon and Wadsworth developed a hand-decorated Art Nouveau
range known as 'Secessionist Ware' destined for a discerning clientele. However,
the firm also branched out into the manufacture of mass produced Art
Nouveau tiles, executed as printed or machine moulded, dust pressed tiles.

Another large firm at the forefront of making Art Nouveau tiles and
architectural ceramics was Doulton & Co. They were based in London with
subsidiary factories throughout Britain in such places as Burslem, Paisley,
Rowley Regis, St Helen's and Birmingham. By the end of the nineteenth
century they had become one of the largest producers of pottery, tiles,
architectural ceramics and sanitary ware. Their main factory was at Lambeth
where in its heyday in the 1890s some 400 people were employed. The firm

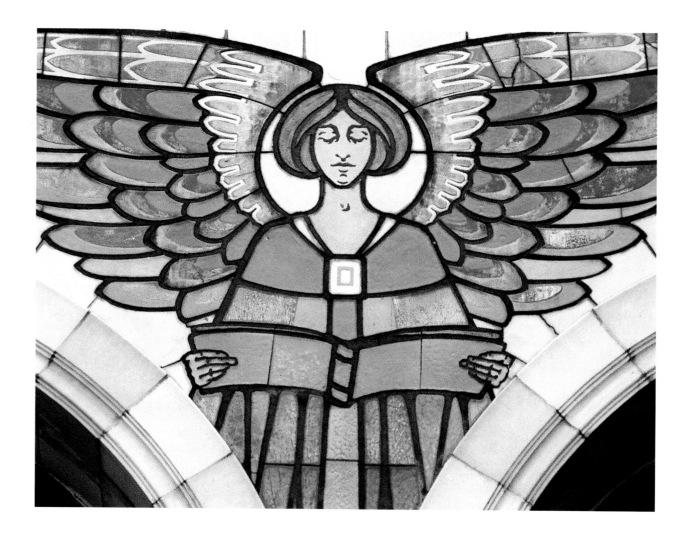

also promoted their tiles and pottery actively abroad via their participation in international exhibitions and they were particularly well represented at the Chicago World Fair of 1893 and the Paris World Fair of 1900.

Doulton, like Minton, was responsible for a number of important innovations in the field of architectural ceramics. By the late 1870s they had developed a frost and smoke resistant type of salt glazed ceramic known as 'Doultonware'. This was followed in 1888 by a matt stoneware that was marketed under the name of 'Carraraware' because it bore a resemblance to Carrara marble. The latter could also be produced in the form of polychrome ceramics if desired and it was this material that was used so successfully by William J. Neatby for a number of architectural commissions.

Tiles and architectural ceramics were made at Doulton's architectural department, which between 1890 and 1907 was under the direction of William J. Neatby. He was not only an able technical manager but also a designer of great calibre. In an article called 'Mr. W.J. Neatby and his Work' published in *The Studio* in 1903, Aymer Vallance, the biographer of William Morris, stated that it was 'the strength of Mr. Neatby's work, that he is no mere theorist, but at once a designer, vivid in imagination and a handicraftsman who has thoroughly mastered the ways and means of his material.' This can be seen

A detail of the handmade Doulton tiles on the facade of the Everard Building, 38 Broad Street, Bristol, designed by William J. Neatby in 1901. The figure represents the Spirit of Literature.

Above: Hand-painted tile with the head of a king by William J. Neatby, made at Doulton's in London, around 1900. Neatby's initials WN can be seen in the bottom right corner.

Right: Tile with a floral design made by Burmantofts of Leeds, around 1905.

clearly in several of his major architectural tiling schemes such as the Everard Building in Bristol and Harrods Meat Hall in London.

The Everard Building, built for the printer Edward Everard in 1901, has a polychrome tiled exterior celebrating the printer's craft. At the top of the facade is a female figure representing the Spirit of Light and Truth, while between the ground floor and the first floor one can see the printers Gutenburg and Morris at their presses on either side of a figure representing the Spirit of Literature. Bold black lines delineate the coloured figures creating a vibrant, polychromatic facade. A similar approach can be seen in Neatby's designs for the interior of Harrods Meat Hall, completed in 1902. It is tiled throughout and has an extensively tiled ceiling showing stylized trees, below which there are hunting and animal scenes in circular frames executed in strong colours. The tiled pillars supporting the ceiling have beautiful abstract Art Nouveau tiles which add to the opulence of the interior.

Other tile artists of merit at Doulton's were Margaret Thompson and William Rowe who were responsible for several outstanding Art Nouveau panels for hospitals showing fairy tales. Some of their finest work in this field was undertaken for the Seymour Ward and the Lilian Ward at St Thomas's Hospital, London, in 1901-3. Tiles were not made only for interior use in

GRAND=PRIX Dieppe
de l'A·C·F· 1908

LAUTE
sur

*Right: Art Nouveau tiles
designed by Charles Henry
Temple, the in-house designer
at Maw & Co., Jackfield,
Shropshire, around 1905.*

Above: Panel on the exterior of the Michelin Building, Fulham Road, London, made by the French firm Gilardoni around 1910. It shows a Grand Prix motor race at Dieppe in 1908 with the German driver Lautenschlager in a Mercedes Benz racing car.

hospitals. A major exterior scheme was carried out for the Royal Hospital for Children and Women, Waterloo Road, London, built in 1903-5. It has a fine entrance of green Doultonware, but of particular interest also are the Art Nouveau panels showing female nudes with flowing hair on the facade of the Outpatients Department.

The firm of Burmantofts in Leeds was an important manufacturer of tiles and architectural ceramics between 1880 and 1914. During the last two decades of the nineteenth century they made tiles which in their appearance responded to the current fashion of the Aesthetic Movement. They employed William J. Neatby as a designer during the late 1880s before he moved to Doulton. Other artists of note who worked for Burmantofts were George C. Haité, E. Caldwell Spruce and the Frenchman Pierre Mallet. Burmantofts' tiles were usually made from plastic clay and moulded with designs of animals, birds and human figures. Floral tiles painted with colourful slips (barbotine) and covered with a transparent glaze became a speciality of the firm. Their architectural ceramics were used for the interiors of such buildings as banks, hotels, universities, town halls and shopping arcades and were usually executed as elaborately moulded ceramics covered with transparent or translucent glazes. At the beginning of the twentieth century they developed a white glazed architectural ceramic suitable for outdoor use called 'Marmo' which was produced to compete with Doulton's Carraraware. A celebrated example of the use of Marmo is the exterior of the Michelin Building, Fulham Road in London, built in 1910-11. In this instance Marmo was used in conjunction with highly decorative Art Nouveau tile panels showing scenes from famous early motorbike and car races using Michelin pneumatic tyres. The panels were made by the Parisian firm Gilardoni Fils & Cie.

Maw & Co. in Jackfield near Ironbridge was another well established manufacturer who made high quality Art Nouveau tiles. The firm was founded in 1850 by George and Arthur Maw and during the second half of the nineteenth century it grew to become one of the largest tile firms in Britain. It commissioned many well known designers, including Matthew Digby Wyatt, George Goldie, John Pollard Seddon and Walter Crane. By the beginning of the twentieth century they began to make dust pressed Art Nouveau tiles, some of which were designed by their in-house artist Charles Henry Temple who worked for the firm between 1887 and 1906. An interesting application can be seen in the tiles and architectural ceramics for the ticket booths and entrances of the London Underground.

Pilkington's Tile and Pottery Co. in Manchester was a relative newcomer to the tile industry compared with the well established firms of Doulton, Minton and Maw. The firm began production in 1892 and by the turn of the century it had established itself as a small but leading tile and pottery manufacturer employing about 80 people. The driving force in the early years was William Burton, who was the company manager between 1892 and 1915 and whose own expertise was glaze chemistry. He was friendly with important designers such as Walter Crane, Lewis F. Day and C.F. A. Voysey and instrumental in encouraging these artists to design tiles for the firm. The work he commissioned from them became part of Pilkington's standard repertoire.

Voysey designed some beautiful tiles with restrained, semi-abstract designs based on flowers and foliage. They were executed as dust pressed tiles with the

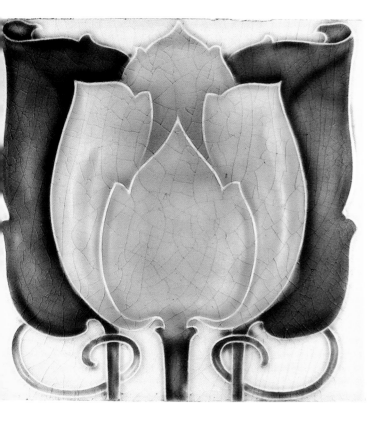
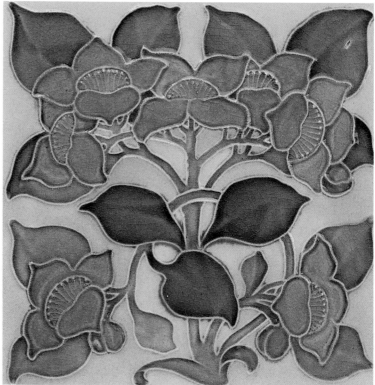

designs in raised lines decorated with monochrome or muted translucent colours. He also produced an interesting set called *The Labours* which were executed as underglaze printed work. Lewis F. Day designed a large series of tiles in a range of techniques such as dust pressing, stencilling and underglaze printing. Of particular interest are six tiles by Walter Crane for Pilkington's called *Flora's Train*. They were first shown at the Wolverhampton Exhibition of 1902 and show female personifications of flowers entitled *Anemone*, *Bluebell*, *Cornflower*, *Daffodil*, *Columbine* and *Poppy*. They were executed as dust pressed relief designs painted with translucent glazes, confirming Crane as a flexible Arts and Crafts designer who believed in harnessing the power of the machine in combination with good design.

A particularly intriguing contract was the supply of lustre tiles for dados and tiled fireplaces for the ill-fated ocean liner *Titanic*. They also commissioned tiled fireplace designs from the Manchester architect Henry J. Sellers, often decorated with Pilkington's lustre tiles. One of these fireplaces was illustrated in *The Studio* in 1909. Another important commission for Pilkington's was the production of tile panels for the City of Liverpool Museum showing the history of pottery through the ages. They were designed in 1914 by Gordon Mitchell Forsyth in an Iznik–Persian style.

Pilkington's also commissioned designs from foreign artists such as Alphonse Mucha. His four panels *Les Fleurs* were painted by their in-house artist Thomas F. Evans and exhibited for the first time at the Glasgow Exhibition of 1901. The only surviving section, *La Rose*, can still be seen in a shop entrance at 713 Great Western Road, Glasgow.

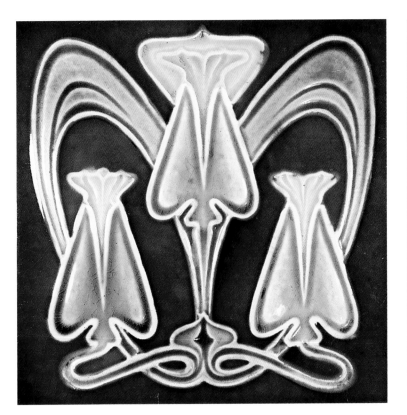

Opposite, left: Floral tile by the architect and designer C.F.A. Voysey for Pilkington's Tile and Pottery Co., Manchester, around 1902.

Opposite, right: Floral tile by the designer Lewis F. Day for Pilkington's Tile and Pottery Co., Manchester, around 1902.

Above, left: English Art Nouveau tile made by the firm Corn Brothers, Stoke-on-Trent, around 1905.

Above, right: Art Nouveau tile with swirling flowers made by Marsden Tiles, Stoke-on-Trent, around 1905.

There were also numerous other tile makers that produced machine pressed and tube lined Art Nouveau tiles, for example J. H. Barrett & Co., T. & R. Boote, Gibbons, Hinton & Co. Ltd, Craven Dunnill & Co., Henry Richards Tile Co., Rhodes Tiles Co., Campbell Tile Co., Corn Brothers and Sherwin & Cotton. An interesting oddity was a very small but unusual firm, the Photo Decorated Tile Co. Ltd, established by George Henry Grundy in Derby in 1896. They developed a method of transferring photographic images to tiles. Most are photographs of towns or buildings but there are also a few tiles with female models set within ornate linear borders reminiscent of Art Nouveau.

All tile firms issued catalogues, which not only showed ranges of single tiles but also provided suggestions for wall tile arrangements for use in public buildings, shops and houses. These set arrangements could be used directly by architects. A specific feature of many late nineteenth century and early twentieth century British houses were tiled vestibules and porches. Most houses of this period also had one or more open fireplaces with vertical arrangements of five or six tiles on either side of the grate. Suggestions for tile dados in porches and for tiles in cast iron grates were therefore also a common feature of tile catalogues of that time.

Although Britain made its own distinct contribution to Art Nouveau tiles via the work of some eminent designers, such as Lewis F. Day, Léon V. Solon and William J. Neatby, the mass production of 15 centimetre (six inch), machine pressed Art Nouveau tiles by scores of British manufacturers is a feature shared with other countries like Belgium and Germany, where a similar output took place.

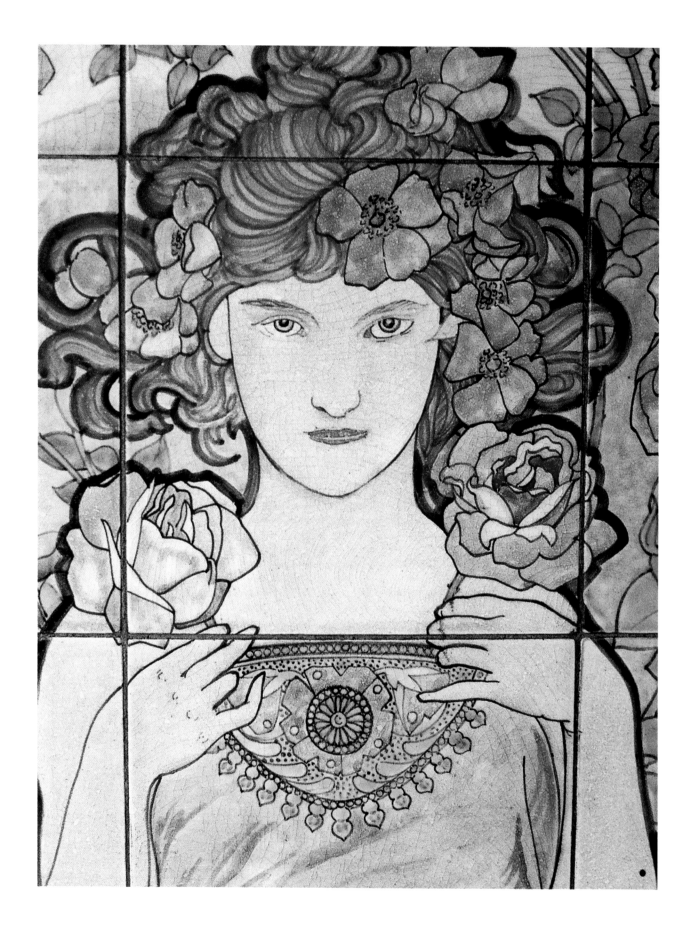

Opposite: Detail of a rare panel designed by the Czech artist Alphonse Mucha for Pilkington's Tile and Pottery Co., Manchester, and painted by their in-house artist Thomas F. Evans for the 1901 Glasgow Exhibition. It is part of a series of four panels known as Les Fleurs. Shown here is La Rose still in situ in a shop entrance at 713 Great Western Road, Glasgow.

Right: Detail of tiled porch in Catherine Street, Crewe. The central panel was made by the Photo Decorated Tile Co. in Derby at the turn of the century. It shows a girl with flowers set within an elaborate linear border. The tiles with pansies surrounding the panel date from around 1905.

Below: Transfer printed Art Nouveau tile by T. & R. Boote, Stoke-on-Trent, around 1905

GERMANY

*Opposite: German Art
Nouveau tile produced by
Düsseldorfer Tonwarenfabrik
A.G. (D.T.A.G), around
1905. The design is
influenced by the Wiener
Werkstätte. Shown larger
than actual size (15 x
15 cm, 6 x 6 ins).*

*Opposite, below: High relief
Art Nouveau tiles in
strongly contrasting red and
green by the Meissner Ofen
und Porzellanfabrik vormals
Carl Teichert, in Meissen,
around 1905. These tiles can
be found in the entrances of
several apartment buildings
in Berlin, for instance in the
Prenzllauer Berg and the
Friedrichshain districts.*

In the nineteenth century, Munich, the capital of Bavaria, was looked on by
many as the cultural centre of Germany. It was here that Peter Behrens, Otto
Eckmann, August Endell and Bernard Pankok started their artistic careers. It
was also in Munich in 1896 that the art magazine *Jugend* started to appear,
from which the name Jugendstil is derived; therefore in this book the term
'Jugendstil' is exclusively reserved for the German contribution to the
international Art Nouveau movement. Although during the last years of the
nineteenth century the art scene in Munich was very vibrant, around 1902
Jugendstil artists began to leave the city for places like Darmstadt, Hagen and
Berlin where artists' colonies were being established with funds from wealthy
art patrons. Not only German designers were invited to join these colonies,
but also artists from Austria and Holland. In 1901 the Austrian designer
Joseph Olbrich was invited to Darmstadt to manage the new art colony
Mathildenhöhe that was financed by the archduke Ernst Ludwig von Hessen
und bei Rhein. The German architect Peter Behrens was also invited to
come and work in Darmstadt, and there he created many designs that were
typical of the German Jugendstil. In 1909, the wealthy banker Karl Ernst
Osthaus invited several artists to his home town of Hagen, in the Ruhr area,
to stimulate the applied arts in Germany. Most of them came from Holland,
including Jan Eisenloeffel, Lambertus Nienhuis, Johan Thorn Prikker and Jan
Lauweriks, while the Belgian Henry van de Velde designed the new villa for
Karl Ernst Osthaus, close to the houses for the artists.

A new spirit had been astir since around 1890. In 1893, the young designer
Hans Christiansen pointed at artistic developments in Britain and France that
should be examples for German ceramicists:

> The English and French porcelain manufacturers use the Rococo style but
> also manage, and with good results, to apply naturalistic and stylized plant
> forms. In both countries one can see zealous study of Japanese decorative
> art. With some French porcelain decorations one can recognize, by their
> original presentation, plant forms combined with small irregular undulating
> line ornament the influence of the artist Herbert Dys. In the partly natural,
> partly stylized interpretation of plants one can see in many instances the
> poppy executed in many different forms and colours. Though one can also
> find roses, waterlilies, violets and other flowers in magnificent presentation.
> Although the manner of expression in both countries may be different, in
> both a Japanese spirit can clearly be detected.

German Jugendstil took different stylistic directions. First there was the
curvilinear floral work of artists such as Eckmann, which was followed by the
more abstract organic ornaments of Henry van de Velde. The geometric designs
of the Viennese Sezession led to the increasing simplification of decorative
elements, a trend that can seen in the work of the German Werkbund founded
in 1907. This was an alliance between industrialists and prominent designers,
such as Riemerschmidt, Läuger and Scharvogel, and acted as a kind of advisory
body on matters of design. The German Jugendstil therefore was very much
formed by the influence of foreign designers. Since the arrival of Henry van

de Velde in Germany, where he worked first in Berlin and later settled in Weimar in 1902, the Jugendstil was more determined by the abstract and geometric work of this Belgian designer than by the more naturalistic, floral designs of Eckmann.

Publishers played an important role in spreading the latest designs, by publishing new books on patterns and ornament such as *Neue Flachornamente* by Hans Christiansen, in 1893. The Jugendstil was also propagated by many German architectural and design magazines. One of the leaders was *Dekorative Vorbilder* published by Julius Hoffmann Verlag in Stuttgart. It appeared as a periodical from 1889 to 1914 with examples of Jugendstil ornament. Plates were exchanged on a co-production basis with the French *Journal de la décoration*, the British *Art Decorator*, and probably also with publications in other countries. Most of the published artists were French, for example René Beauclair, but the work of German designers was also included, such as H.E. von Berlepsch-Valendas, M.J. and E. Gradl and Anton Seder. Other important magazines on the applied arts were *Innendekoration* founded in 1890, *Dekorative Kunst* and *Kunst und Dekoration*, with its French counterpart *Art et décoration*.

Jugendstil was also actively encouraged by manufacturers who held competitions for the best designs. Young artists like Eckmann, Behrens, Paul Bürck and Rudolf Bosselt started their careers in this way. The success of the German tile manufacturers depended on a research and development policy that was alert to the latest trends, so the salient features of Art Nouveau - its dynamic whiplash curves and undulating, free flowing lines of human and animal forms - were soon adopted. Between 1897 and 1905 many designs for flat ornament were derived from the work of Van de Velde and Behrens, as well as from the more geometric work of Charles Rennie Mackintosh and the Sezession artists in Vienna.

Typical of this period were the tiles with geometric motifs designed late in 1903 by Peter Behrens and made by Villeroy & Boch in Mettlach. These tiles were patterned with black or dark brown lines on a white background. In some of them Behrens used a spiral motif, similar to those he used for book covers and wall decorations at that time. Some of these tiles were used on the floors in the restaurant Jungbrunnen that Behrens designed for the Kunst-und-Gartenbau-Ausstellung in Düsseldorf in 1904. Tiles with similar spiral-like curves in white on a dark blue background were also used by Olbrich for the exterior walls of his own house in the Mathildenhöhe art colony in Darmstadt, built in 1901. Similar tiles designed by Henry van de Velde and produced by Villeroy & Boch were used by him for the Possehl House in Travemünde. But on the whole most of the designs for tiles in the collections of the German manufacturers are anonymous.

A particular feature of German Art Nouveau tile production was the enormous output. Large manufacturers made dust pressed relief tiles decorated with colourful translucent glazes. Between 1900 and 1910 this type of tile was produced in millions for use in public and domestic architecture, especially in the cities in the north, like Berlin and Hamburg, or in the eastern provinces, such as in Riga. In many apartment blocks from this period tiled dados in the entrance hall are still intact. Export markets were also important and German Jugendstil tiles can be found as far away as Istanbul, Moscow and Rio de Janeiro. The enormous scope of this production is also reflected in employment

Joseph Olbrich's own house in Darmstadt built in 1901.
The exterior walls are decorated with tiles showing simple
spiral motifs probably made by Villeroy & Boch.

Above: Tile with toadstools by Ernst Teichert, Meissen, around 1905.

Above, left: Tile with waterlilies made by the Norddeutsche Steingutfabrik (N.S.T.G.), Bremen, around 1910.

Left: Floor tiles with simple geometric spiral motifs designed by Peter Behrens for Villeroy & Boch, Mettlach, 1903.

German Art Nouveau tiles, probably made by Boizenburg, with highly abstracted flowers and plant stems, in a porch at 66-8 Slotlaan, Zeist, Holland, around 1910.

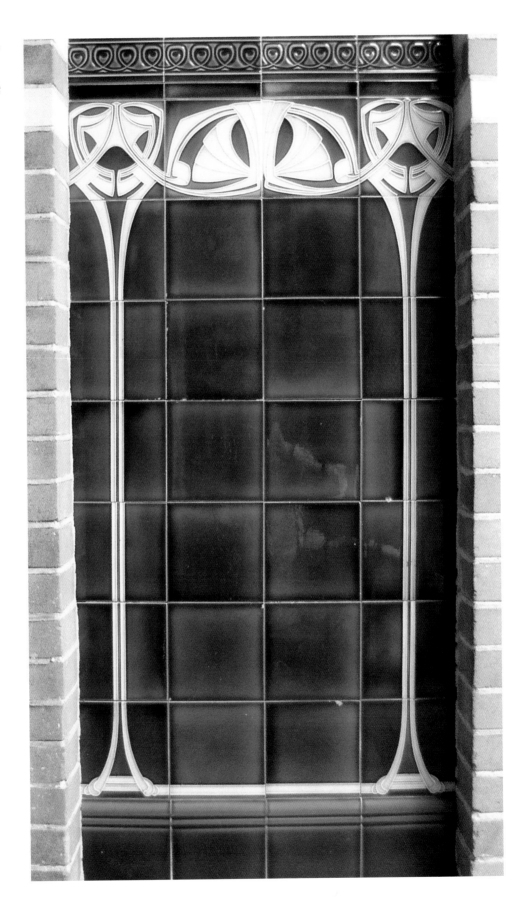

figures of the period which show an enormous rise between 1900 and 1910. Rough estimations show that around 5000 people worked in German tile factories in 1900 and this figure had doubled by 1910. The Norddeutsche Steingutfabrik near Bremen for example employed 200 workers in 1890 and 650 in 1907.

To produce these enormous quantities of tiles, often of high quality, many new factories had come into being from 1860 onwards and the list is long. Examples are the Norddeutsche Steingutfabrik (N.S.T.G.) in Grohn near Bremen in 1869; Servais & Cie in Ehrang near Trier in 1878; and the firm of Georg Bankel Chamotteofen- und Wandplattenfabrik in Lauf-an-der-Pegnitz, near Nürnberg in 1889. The Steingutfabrik Witteburg in Farge, near Bremen, produced tiles from 1885. In 1918 the firm was taken over by the nearby N.S.T.G. factory. In Bonn-Dransdorf the Wessel's Wandplattenfabrik began production in 1896. Around the same year production began at the Boizenburger Plattenfabrik A.G. in Boizenburg on the river Elbe. In 1899 production started at the Tonwerk Offstein in Offstein near Worms. In 1900 in Düsseldorf-Reisholz on the river Rhine the Düsseldorfer Tonwarenfabrik A.G. (D.T.A.G.) was founded. Around 1906 the production of wall tiles was started at the Bendorfer Wandplattenfabrik, renamed in 1911 the Rheinische Wandplattenfabrik GmbH, in Bendorf, a village on the Rhine, near Koblenz. In the porcelain centre of Meissen, the Sächsische Ofen und Chamottewaarenfabrik, vormals (formerly) Ernst Teichert Meissen (S.O.F., vorm. E.T.M.) had two or three tile works. Other large tile factories were located in Mügeln and in Mühlacker, near Pforzheim.

Villeroy & Boch, however, was without doubt the most important German tile factory in the nineteenth and twentieth centuries. The firm was the final result of a series of mergers in 1846 of factories owned by N. Villeroy and Jean-François Boch at Vaudrevanges (Wallerfangen) in Luxemburg, Mettlach in the Saar area and Septfontaines in Luxemburg. As a direct result of J.F. Boch's visit to several factories in Staffordshire, they were among the first to introduce modern ceramic techniques such as transfer printing from England. The dust pressing of tiles was introduced into the Septfontaines factory in 1846. The major production centre of floor and wall tiles was in Mettlach. From around 1850 encaustic tiles were produced here under the name *Mettlacher platten* or *Mosaikplatten*. These encaustic tiles, as well as the white, dust pressed wall tiles, became so popular that in 1869 a separate factory was set up in Mettlach. Facilities for the mass production of polychrome wall tiles were set up at Dresden, in 1856. In 1889 the factory at Merzig, a neighbouring town of Mettlach, was refurbished for tile manufacture. At the end of the nineteenth century, Villeroy & Boch opened new factories for the mass production of tiles in Leipzig and one in Lübeck-Danishburg in 1906. By 1900, the Villeroy & Boch factories used around 60 kilns for the production of tiles, and out of the total work force of 7000 people, some 2000 were employed in tile making. During the beginning of the twentieth century tile production expanded strongly and in 1912 the Dresden factory alone employed around 1500 workers.

Many of the tiles and architectural ceramics that had been produced by Villeroy & Boch during the second half of the nineteenth century had been rather traditional in nature, but from 1900 new Jugendstil products were added

Opposite: Catalogue pages with Art Nouveau tiles by Villeroy & Boch, 1907.

Below: Relief tile with a woman's head, made by the Sächsische Ofen und Chamottewaarenfabrik vormals Ernst Teichert in Meissen, around 1905.

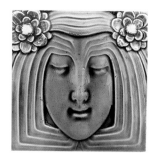

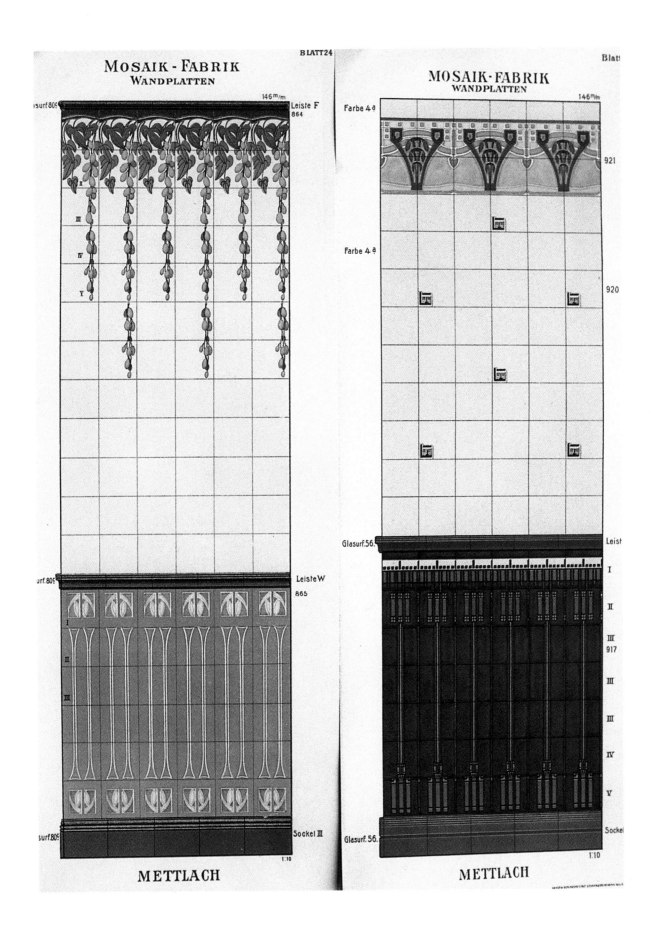

to their extensive range. Shortly before 1900 they took into production a
design for a tile dado called *Waterlily* by the Frenchman M.P. Verneuil, which
was one of the attractive designs in *La Plante et ses applications ornamentales*
published in 1897. The waterlily motif would become one of the most popular
designs for Art Nouveau tiles in Germany and almost all the major
manufacturers had one or more examples in production. The design is a
horizontal strip of three tiles, showing waterlilies and dragonflies, to be used as
a frieze along the top of a dado. Villeroy & Boch also commissioned Jugendstil
tiles from a new generation of designers. In 1899 mosaic tiles by the
Frenchman Tony Selmersheim and by the German Eckmann were brought
out. Designs by Eckmann published in the magazine *Deutsche Kunst und
Dekoration* in 1900 were also taken into production. A single tile design by
Eckmann called *Fuchsenkopf* (fox head), printed in a lithography technique, was
put on the market in 1902, as well as moulded relief tiles with stylized flowers
designed by P. Leschhorn-Strassburg. Villeroy & Boch catalogues of 1907 show
many Jugendstil tile designs. Besides mass production, the company also made
special tile panels, although only in small quantities. At the World Fair in Paris
in 1900 two tile panels with arcadian landscapes were shown. They were
designed by Georg Müller-Breslau and executed by the Villeroy & Boch
factory in Dresden.

Villeroy & Boch had its own pavilion at several international fairs that
took place in the years leading up to the First World War. The one
designed by the architect Pleyer for the Gewerbe und Industrieausstellung
in Düsseldorf in 1902 was conceived in a mix of German Baroque and
modern Jugendstil. In contrast, the architecture of other pavilions, at the
third Deutsche Kunstgewerbeausttellung in Dresden in 1906, at the second
Ton-, Zement- und Kalkindustrieausstellung in Berlin in 1910 and at the
Bayerischen Gewerbeausstellung in Munich in 1912 were all in a restrained
modern Deutsche Werkbund style.

*Above: Tube lined tile panel
by Max Läuger from the
Kareol House near
Aerdenhout, Holland
(demolished in 1979), now
on show at the National Tile
Museum, Otterlo.*

*Above, right: Art Nouveau
tile panel by Villeroy &
Boch, Mettlach.*

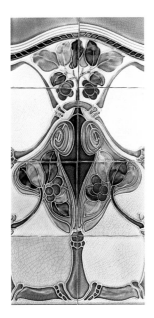

Although large factories dominated most of the market for Jugendstil tiles there was still room for small firms like Max Läuger in Kandern in the Black Forest and Julius Scharvogel in Darmstadt to produce special commissions for wealthy clients. Max Läuger (1864-1952) was an individualist who made some very interesting tile panels. After an education as a painter and interior designer, he learnt the secrets of ceramic art in the traditional potteries in Kandern. In 1893 he began his own pottery, for which he developed his characteristic, crackled and rather bubbled transparent glazes. Around 1900 he produced his first tiles, at first intended as individual decorative tiles and panels for mantelpieces. For most of them he employed the traditional *Schlichermalerei*, as used by the Black Forest farmers. First lines were carved freehand in the porous red stoneware. Then the objects were covered with a coloured glaze with the carved lines still clearly visible. Next, thick black lines were drawn over the carvings in slip. Finally the objects were covered with a transparent glaze.

In 1916 Läuger established his own atelier at the Königliche Majolika-manufaktur in Karlsruhe. Characteristic of much of his work is the special turquoise glaze that became known as 'Läuger blue'. This was used for one of the largest and most interesting commissions he undertook, the tile panels for the Kareol House near Aerdenhout in Holland, built between 1907 and 1911 to a design by the young Swedish architect Anders Lundberg. It was inspired by Wagner's opera *Tristan and Isolde*. On the outside there were more than 20 large tile panels designed and made by Max Läuger. There were also tiles in the form of friezes on the facades, tiles on the columns and at the top of the tower. In the bathroom the floor and walls were covered with large tiles representing a forest with flowers, birds and a squirrel. Unfortunately, this eccentric villa was demolished in 1979, but about eight panels were rescued before the building was taken down. They are at present in the National Tile Museum in Otterlo and in the Town Hall of Heemstede.

Jakob Julius Scharvogel (1854-1938) started his career as a potter, after visiting ceramic collections during his stay in London in 1879. In 1883 he was engaged as an engineer and deputy director at the Villeroy & Boch factory in Mettlach. There he was responsible for the design department and the studio for mosaic floor tiles. No designs by him have been preserved, but he was responsible for the execution of most of the architectural ceramic projects, as well as with problems of interior decoration. At his resignation in 1898 Scharvogel started his own small factory in Obersendling near Munich for the production of stoneware in a Japanese style, with a strong emphasis on new glazes. In 1900 he used these new flambé glazes on tiles, which he exhibited at important international exhibitions, in Turin in 1902 and St Louis in 1906. The designs of the tiles were rather simple, mostly stylized flowers. In 1906 he was appointed director at the newly established Grossherzögliche Keramische Manufaktur in Darmstadt. The factory employed other artists, like Paul Haustein who made designs for tiles. The technical equipment in the newly built factory was very advanced and there was one kiln that could be fired up to 1400°C. The most important commissions were the swimming pools in Bad Nauheim (1908), the grand-ducal reception rooms at the Darmstadt railway station (1912) and the Kaiser-Friedrich swimming pools in Wiesbaden (1912-13). Scharvogel resigned from his post in Darmstadt in 1913 and returned to Munich.

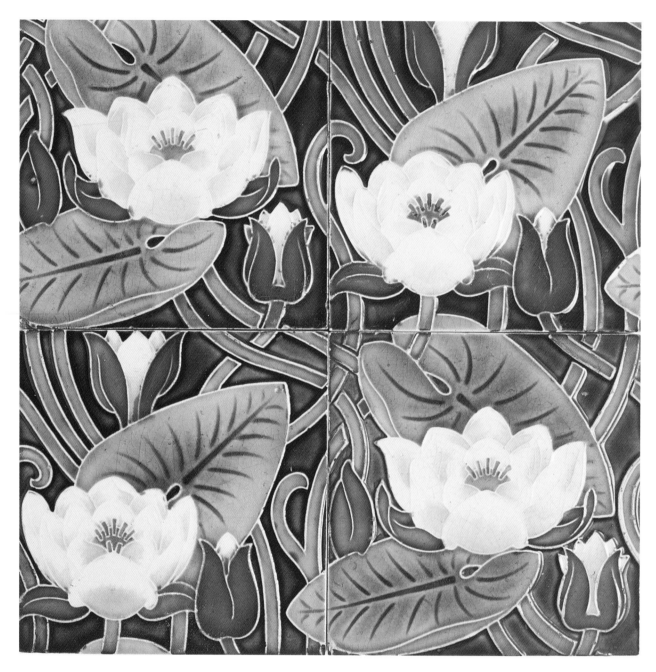

*Panel of four tiles by
Villeroy & Boch, Mettlach,
after the design* Waterlily *by
the Frenchman M.P.
Verneuil published in 1897
in* La plante et ses
applications ornamentales.

Tile by the designer Otto Eckmann entitled Fuchsenkopf *(fox head), executed in a lithographic printing technique, Villeroy & Boch, Mettlach, 1902.*

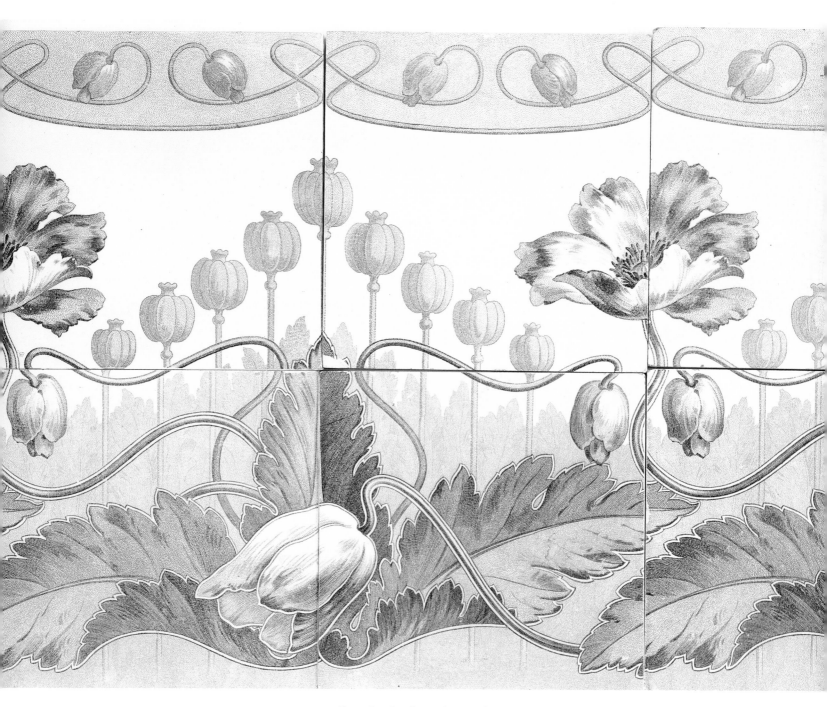

Above: Panel with transfer printed Art Nouveau designs of poppies by Villeroy & Boch, Mettlach, around 1905.

Right, top: Exquisite Art Nouveau tile by the firm Johann von Schwarz of Nürnberg, designed by their in-house artist Carl Siegmund Luber, around 1900.

Right, bottom: Stove tile with an Art Nouveau design of a lake with swans, made by the Ofenfabrik Georg Bankel, Lauf bei Nürnberg, 1905.

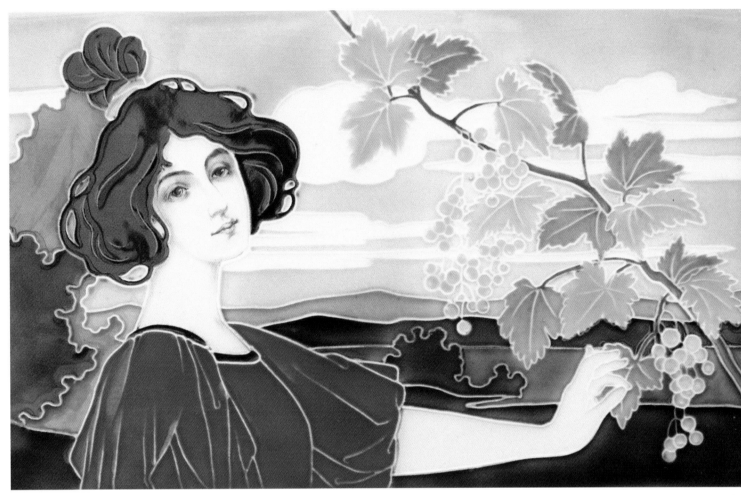

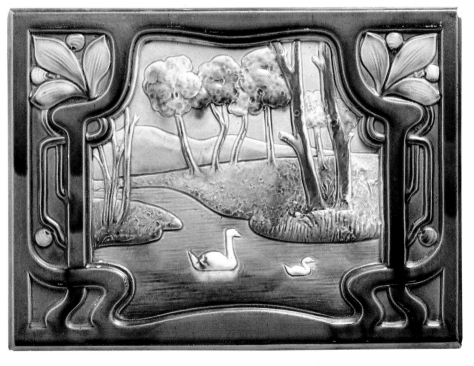

The firm Johann von Schwarz in Nürnberg produced a large number of high quality Jugendstil tiles between 1897 and 1906. The painter and artist Carl Siegmund Luber was responsible for most of the Jugendstil work and he became design director of the firm in 1896. Most famous were his tiles with female figures against an idealized landscape background. Similar tiles with female figures were produced by the factory of the Gebrüder Meinhold in Schweinsburg in Saxony.

The Grossherzöglichen Manufaktur - Kunstkeramische Werkstätten in Karlsruhe was established in 1900 and here the activities of the architect H. Grossmann as an aesthetic adviser channelled production mainly toward the manufacture of tile panels. However most of his designs were traditional, generally inspired by Italian maiolica. The production was expanded to making larger objects, such as stoves and wall fountains. Around 1910 several large projects were completed, including the Admiralsbad in Berlin (destroyed in the Second World War), where all the walls, columns and interior of the basin were lined with ceramics. Other examples are the University of Freiburg and the Town Hall in Kiel, both designed by the architect Prof. Hermann Billing, where architectural ceramics were applied on a large scale. These were in a more contemporary style, indebted to both the Wiener Werkstätte and the more purist Deutsche Werkbund.

A new direction in the use of architectural ceramics can be seen in the Elbe tunnel in Hamburg, opened in 1911. The stress was no longer on brightly coloured tiles but on heavy stoneware applications made to special designs. The ceramic ornaments in the Elbe tunnel, made by Servais in Ehrang, can still be labelled as 'late Jugendstil', but most German architectural ceramics at this time had moved on to early Modernist or Expressionist styles. The Werkbund exhibition of 1914 in Cologne was an important step towards this development. Several pavilions were showpieces for the sculptural possibilities of ceramics, as could be seen in the terracotta friezes by Gerhard Marcks for the entrance hall of Walter Gropius's Model factory.

HOLLAND

Nineteenth century Dutch industry was rather backward and it was not until the end of the century that the economy began to grow and a substantial tile manufacture was established. Alongside these developments, a small group of Dutch architects and designers began to agitate for changes in the field of art and design. The radical architects J.L.M. Lauweriks, K.P.C. de Bazel and H. P. Berlage advocated what is called in Holland 'Nieuwe Kunst' (New Art), a purer version of the style that became the Dutch contribution to Art Nouveau. This movement also affected tile design as can be seen in the work of Jac. van den Bosch, A. Le Comte and L. Nienhuis. They produced highly innovative tile dados and panels that departed radically from Holland's traditional blue-and-white delftware. In contrast to surrounding countries, Dutch tile firms still used traditional craft techniques. Much of the production consisted of custom-made tile panels and this continued as long as labour costs were relatively low. However, the Dutch tile revival was shortlived and by the outbreak of the First World War the majority of the new tile works had disappeared.

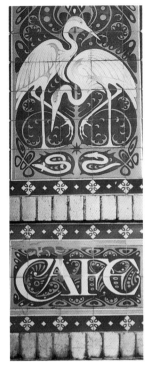

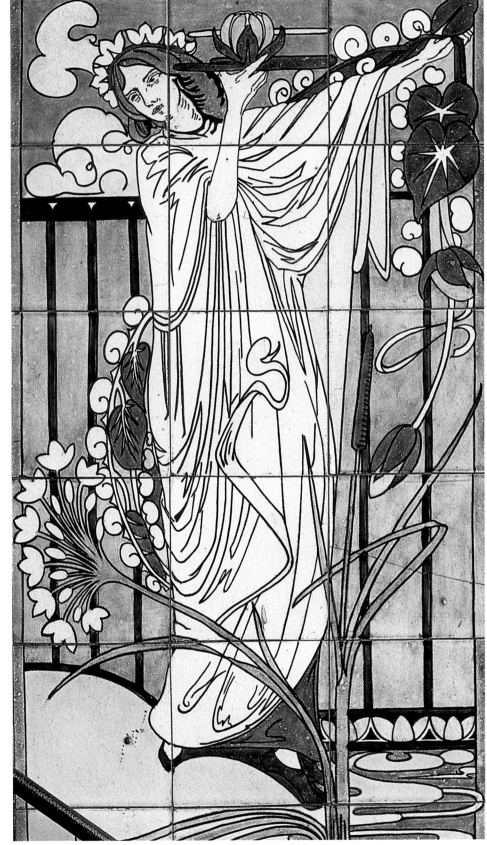

Above: Hand-painted panel with two cranes made by J. van Hulst, Harlingen, on the exterior of the American Hotel, Leidseplein, Amsterdam, designed by W. Kromhout, around 1902. The flat design and muted colouring are well integrated with the yellow brickwork.

Right: Hand-painted panel made by De Distel, Amsterdam, in an entrance porch of a house at 168 Ferdinand Bolstraat, Amsterdam, around 1905. The influence of the English artist Aubrey Beardsley is discernible.

Opposite: The facade of the Centraal Apotheek, Voorstreek, Leeuwarden, built in 1905, with an Art Nouveau panel in the centre of the facade showing a woman holding a chalice and snake, probably representing Panacea, the daughter of Asclepios, the Greek god of Healing.

Above: Sectile panel made by De Porceleyne Fles, probably designed by Adolf Le Comte, on the central facade of the Vrouwe Groenevelt's Liefdegesticht, 16 Vrederuststraat, Rotterdam, built in 1902 by the architect J. Verheul.

Left: Sectile panel by De Porceleyne Fles, designed by Adolf Le Comte, on the exterior of a house in the Geestbrugweg, Rijswijk, around 1904.

There were precursors to the new movement such as the work of the Roman Catholic architect P.J.H. Cuypers, who designed a large number of churches. At the height of his career he received commissions for important new public buildings like the Central Station and the Rijksmuseum in Amsterdam. The facades of the Rijksmuseum, built between 1877 and 1885, included large panels which have all survived in good condition. They were designed by the German artist Georg Sturm and depict important episodes in Dutch history. At that time, tile of requisite quality could not be produced by Dutch manufacturers and therefore most of the panels were made of frost resistant encaustic tiles by Villeroy & Boch in Mettlach in Germany. Some panels were made in France in *lave émaillée*. In 1884-5 Cuypers used colourful tile panels on the exterior of his own home Oud Leijerhoven II in the Vondelstraat, Amsterdam, showing he was a convinced follower of the French architect Viollet-le-Duc in the use of colour in architecture. Only when the Rembrandt wing was added to the Rijksmuseum in 1909, were two more pictorial panels commissioned from a Dutch tile manufacturer, De Porceleyne Fles.

The revival of Dutch design was also stimulated by the establishment of art schools throughout Holland. Influenced by English examples, a school for arts and crafts was founded in Haarlem in 1879, in conjunction with the new Museum for Applied Arts. New art schools were also set up in The Hague and Rotterdam. Design reform was further fostered by artists like Adolf Le Comte, who was a teacher of decorative arts at the Polytechnic School in Delft, where he taught several ceramic painters from the De Porceleyne Fles factory. There was also the Nieuwe Kunst painter Jan Toorop whose paintings and design work proved a vital catalyst in the renewal of Dutch art and design at the end of the century. But there were also strong foreign influences. The work and publications of William Morris, Edward Burne-Jones and Walter Crane were well known in Holland, through translations of their books or *The Studio* which had been popular with the Dutch avant garde since its first issue in 1893.

Holland was also particularly influenced by Japanese and Indonesian art and by the traditional Dutch interest in strong stylization of ornament based on strict geometric principles. At the end of the nineteenth century several publications were dedicated to this design approach, for example J.H. de Groot's *Driehoeken bij ontwerpen van Ornament* (Triangles for Designing Ornament) published in 1896, in which he demonstrated the use of triangles with angles of 30° and 45° as a basis for artistic composition. These ideas were directly inspired by the book *Claims of Decorative Art* by Walter Crane, published in 1886, which was translated into the Dutch language in 1893 under the title *Kunst en samenleving*. It is therefore no surprise to learn that two dimensional geometric design elements were applied to tile decoration, for example in the designs by Jac. van den Bosch for the tile factory Holland in Utrecht. Work by Verneuil and Grasset also brought French and Belgian Art Nouveau to the notice of Dutch artists. There is no doubt that these foreign influences inspired the many Dutch Art Nouveau panels that show elegantly flowing, semi-naturalistic flowers in bright colours, with sinuous plant stems and leaves, exotic birds and female figures with long, flowing hair.

However, the rather exuberant, free flowing lines of Belgian and French
Art Nouveau were heavily criticized by Dutch architects like H.P. Berlage
and K.P.C. de Bazel or artists like Jac. van den Bosch. This group, the initiators
of Nieuwe Kunst, was mainly based in Amsterdam and in 1900 founded
't Binnenhuis, a shop and design studio for arts and crafts, furniture and
architecture. But in contrast to the Amsterdam group, artists in other places
such as The Hague were more orientated towards French or Belgian
curvilinear Art Nouveau.

H.P. Berlage was the most important architect of the Nieuwe Kunst in
Holland and an enthusiastic user of tiles in architecture. In his key building the
Koopmansbeurs (Stock Exchange) in Amsterdam, built between 1898 and
1901, three large tile panels with allegorical and mystical representations
designed by Jan Toorop were placed in the entrance hall. Tiles were also used
in the two clockfaces on the tower. In several office buildings for the insurance
company De Nederlanden van 1845 tile panels were applied, while in Villa
Henny in The Hague, the home of the company's director, standard wall tiles
from the Holland factory were used in the kitchen.

The architect Eduard Cuypers, a nephew of P.J.H. Cuypers, was less strict
in his views than most architects of the Amsterdam group, and around 1900 he
followed the latest Art Nouveau design fashions. His approach could once be
seen in tile panels in the tap rooms of the famous Lucas Bols distillery in
Amsterdam, none of which have survived. The painter Johan Bernhard Kamp,
who worked for the office of Eduard Cuypers, was almost certainly responsible
for the design of these panels made between 1899 and 1904. They depicted
men and women in graceful poses with a strong resemblance to posters and
book illustrations by Alphonse Mucha.

One of the first signs of the renaissance of the applied arts in Holland was
the rebirth of De Porceleyne Fles, the last remaining pottery in Delft. In 1876 a
young engineer, Joost Thooft, bought this factory with the aim of reviving
traditional Dutch delftware production. This idea was derived from his contacts
with collectors of antique Dutch delftware in Germany, where Thooft had
worked as an engineer before he came to Delft. In 1884 Thooft went into
partnership with Abel Labouchere, scion of a banking dynasty and from then on
the factory was called Joost Thooft & Labouchere. For practical reasons Thooft
decided from the start to use modern English techniques for his new products.
The decoration was painted in an underglaze technique instead of the tin glaze
of traditional Dutch delftware. The artist and art critic Adolf Le Comte created
new designs for this novel technique, exploiting all its possibilities, and from the
beginning the art critics were unanimously positive. These underglaze tiles were
used for the first time in 1881 in the Ministry of Justice building in The Hague.
The underglaze technique was ideal for making tile pictures, mostly copies of
oil paintings or watercolours by famous artists, a practice that reflected the
ambitions of some architects to revive Holland's seventeenth century Golden
Age. Only later was the technique applied to Art Nouveau designs.

The use of ceramics in architecture was hampered in Holland because
traditional Dutch tiles had a bad reputation for lack of weather and frost
resistance. Like everywhere else in Europe at this time, Art Nouveau created a
demand for colourful glazed decorations on facades. To meet this demand De
Porceleyne Fles introduced a new product at the World Fair of 1900 in Paris,

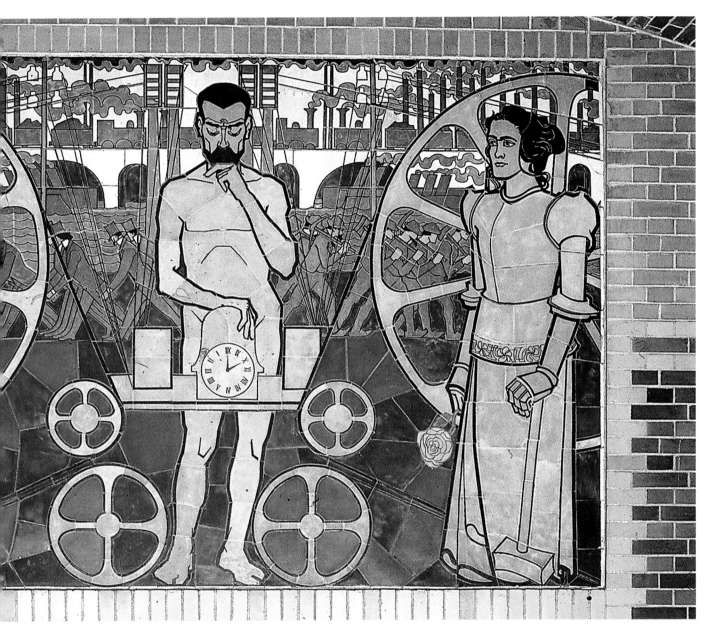

*Sectile panel by De Porceleyne Fles, designed by the Dutch
artist Jan Toorop, symbolizing the present, in the entrance of
Berlage's Stock Exchange in Amsterdam, 1902. It is part
of a series of panels representing allegories of the Past,
Present and Future. The bold, flat forms of the design
match the severe brick walls of the building.*

Opposite: Hand-painted panels with exotic birds by the Friesian firm Tjallingii in a porch of one of the houses at 152-80 Admirael de Ruyterweg, Amsterdam, around 1905.

Right: Transfer printed tiles with peacocks, made by the Dutch firm Regout, on the facade of a house at 78 Gistelsesteenweg, Bruges, around 1900.

*Section of a dado in a porch of a house on the Leliegracht
in Amsterdam, with tiles decorated in a stencil technique
probably by the firm Holland in Utrecht, around 1900.*

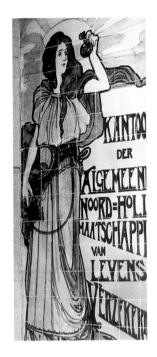

The entrance of the former Dutch life insurance firm Algemeene Noordhollandsche Maatschappij van Levensverzekeringen at 48 Spaarne, Haarlem, with a panel advertizing the firm's name made by De Distel in Amsterdam, around 1905.

especially intended for facades. Called *sectiel*, or 'Sectile', this was a semi-porcellanous stoneware fired at a high temperature of around 1300°C to 1400°C, with a coloured decoration of porcelain slip which remained unglazed. The tiles were not rectangular, but instead were cut following the main lines of the design (hence the name 'Sectile', derived from the Latin word *secare*, to cut); the technique was similar to that of stained glass windows. The factory claimed that the Sectile panels were frost resistant, and that they could be made to any special design. Of course, Sectile was a lot more expensive than ordinary glazed tiles. Nevertheless panels were commissioned for many official buildings, and some of the more expensive houses in Holland, and they were also exported. Time has confirmed the outstanding quality of this material.

Art Nouveau designs in Sectile were either made by in-house designers like Adolf Le Comte, or by freelance artists like the painter Jan Toorop. The work of Le Comte can be recognized by the use of carefully stylized flowers and flat compositions with charming figures of children. In 1903 a large commission for Sectile panels came from abroad when 78 large panels were made for the Ostrich House in the Hagenbeck Zoo in Hamburg. All the panels, with representations of wading birds, ostriches and reptiles, were designed by Le Comte.

The success of De Porceleyne Fles helped to free the way for the emergence of other tile makers. Some of these were already established. Relatively isolated in the most southern tip of Holland, wedged between the industrial regions in southern Belgium and the German Ruhr area, lies Maastricht on the river Maas. In this city two large ceramics factories had been set up, Petrus Regout, founded in 1834, and Société Céramique, established in 1859. Petrus Regout introduced new ceramic techniques by attracting an Englishman, Adwin Abington, who became one of their directors in 1856. After the death of Petrus Regout in 1879, his four sons continued the firm as C.V. Petrus Regout & Cie. Around that time they started production of dust pressed tiles with underglaze, transfer printed decorations. In 1899 the name of the firm was changed to De Sphinx v/h Petrus Regout & Co. N.V. and in 1902 a separate factory for the production of dust pressed wall tiles was established in the neighbouring town of Limmel. Most Regout wall tiles are back marked with a capital *R* in a diamond (copying British diamond shaped registration marks), or just with an ink stamp with the name of the decoration, for instance *geelgroen* (yellow green). Another company in Maastricht producing tiles was the M.O.S.A. factory, founded in 1883 by another branch of the Regout dynasty, the firm Louis Regout & Son. A factory sales leaflet from around 1910 shows that their designs were rather traditional, with only a few in the Art Nouveau style.

The Société Céramique firm started in 1859 and during the first four years, until 1863, the management of this new company was in the hands of the Belgian born mining engineer Guillaume Lambert. After his departure he travelled through England, on commission from the Belgian government, and wrote a well documented book on the ceramic industry entitled *Art céramique*. Around the same time Société Céramique began production of dust pressed tiles marked on the back with 'Société Céramique Wyck Maestricht'. From the start the production was on a modern basis, mostly the serial production of standard tiles, with a limited range of colours and decorations.

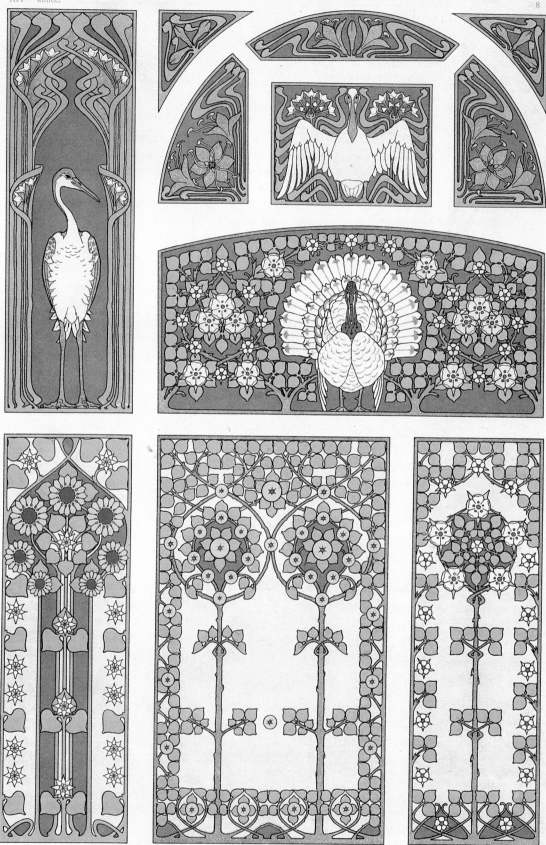

Above: Detail of an interesting arrangement of curvilinear brickwork, with insets of hand-painted Art Nouveau tiles by the firm Holland of Utrecht, above one of the windows on the facade of a large semi-detached mansion at 64-6 Van Eeghenstraat, Amsterdam, built in 1900.

Opposite: Page from Le Journal de la décoration, *around 1904, with Art Nouveau designs intended for tile panels by Lambertus Nienhuis and Amp Smit.*

At the beginning of the twentieth century, therefore, Regout, Société Céramique and to a certain extent M.O.S.A. followed fashion trends in their production of Art Nouveau tiles, employing both flowing curves and more geometric patterns inspired by the modern designers in Holland and Germany. However, on an artistic level, the production of these tiles had little impact elsewhere in Holland. Large factories with a substantial degree of mechanization, as in Maastricht, were non-existent in the rest of the country. There the rise of a new tile industry was determined by small companies, managing with small investments and limited knowledge of modern production processes.

Dutch tile factories differed greatly in their production techniques. Ravesteijn in Utrecht, Van Hulst and Tjallingii in Harlingen, and Tichelaar in Makkum manufactured tiles by hand using traditional tin glaze techniques that had changed little since the seventeenth century. Much of their production consisted of single hand-painted tiles made from plastic clay, with a standard size of 13 by 13 centimetres (five by five inches), and custom-made tile panels. They were able to survive economically because of low labour costs. Although much of their output was in the tradition of Dutch delftware, they also produced some tiles and panels in the Arts and Crafts and Art Nouveau styles. Other established firms that produced Art Nouveau tiles were the Zuid-Holland factory and the firm Hollandsche Pijpen- en aardewerkfabriek Goedewaagen in Gouda. However, as we have already seen, there were also factories that began to adopt industrial production methods, such as Regout and Société Céramique in Maastricht where dust pressing and underglaze transfer printing became the norm. Dust pressed tiles have a standard size of 15 by 15 centimetres (six by six inches) and are very different in character to traditional Dutch tiles. There were also firms like De Porceleyne Fles in Delft and Rozenburg in The Hague that operated between these two extremes and made dust pressed tiles but continued to paint them by hand or use stencil and sometimes tube line techniques.

In The Hague, the Rozenburg factory was established in 1883 by the German born Baron Wolff von Gudenberg, the result – it was claimed – of his industrial espionage at De Porceleyne Fles factory in Delft. During the first years, Rozenburg produced ceramic wares rather similar to that of De Porceleyne Fles but they soon succeeded in making their own more distinctive ware. In 1903 they began to make a product comparable to the Sectile of De Porceleyne Fles, which they marketed under the name *grès*. But in contrast to Sectile, Rozenburg *grès* was a product covered with lead glaze and therefore it came closer to porcelain. The design was given extra accentuation by a light relief on the tiles and by inscribed lines. The bold effect was stressed by the wide joints between the tiles. De Distel pottery was established in Amsterdam in 1895, where the young artist Lambertus Nienhuis (1873-1960) was one of the designers. However, a year later Nienhuis started his own factory called Lotus just outside the city borders of Amsterdam for the sole purpose of producing tiles. Lotus merged for financial reasons with De Distel in 1901 and Nienhuis became the head of the decoration department. In 1912 he left for the German city of Hagen, to which he had been invited to work in the newly established art colony founded by Karl Ernst Osthaus. The tile designs by Nienhuis, mostly stylized flowers and birds

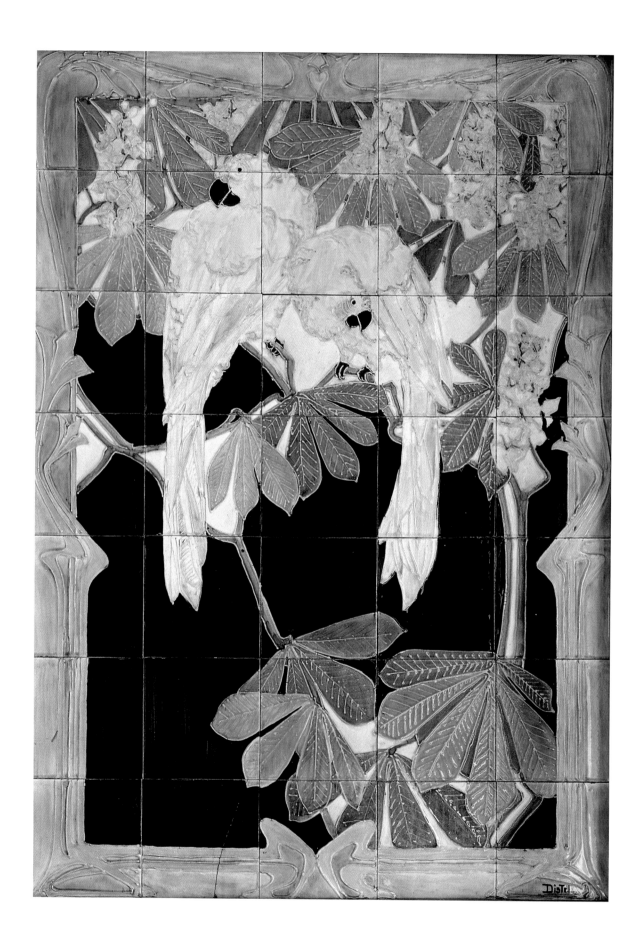

Above: Panel of Carduus tiles with butterflies (pattern no. 34) made by De Distel, Amsterdam, in the porch of a house on the Nicolaas Witsenkade in Amsterdam, around 1910.

Opposite: Tube lined tile panel with parrots in the entrance of Hotel Jan Luyken, 58 Jan Luykenstraat, Amsterdam, made by De Distel in Amsterdam, around 1905.

Overleaf, left: Page from a catalogue issued around 1900 by the firm Holland in Utrecht, showing a design entitled Waterkip *(waterhen) by Jac. van den Bosch. It is based on a wallpaper pattern by C.F.A. Voysey, illustrated in* The Studio *magazine of 1896 under the name* Bird and Tulip.

Overleaf, right: Unusual 'Jacoba' Art Nouveau tiles made by De Porceleyne Fles in Delft, probably designed by Adolf Le Comte, in a fireplace in the former royal waiting room at Soestdijk railway station, around 1902.

in bright colours, were from the beginning executed in a very convincing Art Nouveau style.

In 1894 Jan Willem Mijnlieff, who was already owner of a brick and roof tile factory in Utrecht, took over a wall tile factory in the same city which he named Faience en tegelfabriek 'Holland'. Inspired by the success of the Rozenburg factory, Mijnlieff intended to produce tiles and decorative pottery, in the modern 'Rozenburg' Art Nouveau style. In 1896, since Mijnlieff was only a businessman with a head for finance, he hired two designers from the Rozenburg factory, J.K. Leurs and J.C. Heytze. They were responsible for a great variety of Art Nouveau designs, mainly floral motifs in bright colours. The firm's most successful periods were the years 1895 and 1904, when they employed around 75 workers and between 1909 and 1912 when the company had 101 workers. The Plateelbakkerij Delft (P.B.D.) was set up in Amsterdam in 1897 but production was moved to the nearby town of Hilversum in 1902.

A particular facet of the Dutch tile industry was the making of custom designed tiled dados. Tiled dados cover the lower half of the wall up to a height of around one and a half metres (between four or five feet) and were frequently used in Dutch architecture in porches, hallways, kitchens and sometimes staircases. Initially these dados were made with traditional tile designs, but between 1900 and 1910 many firms made them in the popular Art Nouveau style. The first tiled Art Nouveau dados were produced around 1900 by Rozenburg and De Porceleyne Fles as the new style from Paris and Brussels was finding its way into Holland. The instigator was the architect Johannes Mutters junior (1858-1930), who around the turn of the century was very keen on following new fashion trends. He introduced the flamboyant, curvilinear Art Nouveau manner to his home town The Hague as early as 1896. By 1900 he was encouraging De Porceleyne Fles in Delft and Holland in Utrecht to produce tiles with Art Nouveau designs and the other tile factories followed suit in or shortly after 1900.

Most of the designs for Dutch tiled dados show a striking resemblance. First in technique, since all the factories used stencils for applying the usually multicoloured designs on the white background of the flat tile. The designs themselves are in most cases a dado of just over a metre (about four feet) high with highly stylized patterns. Frequently one can see that the artist tried to camouflage the joints between the tiles. Many designs resemble growing plants, with a continuous band of long-stemmed flowers at the top and the roots at the bottom. At De Porceleyne Fles these designs were almost certainly created by Adolf Le Comte and at the Rozenburg factory by D.P.J. de Ruiter. The designs by Le Comte are highly individual. They are open compositions of a restrained semi-abstract nature in sombre colours, mostly dark blue, brown and yellow-gold. The designs are cleverly composed so most tiles can be arranged in different combinations. The Rozenburg tiles are also of a semi-abstract nature, although in a variety of colours. At the Holland factory the modern designs were by Jac. van den Bosch who began as a sales representative for this firm, after his artistic training at the Quellinus school in Haarlem and the Rijksschool voor kunstnijverheid in Amsterdam. In the years 1899 and 1900 he travelled through the country by train or boat, and even by bicycle, with a heavy trunk with samples of traditional blue-and-white tiles, visiting architects

and builders' merchants. Not satisfied with the look of the tiles he was selling, he made new designs, some of them clearly inspired by other patterns, such as the *Waterkip* (waterhen) that is a direct copy of a wallpaper by the English Arts and Crafts designer C.F.A. Voysey. Most designs by Van den Bosch are stylized derivations of plants, leaves and flowers. In 1900 Van den Bosch showed his work to the architect Johan Mutters junior, who became so enthusiastic that he specified in the plans for the new building of the De Witte literary club in The Hague that Van den Bosch tiles be used in the hallway, toilets and bicycle shed. When Van den Bosch's director Mr Mijnlieff was shown this important order he had to abandon his objections to their Art Nouveau designs and make them part of the firm's collection. Modernist architects also used these tiled dados in their projects. In 1900 Van den Bosch left the tile factory and joined a group of arts and crafts designers in Amsterdam in the newly established firm 't Binnenhuis. Similar Art Nouveau designs were introduced by De Distel factory in or shortly after 1900. In 1903 they introduced a new series of tile dados designed by Lambertus Nienhuis with new matt glazes invented by Cornelis Vet. The matt glazes did not have the sheen of the usual lead glazed tiles and so harmonized better with the brickwork used in most Dutch buildings.

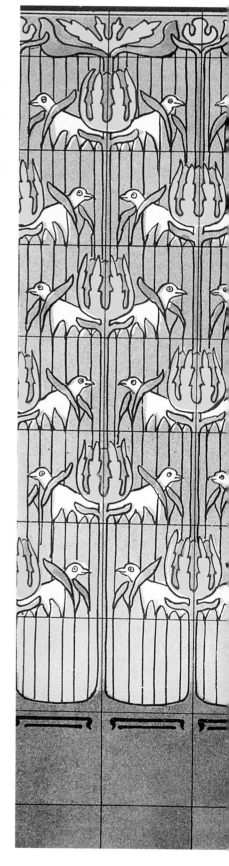

Complete tiled dados can still be found in many houses, shops and public buildings dating from the period 1900 to 1914. Of particular interest are the examples to be seen in the streets round the Vondelpark in Amsterdam and the 1900 neighbourhoods in The Hague and Rotterdam. In many cases, when they are used in the entrance porches, these tiles can still be seen from the street. In several public buildings large areas with tiles are still preserved, for example in the former Postgiro office (now Sweelinck conservatory) at the Van Baerlestraat in Amsterdam, with specially designed dados by Rozenburg and De Distel, or in Leeuwarden railway station where the striking tiled dados were also made by Rozenburg.

Between 1900 and 1910 the enormous popularity of Art Nouveau tiles in Holland also led to the installation of specially designed tile panels, many of which can still be seen. They were used in private houses, shops, theatres and also in buildings for new firms such as life insurance companies. Here they were thought to give an up-to-date image. From 1908 onwards the artist C.A. Lion Cachet, one of the representatives of Nieuwe Kunst, designed tile panels that were produced by De Porceleyne Fles, De Distel and Goedewaagen factories. Inspired by ancient Persian tile panels, he was very inventive in the use of decoration techniques, such as sgraffito. For tiles that were used on passenger ships he used lead moulds that were pressed into the unfired, leather hard tile. Then the upper parts were finished with a matt glaze and the lower parts filled in with gold-brown or platinum glaze.

In 1910 the Distel factory introduced a new product that was specially intended for use on facades, the so-called 'Carduus' tile. The material was not comparable to the densely fired Sectile, but instead to a rather porous, partly glazed stone. The decorations were put on in tube lining technique with a slip trailer. Carduus tiles were introduced with a series of about 30 designs. These were created by the chief of the design department W. van Norden and other known artists, such as Jac. van den Bosch, J. Eisenloeffel and Th. W. Nieuwenhuis.

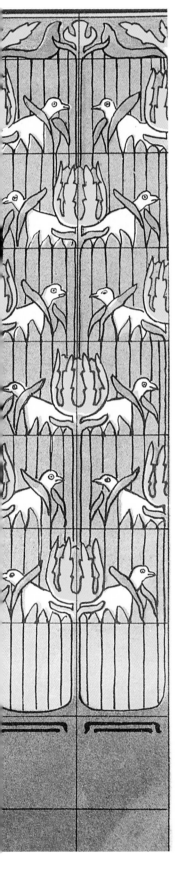

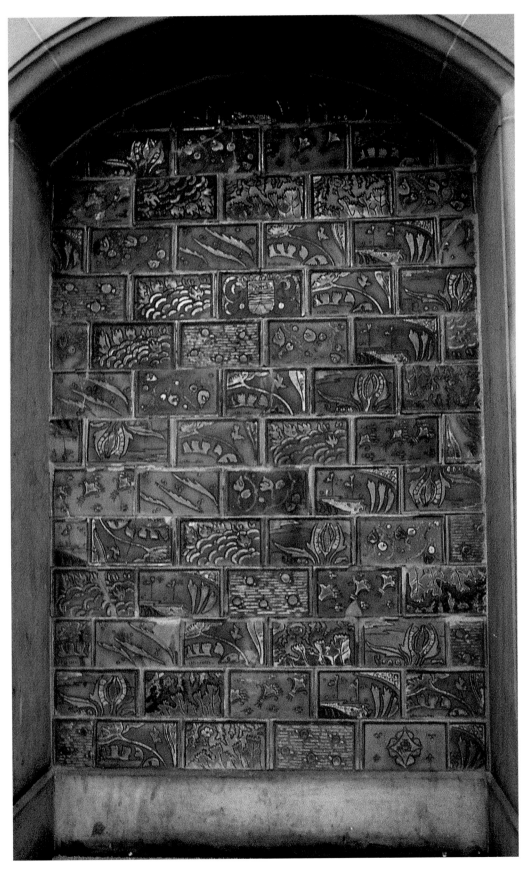

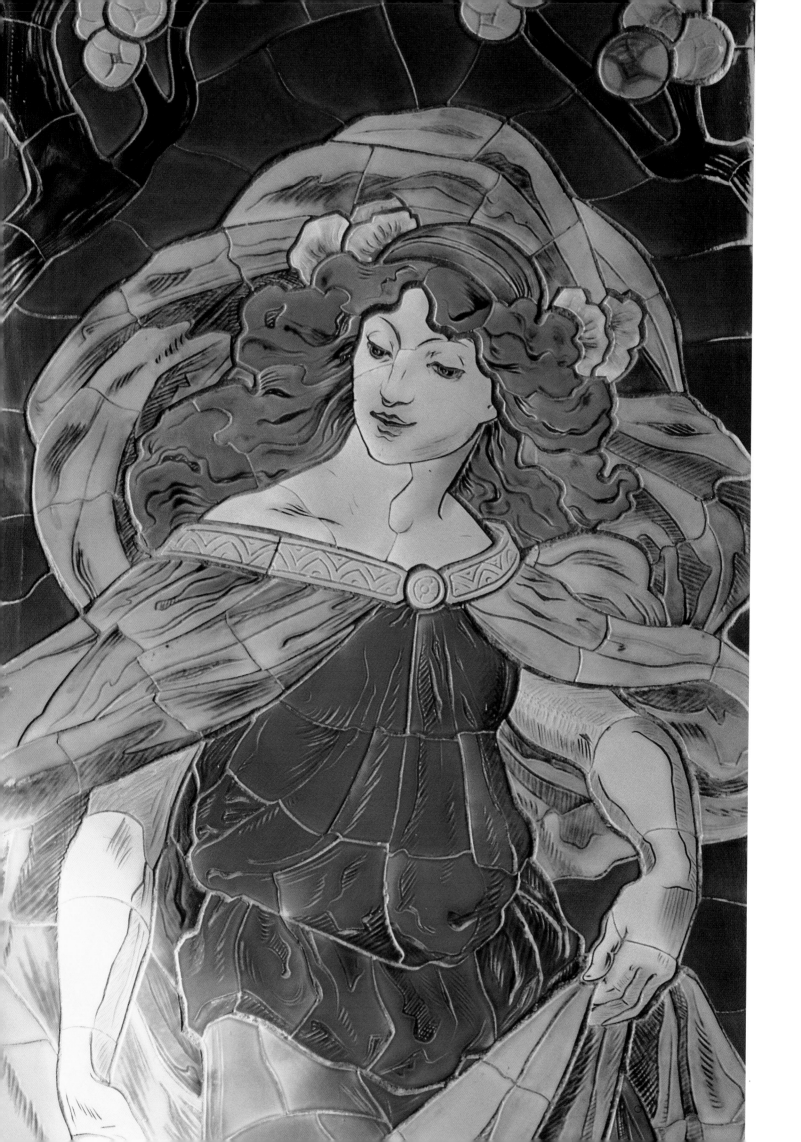

CENTRAL EUROPE

A T the turn of the century, the political map of Central Europe looked very different from what it is today. Austria, the Czech Republic, Slovakia and Hungary were part of the Dual Monarchy of Austria-Hungary (1867-1918) under the rule of Emperor Francis Joseph who resided in the imperial capital of Vienna. Bohemia, now part of the Czech Republic, was at that time under direct Austrian rule, but Hungary enjoyed greater independence and had its own laws and parliament though still owing allegiance to the Austrian emperor. Culturally, therefore there was a great deal of common ground in Central Europe and the new trends of Art Nouveau spread throughout the different countries while still showing diverse regional variations.

In Vienna, Prague, Budapest and other major cities in the Austrian Empire, the Art Nouveau developments from Paris and Brussels were at first strongly opposed. Many designers and architects in Central Europe favoured historical styles from the past and only gradually did they combine these with elements from the new style. In Austria Art Nouveau was called 'Sezession', in Bohemia 'Secese', and in Hungarian 'Szecesszío'. All these names indicate the idea of 'breakaway' but despite the similarities between the names, there were marked differences between them. In Vienna we find both the floral and geometric varieties of Art Nouveau reflecting a more outward looking and international character; in Prague it became an eclectic mixture of Art Nouveau combined with historical styles; while in Budapest Art Nouveau was fused with Hungarian vernacular culture, reflecting a rising interest in local folklore and

Opposite: Detail of tile panel showing a young woman made by Rako of Rakovník in the restaurant of Prague Central Station, around 1903.

Below: Detail of the facade of Otto Wagner's Majolica House in the Linke Wienzeile, Vienna, with extensive Art Nouveau tile decorations probably made by the Hungarian firm Zsolnay of Pécs, 1898. The flat, floral, curvilinear design on the tiles links up with the decorative ceramic window sills to create a carefully integrated overall design.

nationalist aspirations. In the case of tiles these local variants can be seen in the work by architects like Otto Wagner and Joseph Hoffmann in Vienna, Osvald Polívka in Prague and Ödön Lechner in Budapest. Tile production in the Austrian Empire was dominated by two large firms, Rako in Bohemia and Zsolnay in Hungary, who between them produced an astonishing variety of ceramic building material.

AUSTRIA

The cultural centre of the Austrian Empire was undoubtedly the capital, Vienna, where at the end of the nineteenth century the Classical style in architecture and design continued undiminished. A reaction against this began to emerge in the more individual work of Joseph Maria Olbrich. As well as an architect he was also a talented designer as can be seen in his striking decorative designs for textiles, wallpapers and graphics. In 1897 Olbrich and several other artists and designers including Gustave Klimt and Koloman Moser founded the breakaway group, the Sezession. Until 1905 this was the leading innovative movement in Vienna, in line with the Art Nouveau movements in other countries. In 1900 the work of Charles Rennie Mackintosh and other members of the Glasgow Four was put on show in the Sezession's exhibition building where it created a sensation. From then on the work of Olbrich and Hoffmann was strongly influenced by the two dimensional, curvilinear and geometrically abstract forms in the work of Mackintosh. This influence continued in the first products of the Wiener Werkstätte, a commercial enterprise set up in 1903 by Sezession members and other young artists and designers, inspired by Arts and Crafts workshops in Britain. The influence from Britain also came through

Above, left: Detail of the blue tiles with white decoration on the exterior of the Kaiserbad lockhouse in Vienna. Severe geometry is one direction the Viennese Sezession took at the beginning of the twentieth century.

Above, right: Tiled doorway of the Kaiserbad lockhouse on the left bank of the river Danube in Vienna, designed by the architect Otto Wagner in 1906, with striking blue tiles and white geometric decorations evoking the movement of the river's waves.

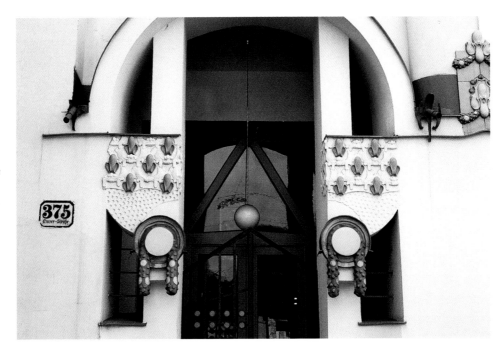

Right: The entrance of Villa Vojcsik built in 1901 by Otto Schönthal at 375 Linzerstrasse, Vienna. Subtle tile decoration helps to augment the Art Nouveau ornament around the doorway.

Below: Detail of the tiled frieze on the exterior of Villa Vojscik in Vienna, probably made by the Hungarian firm Zsolnay of Pécs.

publications in German art magazines. From 1898 Arthur Scala, director of the Museum for Art and Design in Vienna, regularly reviewed the work of Ashbee, Baillie Scott, Norman Shaw and Voysey in the magazine *Kunst und Kunsthandwerk*, founded in 1898.

All these developments had a major influence on the work of the Viennese architect Otto Wagner. In his architecture there is clear tendency to treat the facade as an independent aesthetic element. It then takes the form of a flat area that covers the entire surface of the building and is used as a background for curvilinear Art Nouveau floral decorations. This approach is epitomized in Wagner's Majolica House at 4 Linke Wienzeile. A further development of the concept is the Portois & Fix Building, 59-61 Ungargasse in Vienna, designed by Max Fabiani, a pupil of Wagner in 1899-1900. The facade is entirely covered with Pyrogranit tiles made by the Zsolnay factory in Pécs. The tile ornamentation is abstract and helps to assert the independence of the facade as an autonomous object. Another pupil of Wagner who used tiles was Otto Schöntal (1878-1961). He designed the Villa Vojcsik, 375 Linzerstrasse in Vienna, built in 1901, which has an elegant white stuccoed Jugendstil facade with rounded doors and windows and black wrought iron decorations. There is a prominent tiled frieze on the exterior of the ground floor showing stylized white flowers between swags of greenery, probably made by the Zsolnay factory in Pécs.

In several interiors designed by Wiener Werkstätte artists, Art Nouveau tiles were applied in very unconventional ways. In some cases the tiles for these commissions were produced locally by the Wiener Keramik founded by Michael Powolny and Berthold Löffner in 1906. They made tiles as a sideline, their main output being vases and ornamental sculpture. Their most important works were the Palais Stoclet in Brussels, built in 1905–11 for Adolphe Stoclet, and the bar in the Cabaret Fledermaus in Vienna, built for Fritz Wärndörfer in

1907. Both patrons were wealthy and generous, with money as well as taste. These commissions were designed as a *Gesamtkunstwerk* (total work of art) by Josef Hoffmann, in collaboration with several artists of the Wiener Werkstätte. Although Hoffmann had already used tiles in his early villas, the most innovative feature in the interior of the Fledermaus bar was the decorative use of wall tiles in the form of a complex colourful mosaic. This was a logical outcome of Koloman Moser's experiments with mosaics, which show unconventional combinations of materials such as ceramics, glass and copper, which he embedded in a ground of cement. The same free interpretation of tiles as decoration can also be seen in the large relief panels that were designed and executed by the Wiener Werkstätte member Elena Luksch-Makowski for the Burgtheater in Vienna in 1905. Although this theatre was destroyed in the Second World War, all the panels, as well as the clay models, have been preserved and are now in the collection of the Museum for Art and Design in Hamburg.

Although Vienna is not noted for its production of Art Nouveau tiles, it is interesting to draw attention to the Wienerberger Ziegelfabriks- und Baugesellschaft. In 1917 they donated several tiles to the Technical Museum for Industrial Design in Vienna, in several sizes and decoration techniques and with a variety of Art Nouveau motifs.

The Vienna based Sezession movement had hardly any direct impact on art and architecture in Prague and Budapest, the other main cultural centres of the Austrian Empire. No doubt much of this was to do with the nationalistic aspirations of these regions which were attempting to be as culturally independent from Vienna as possible.

BOHEMIA

In nineteenth century central Europe, Bohemia was one of the most important industrial regions. It was also a centre of tile production. The Rako factory (Rakovnícké keramické) in Rakovník, 50 kilometres (30 miles) west of Prague, was the largest manufacturer, but there were also factories in other ceramic centres, such as Teplice (Teplitz) on the northern border and Znojmo on the border with Austria. The Rako factory was established in 1883 and their first products were refractory tiles and plain floor tiles. Around 1900 production was diversified to all sorts of architectural ceramics and the growth of the factory was stimulated by a successful export policy. From 1910 onwards, Rako tiles were used in many European countries, as well as in other parts of the world. The firm still exists today as a large producer.

In Bohemia the improvement of art and handicrafts was not left to chance. Special schools were established whose main purpose was to improve the artistic and technical quality of product design. Such schools were founded in Znojmo in 1872, in Teplice in 1874 and in Prague in 1885. In 1900 the art school in Teplice offered three courses of study, one of which was 'architectural and fine ceramics'.

In Prague and the surrounding Bohemia region, Art Nouveau architecture is characterized by strongly modelled sculptures and relief panels, as well as by

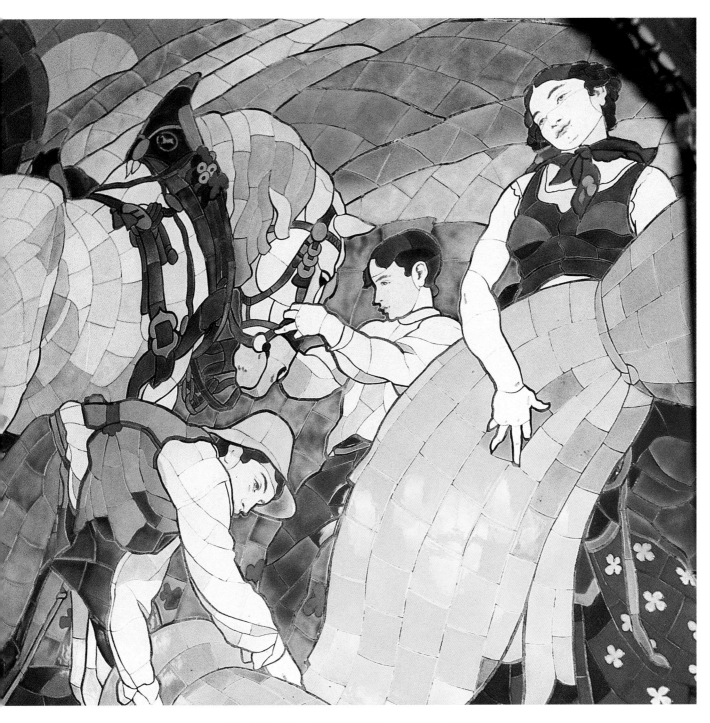

Detail of a tile panel depicting Harvest in Bohemia *in the Pilsen Restaurant in the basement of the Municipal House, Prague. It was designed by Jakub Obrovský and made by Rako, around 1912.*

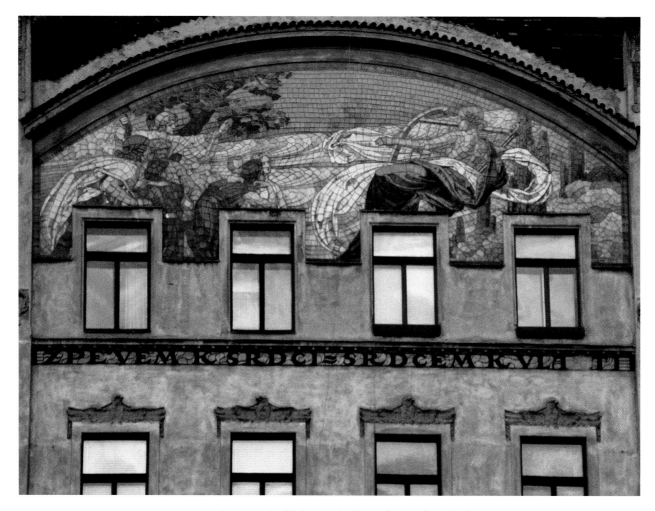

*Large panel of Rako mosaic tiles at the top of the facade
of the Hlalol Patriotic Choral Society building,
248/16 Masarykovo street, Prague, facing the Vltava river,
designed by the architect Josef Fanta, 1905.*

frescoes, large mosaics and tile panels that act as central eye catchers on the facade. In Prague the first Art Nouveau building was the Café Corso, designed by Friedrich Ohmann, which dates from 1897. The composition of the facade is still in the Bohemian Neo-Renaissance style, but in the details, for instance the curvilinear name panels, the influence of Art Nouveau is evident. However, in other buildings in Prague, an orientation towards Parisian Neo-Baroque or other eclectic styles combined with Art Nouveau detailing can be seen, notably in the Obecní Dům (Municipal House) and the Central Station.

Tiles by the firm Rako can be found in many public buildings, apartment blocks and private houses in Prague. The Obecní Dům is without doubt the most spectacular example. It was finally completed in 1912, after a long drawn-out procedure commencing in 1903 with two design competitions. The tiles were produced by Rako in the years 1911-13, so the Obecní Dům can be regarded as a spectacular ending or the ultimate climax to the Art Nouveau period. Antonín Balšánek and Osvald Polívka made the design that was finally accepted and executed. From the beginning their concept was heavily criticized, both by the older and younger generations of artists and architects, mainly because of its compromising eclecticism. Polívka was responsible for most of the remarkable interiors. The main staircase into the basement is lined with ceramic wall tiles with brightly coloured panels illustrating scenes of historic Prague designed by E. Hlavín. The decorative panels on the landing are by A. Mará. In the large basement foyer the walls and columns are covered with tiles and against one of the walls there is a tiled fountain. Even the floor tiles have a special Art Nouveau design and throughout there are special tiles with the name of the firm Rako. The basement foyer leads to the Pilsen Restaurant whose most striking feature is three mosaic tile panels designed by Jakub Obrovský. The largest one is *Harvest in Bohemia*, the other two depict a boy and a girl. All the wall panels between the windows are decorated with city emblems in relief tiles and in the adjacent wine bar tiles are used as decorative insets in the wooden panelling.

The Central Station, built in 1903-4 to a design by Josef Fanta, is another important site of Rako tiles in Prague. No less than 24 large, brightly coloured tile panels can be seen on the square columns in the restaurant, with such subjects as *The Four Seasons* executed in a mosaic tile technique. Large Rako tile mosaic panels can also be admired in the building of the Hlahol Patriotic Choral Society, 248/16 Masarykovo street, built in 1905 to the design of Josef Fanta, and the Paříž Hotel, Dlouhá street, built between 1905 and 1907.

Rako cooperated with several artists. One of them was the young Josef Drahoňovský, a student of the Prague School of Applied Arts, who designed the ceramic decorations on the ground floor of the Imperial Hotel in Prague built in 1911-13. The design was influenced by sculptures from Egypt and the Middle East and shows how in this instance the Art Nouveau style turned into a more traditional form of design, but with an individual use of colours.

Art Nouveau tiles in the entrances of houses and apartment buildings are not so common in Prague and the other main cities of the Czech Republic, but a good example in the centre of the capital is the entrance hall of the apartment building at 96/9 Široká street, built in 1907. This dado with a sunflower motif is one of the rare examples of a completely tiled vestibule in Prague. On the facades of the Široká street corner building there are several

Tile with the head of a gypsy woman in the vestibule of
the Americko Česka bank at 23 Pařížká, Prague, 1906.
Shown larger than actual size (15 x 15 cm, 6 x 6 ins).

Right: Unusual Art Nouveau panel by the sculptor Richard Luksch, resembling an Egyptian priestess, on the facade of 15/11 Kaprova street, Prague, around 1910.

Below: One of the 24 large, tile mosaic panels by Rako on the columns in the restaurant of the Central Station in Prague, around 1903. They depict men and women in rural dress from different parts of Bohemia and Moravia.

large tile mosaic panels, probably also by Rako. In the new residential areas in Prague built around 1900, particularly in the Vinohrady district, there are interesting examples of tiles in and around Mánesova street and Moskevská street.

The sculptor Richard Luksch, who had worked in Klimt's Sezession group in Vienna, is responsible for the unusual ceramic figures of a man and a woman on the facade of a house at 15/11 Kaprova street, created around 1910. They resemble a priest and a priestess, with raised hands, invoking superhuman powers. This illustrates the tendency of many western countries to seek new inspirations from exotic cultures, in this case from Egyptian mythology.

HUNGARY

In Hungary the new Szecesszío style became heavily politicized, not only because of strong nationalistic aspirations but also because of the firm official reaction against it. Budapest was the second capital of the Austrian Empire and after 1867, when Hungary received limited self-rule, it developed into a real metropolis. It was the youngest of the new capital cities in Europe, and it was here that a group of artists began to seek inspiration in traditional folk art, which they used as a springboard to develop their own style. This was the rather exuberant Hungarian New Style, which, when used in Hungarian pavilions at the international exhibitions, provoked strong reactions. A case in point was the Hungarian pavilion at the Paris World Fair of 1900. It was an exuberant example of the nationalist Magyaros style, with influences from vernacular architecture and contemporary fantastic and exotic forms. These nationalist aspirations were first expressed in the work of the influential architect Ödön Lechner, whose pupils such as Károly Kós and Béla Lajta followed him in the search for inspiration from Hungarian folk architecture. They favoured the use of picturesquely detailed ceramic ornament and tiles, manufactured by the large Zsolnay factory in the town of Pécs (Fünfkirchen in German).

A very important stimulus for the revival of the applied arts in Hungary were the 1896 millennial celebrations. For this occasion the underground railway system for Budapest was inaugurated, as well as the new Museum of Applied Arts, designed by Ödön Lechner. At the Millennial Exhibition several firms making building materials demonstrated a wide range of products and novel construction techniques and showed some of the more extreme possibilities to which they could be put. Even more important was the large exhibition of ethnographic objects, including traditional Hungarian houses from all regions. Innovation, sensation and the promotion of national folk art encapsulated much of the spirit of this event. The strong interest in vernacular sources was directly inspired by the English Arts and Crafts Movement. Around 1900 Ashbee designed several houses in Hungary and Walter Crane visited Budapest. Crane's activities in particular received official attention and as a result some of his books and articles were translated into Hungarian. At the same time Belgian and French Art Nouveau became fashionable. Although Vienna was nearby, very little impact can be detected from the Austrian Sezession movement. No doubt this was because Hungarian artists and

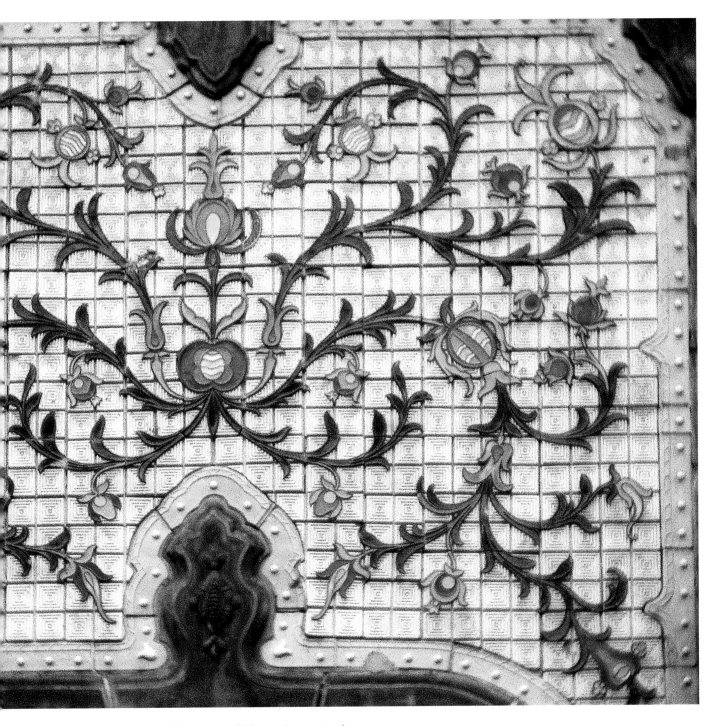

*Pyrogranit tile panel by Zsolnay of Pécs on the exterior of
the Museum of Applied Arts, Budapest, designed by Ödön
Lechner in 1896.*

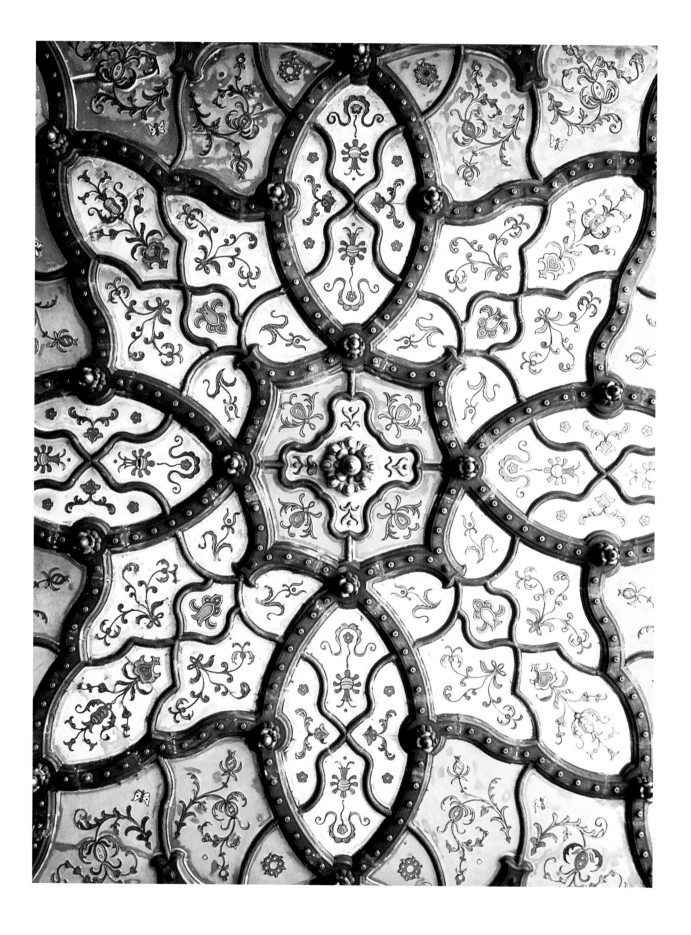

architects strove for cultural independence from Vienna, and this may explain why the art magazine *The Studio* had more influence in Hungary than similar publications from Vienna.

The Zsolnay factory was established by Vilmos Zsolnay in Pécs in 1868, and soon it made every conceivable kind of ceramic product. At the end of the nineteenth century new types of architectural ceramics were put on the market that were used for the first time in public buildings in Budapest. At that time the Zsolnay factory was the leader in industrial ceramics in the Austrian Empire. By 1898, 23% of all ceramic production in this vast region was made in Pécs. In 1900, after the death of Vilmos Zsolnay, the firm was taken over by his son Miklos and his two daughters Terez and Julia. Artistic activity at the firm was then at its height and in that year no less than 700 new products were launched. Most characteristic of this period were the tiles with Eosin glazes (named after Eos, the ancient Greek goddess of the dawn), which show iridescent glaze effects mostly in green, but also in red or purplish blue.

The building boom in Budapest and other main cities stimulated Vilmos Zsolnay to introduce new techniques and products, in collaboration with the more innovative architects of the day such as Ödön Lechner. In 1888, Zsolnay made two study trips to England. He went with Lechner, who himself was the son of a roof tile manufacturer, and they admired the oriental ceramics collection at the South Kensington Museum (now the Victoria and Albert) in London. It was probably these visits to Britain that resulted in the introduction of the dust pressing process at the Zsolnay factory. At the end of the 1880s a frost resistant, multi-purpose product was invented, its name 'Pyrogranit' being first used in factory publications in 1893. It was made from refractory (fireproof) clay, fine grain or coarse grain quartz and ground chamotte. The tiles were either pressed, or formed in plaster moulds. The first firing was between 1200°C and 1300°C. It could be used unglazed, coated with salt glaze, covered with coloured maiolica glazes or decorated with the special Zsolnay lustrous metallic Eosin glazes.

The production of Pyrogranit offered architects a very durable new construction material. Its endless possibilities of form and colour came just when the use of colour was becoming important to the novel Nationalist and Szecesszío designs by architects such as Ödön Lechner, Béla Lajta and Imre Steindl. The design by Lechner for the Museum of Applied Arts in Budapest, completed in 1896, the year of the great Millennial Festival, can be seen as a manifesto for the many possibilities of Pyrogranit, for example in the form of roof tiles and the quaint pretzel-like stair railings. The style of the building is very individual, an eclectic mix of Gothic and Indo-Magyar elements. One can see ogee windows on the outside and Mogulesque or Hinduesque arches around the central exhibition hall. For Lechner the use of architectural ceramics was a revival of the Hungarian tradition of facing brick facades with tiles. As with Gaudí in Catalonia and Berlage in Holland, a major reason was also the lack of suitable stone for decoration purposes. More than a mere representative of the New Style, Lechner considered himself a pursuer 'of the distant ideal of creating a Hungarian national style'. In 1904 Béla Lajta expressed the same goal: 'The visitor from abroad should find houses here that speak Hungarian, and those houses should teach him to speak Hungarian.' Also, in his later designs for public buildings Lechner used Pyrogranit tiles on

Opposite: Pyrogranit tiled ceiling with an elaborate curvilinear design in the entrance of the Museum of Applied Arts, Budapest, 1896.

simple, unbroken planes and simple masses, as can be seen in the Geological Institute built in 1896-9, the Post Office Savings Bank built in 1898-1901 and the Kobanya Church built in 1896-7. Lechner had several pupils who followed his use of folklore motifs and ceramic tiles. In addition to Béla Lajta, there were József and Lázslo Vágó, Marcell Komor and Desző Jakab.

In 1907, Marcell Komor and Desző Jakab designed the Town Hall in Szabadka (nowadays Subotica in Slovenia). Because the architects worked on every little detail of this building, from the ceramic sculptures on the facades to the door handles and chandeliers inside, it is a stunning example of a fully integrated design scheme in the Hungarian New Style. The chief motif is the tulip, a typical Hungarian embellishment. Much of the building derives its character from the use of Zsolnay ceramics, especially the colourful Pyrogranit roof tiles and the tiles on the main staircase. This building can be regarded as a prelude to the Palace of Culture built in Marosvásárhely (now Tirgu Mureş in Romania) in 1911-13, also designed by Komor and Jakab. Here, the exterior is dominated by the curved roof that is finished with alternating red and white triangular Pyrogranit tiles. The inside, which houses a concert hall, a library, an art gallery and a hall of mirrors, is lavishly decorated from floor to ceiling. The backs of the wall benches consist of curved panels of Pyrogranit tiles; the columns are faced with dark green Eosin tiles with gold streaks, ending in organic ornaments with iris and vine leaves. There are frescoes and stained glass windows by several artists of the famous Gödöllö artists' colony, including Aladár Köröshfői Kriesch and Sándor Nagy. Another remarkable building in the same style is the Town Casino in Kecskemét, a provincial town south east of Budapest, designed by Géza Márkus in 1902. Because of its fairytale appearance it was soon nicknamed Cifrapalota (Fancy Palace). The same fantasy can be seen in a much smaller building designed by Ödön Lechner and Béla Lajta. This is the family crypt for Sándor Schmidt, dated 1903, at the Rákoskeresztír cemetery in Budapest, completely faced with large Zsolnay tiles.

After his apprenticeship with Lechner, Béla Lajta worked for Richard Norman Shaw in London in 1899 and visited the Paris 1900 World Fair. In the Ferenc Bárd music store of 1900 and the Rózsavölgyi department store at 5 Martinelli tér of 1911 Lajta shows that he is not only a follower of Wagner, in covering the entire surface of a building, but also a follower of Lechner in the use of national floral motifs derived from Hungarian traditional textiles. Some of the tiles on the facade of the Rózsavölgyi department store are decorated with bold, stylized flower motifs inspired by needlework from the Öcsény area. Zsolnay tiles can also be admired in Budapest on the Opera building by Miklos Ybl built in 1884, the new Town Hall by Imre Steindl constructed in 1894-5, and the Gellert Bath dating from 1918.

Unfortunately in 1902, the minister of culture prohibited the use of state resources for buildings in the Szecesszío style and the new designs lost ground. This also meant that Lechner never became a teacher at Budapest University. The style of the new Franz Liszt Music Academy, designed by Korb and Giergl and built in 1902, reflected official taste much better. In its final form the Music Academy is a mix of Baroque with oriental elements. In the central hall the walls and columns are covered with green tiling.

There are still many splendid tiled buildings to be admired in Budapest. An important example is the Arkaden Basar, 22 and 24 Dohány street, by the Vágó

Opposite: The 'pretzel-like' ceramic balustrade leading to the entrance of the Museum of Applied Arts, Budapest, 1896. It shows the curious mix of Gothic and Indo-Magyar forms characteristic of the Hungarian New Style.

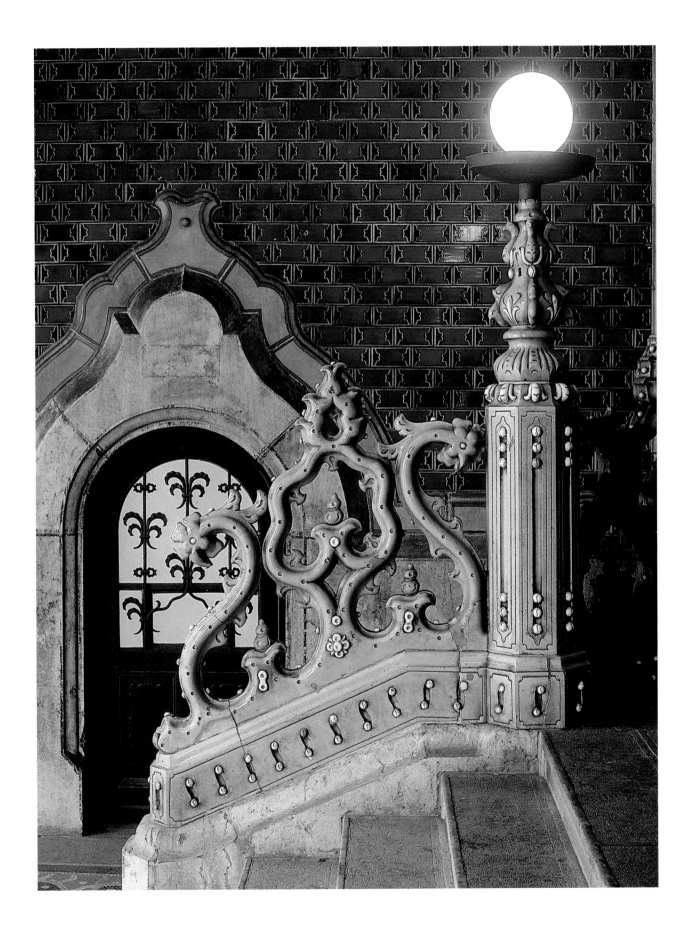

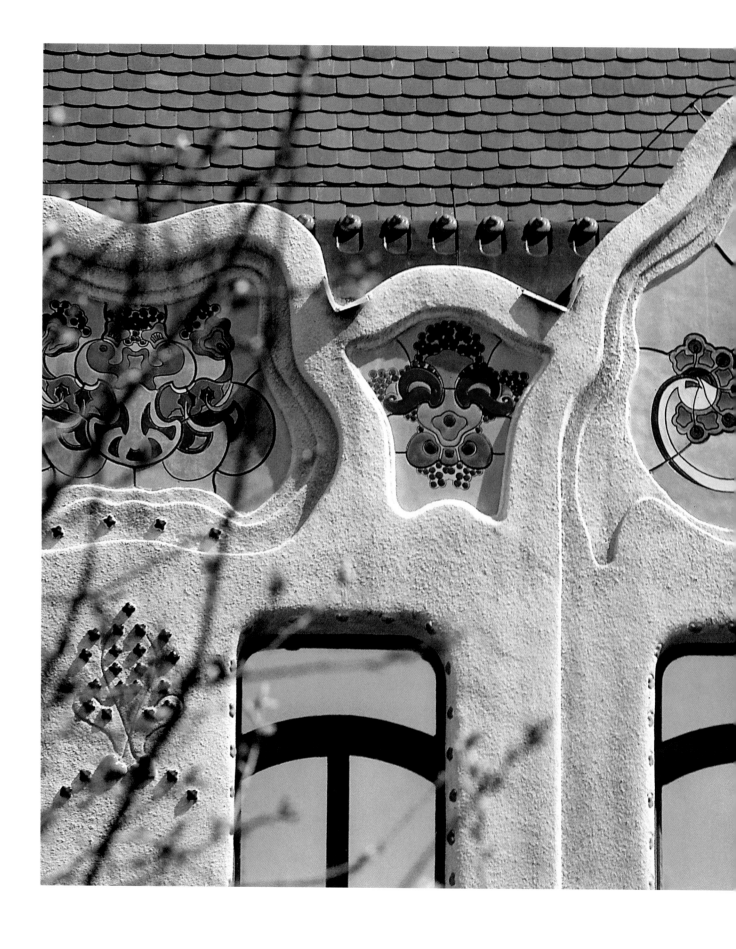

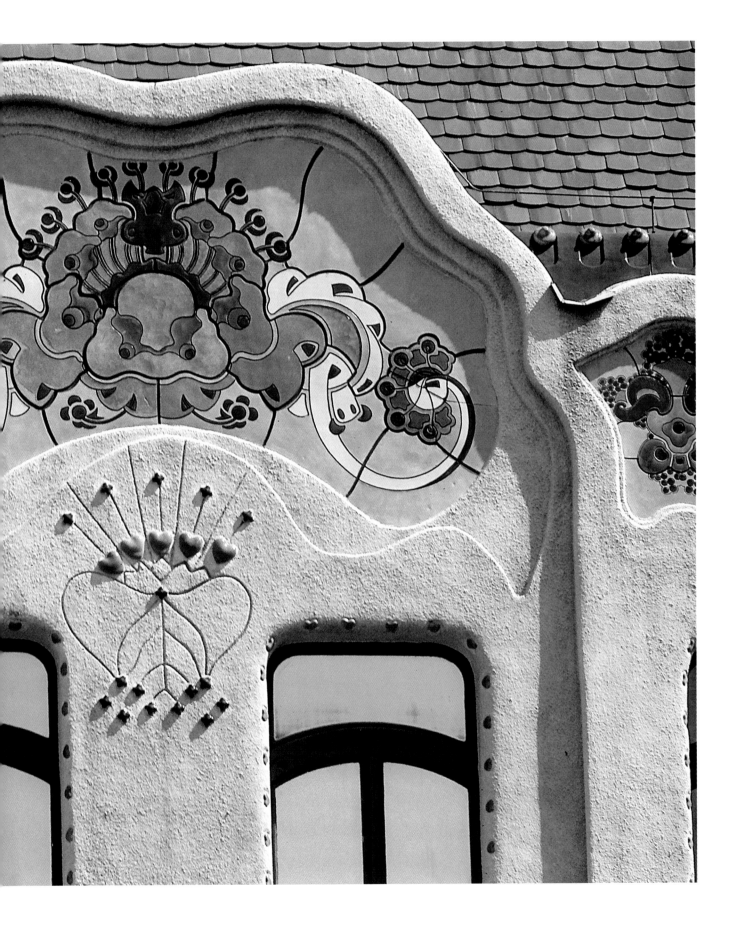

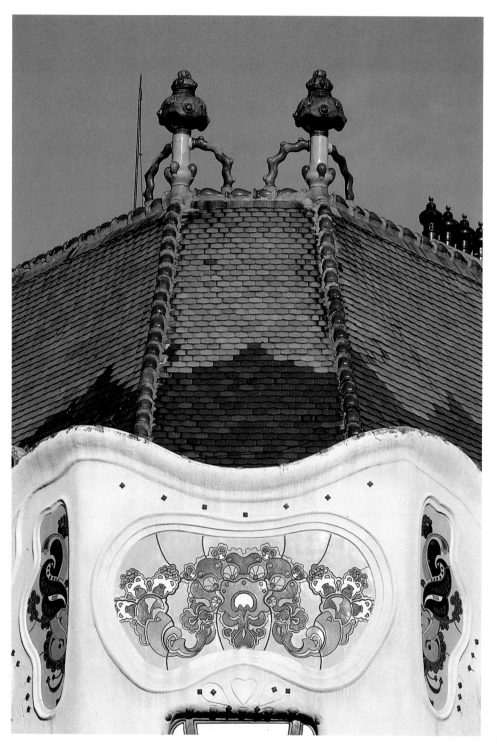

Left: Zsolnay tiles on the exterior of the Town Casino, Kesckemét, Hungary, 1902. The curious and exotic forms and colours of the tiles gave the Casino the nickname of Cifrapalota (Fancy Palace).

Previous page: Colourful Pyrogranit tiles by Zsolnay on the exterior of the Town Casino, Kesckemét, Hungary, 1902.

Right: Detail of the Zsolnay tiles, architectural ceramics and mosaic in the elaborately decorated interior of the Gellert Baths, Budapest, dating from 1918.

Far right: Zsolnay tiles on the facade of the Evangelical Reformed church at Gorkij fasor, Budapest, designed by the architect A. Arkay, 1911-13

brothers built in 1909. The facades of this corner building are almost entirely covered with large Pyrogranit panels. In its use of new building techniques, including concrete, this building is an early example of Modernist architecture. On the ground floor there was originally a toy shop, so the facade above the shop window is decorated with scenes of children at play. Some of the cartoons for these scenes by Géza Nikelsky have survived. They show two boys in soldier hats, chasing hoops and laughing in front of a castle of toy building blocks. Between them are panels with a small monkey riding a rocking horse, a kitten and a regiment of tin soldiers. The other composition shows a girl carrying a toy baby and different dolls. These sketches are inscribed *Pécs, 1909.VI.28.*

Outside Budapest Zsolnay architectural ceramic can be found in several spa baths and in public buildings in cities such as Prague, Kecskemét, Arad (Nagyárad in Hungarian) and Trieste. Zsolnay tiles seem rarely found outside the countries of the Austrian Empire, although, besides Pyrogranit, the factory also produced ordinary tiles in several techniques, such as copper plate printed, dust pressed relief tiles and tiles with special glazes. In the Museum of Applied Arts in Budapest several examples of these tiles can be seen, some with very unusual glaze effects. After 1910 the decoration on their tiles became simpler. An example of this is the tiling in the main hallway in the school in Vas utca in Budapest, designed by Béla Lajta in 1911-12, at a period when his work was strongly influenced by Scandinavian architecture, especially by the Finnish architect Eliel Saarinen, with whom he had much contact.

SOUTHERN EXTRAVAGANZA

ART Nouveau also spread to southern Europe where it manifested itself in Spain, Portugal and Italy. In Spain it took a uniquely independent and flamboyant form in Catalonia. This was the turn-of-the-century 'Modernista' style that showed itself most strongly in the work of the Catalan architects Puig, Domènech and Gaudí who all used tiles and tile mosaic in their architecture. They were able to draw on an active tile industry centred in Barcelona with Pujol i Bausis as one of the leading firms. In Portugal the new style was known as 'Arte Nova' which showed itself in the output of such factories as Sacavém, where the tile panels by Carlos Soares are of considerable interest. However, the most idiosyncratic Portuguese Art Nouveau tile artist was Rafael Bordalo Pinheiro whose colourful relief tiles deviate so strongly from the Portuguese hand-painted tradition. Art Nouveau came late to Italy, where it was known as 'Stile Liberty' or 'Stile Floreale', but an interesting Italian exponent of this style was the ceramic artist Galileo Chini.

SPAIN

Barcelona is the capital of Catalonia, a coastal region in the north east of Spain with its own identity and language. In the past successive Madrid governments attempted to suppress Catalan culture, but these repressive measures were eased by the middle of the nineteenth century and during the second half of the century a Catalan cultural revival movement emerged known as the 'Renaixenca'. This cultural regeneration went hand in hand with strong economic and industrial expansion and as a result Barcelona was greatly extended towards the west with new apartment blocks laid out according to a grid system. This new district was called the 'Eixample' (meaning extension) and it gave an opportunity for progressive architects such as Puig, Domènech and Gaudí to construct new houses for wealthy industrial entrepreneurs. The economic prosperity of the region coincided with a strong upsurge of Catalan intellectual and artistic life during the period 1880-1910 and it is at this time that a distinctive form of Catalan Art Nouveau emerged known as 'Modernista'. The Modernista movement was open to many outside influences but at the same time it was also firmly embedded in local traditions. This explains why Catalan Art Nouveau is such

Opposite: The elaborately tiled roof of Gaudí's Casa Batlló, 43 Passeig de Grácia, Barcelona, built between 1904 and 1906.

a curious, eclectic mixture of Moorish and Gothic architecture, the English Arts and Crafts Movement and European Art Nouveau.

There was already a flourishing tile industry in Barcelona with a long established tradition of producing hand-painted tin glazed tiles. By the end of the nineteenth century much of the hand painting had given way to stencilling which speeded up the decoration process. Two notable tile firms at this time were Orsola, Solá i Comp. and Pujol i Bausis. Orsola, Solá i Comp. was a large producer with an annual turnover of over several million tiles. Their quality was rewarded at the Barcelona World Fair of 1888 and the Paris World Fair of 1889 where they won gold medals. Pujol i Bausis was founded in 1852 and the factory was situated at Esplugues de Llobregat on the outskirts of Barcelona. This firm is of interest because by 1900 it was directly involved with notable Barcelona architects and designers of the day. Lluís Domènech and Antoni Gallissà, another architect, as well as the ceramicist Lluís Bru, designed tiles for them and their work was also used in the various projects by Antoni Gaudí and Josep Puig. This is evident by looking at catalogues by Pujol i Bausis issued between 1900 and 1915; they show a number of wall tile arrangements as well as custom-made pieces by named architects and designers of the day.

The buildings of Josep Puig i Cadafalch (1867-1957) are on the one hand rooted in Catalan medieval architecture and on the other hand show the influence of the French architect Viollet-le-Duc and the English Arts and Crafts tradition. His work is therefore eclectic but his buildings stand out for their handwork and high quality ornament, as a reaction against the prevailing Classical styles and mass production. In that sense he helped to stimulate a new approach to architectural design and ornamentation. His two most outstanding buildings are Casa Amatller and Casa Terrades. Casa Amatller, built for the chocolate manufacturer Antoni Amatller in 1898-1900, is situated next to Gaudí's famous Casa Batlló and close to Domènech's Casa Lleó i Morera on the Passeig de Grácia. The Neo-Gothic influence can be seen in the exuberant stone carvings on the lower half of the facade, but the stepped gable is covered in glorious blue-and-white and purple-and-white tiling, accentuated with red lustre tiles, resulting in the polychromatic facade so characteristic of Modernista architecture. Casa Terrades situated on the Diagonal in Barcelona was built in 1905 for the wealthy heiress Angela Brutau. Built in brick with turrets and gables in the Neo-Gothic style it includes hand-carved stone

Opposite: Stencilled Art Nouveau tiles by the firm Pujol i Bausis of Barcelona on the walls of the light well of the Sant Augusti Hotel, Placa Sant Augusti, Barcelona, around 1908.

Below: The tiled gable of Casa Amatller, 41 Passeig de Grácia, Barcelona, by the architect Josep Puig, built in 1898-1900.

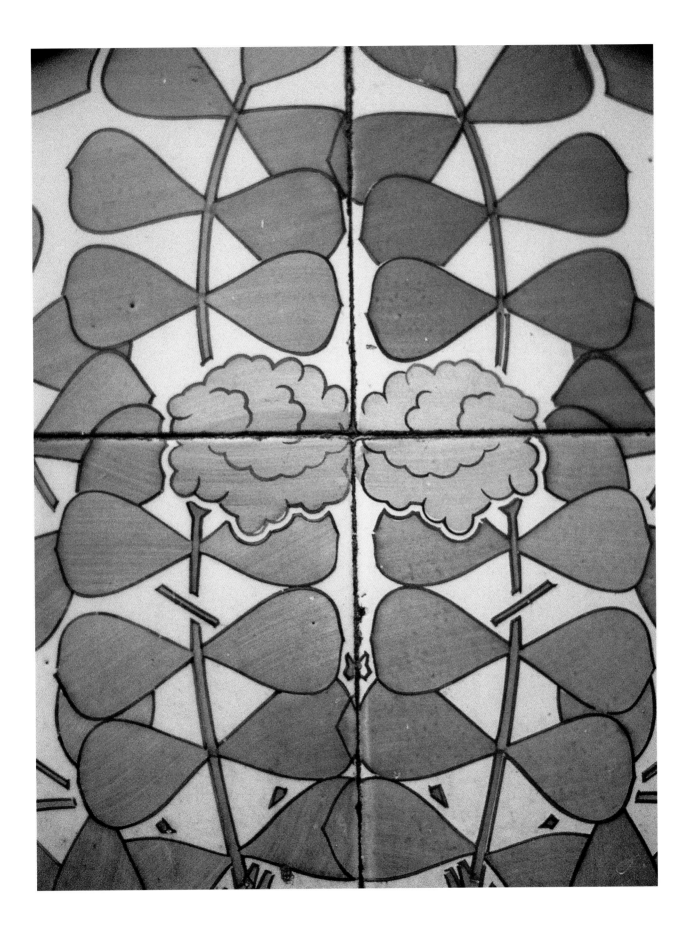

Above: Tiles on the exterior of Casa Ramon built for the owners of the publishing firm Editorial Montaner y Simón in 1893 at 278 Mallorca, Barcelona. Appropriately the tile decorations show scenes from the history of printing.

Left: Panel with St George and the Dragon on the exterior of Casa Terrades, 416-20 Diagonal, Barcelona, by the architect Josep Puig, built in 1905. At the bottom of the panel is a nationalistic Catalan slogan, 'Patron saint of Catalonia give us back our freedom'.

Tiled tower of one of the surgical wards in the grounds of Sant Pau Hospital, Barcelona, designed by Lluís Domènech between 1902 and 1911. The letter P stands for Sant Pau.

ornamentation, wrought iron work and colourful ceramic tile panels in many of the gables. The bold, flat designs of these tile panels reveal a strong influence from the English Arts and Crafts Movement, which is not surprising since Puig was an admirer of John Ruskin and William Morris. One of the panels with a scene of St George and the Dragon is inscribed with a cry for independence: *Sant patrò de Catalunya torneu-nos la llibertat* (patron saint of Catalonia give us back our freedom), revealing Puig as a staunch supporter of Catalan autonomy.

The second great Modernista architect of the period was Lluís Domènech i Montaner (1849-1923). His buildings such as Casa Ramon de Montaner, the Sant Pau Hospital, the Pere Mata Institute, and the remarkable Palau de la Musica Catalana are a testimony to his ability to conceive functional buildings with exuberant decoration. In them, individual tiles, tile panels and tile mosaic feature prominently. Casa Ramon de Montaner was initially designed by the architect Josep Domènech i Estapa for one of the proprietors of the publishing house Editorial Montaner y Simón in 1893. But shortly after construction had commenced, disputes between patron and architect resulted in Lluís Domènech i Montaner taking over. He was responsible for all the decoration, including the tile panels that depict Gutenberg's invention of book printing. In addition to the pictorial panels there are friezes with beautiful lustre tiles decorated with sensuously flowing lines.

Domènech's largest commission was the design and building of the Sant Pau Hospital in Barcelona. The first phase of construction was between 1902 and 1911 and saw the erection of various buildings with extensive tile decorations. Although the style of the hospital belongs to the medieval trend in Catalan Art Nouveau, the extremely rich ornamentation of brick, stone, iron, stained glass, mosaic and tiles suggests such diverse sources as the English Arts and Crafts Movement, the rationalist architecture of Viollet-le-Duc and French Art Nouveau. The hospital covers an extensive site and is built on the pavilion principle but with strict functional criteria in mind. Tiles were not only used for ornamentation of the exteriors but also featured extensively on the walls, ceilings and floors of all the wards, surgical wings and operating theatres where the requirements of hygiene dominate. The lavish tile and mosaic decorations on the exterior follow a carefully pre-determined iconographic programme. Many buildings are decorated with a mosaic of a particular patron saint. Ornamental tile panels with the letters G (for Paul Gil who financed the construction of the hospital) and the letter P (for Sant Pau) feature on most of the buildings, and in addition there are many panels showing a red cross and the arms of Catalonia. Despite all the different stylistic sources and great variety of different materials Domènech created a unified architectural setting of great complexity. François Loyer in his *Art Nouveau in Catalonia* remarked, 'In the Sant Pau Hospital Catalan Art Nouveau finally solved its contradictions but lost none of the richness of its sources or the spontaneity of its inventions.'

Domènech constructed a hospital of a different kind in Reus, south of Barcelona. Here we find the Pere Mata Institute for the mentally ill constructed between 1897 and 1919. Like the Sant Pau Hospital it was built in the Catalan Gothic tradition. The original brick entrance gate is extensively decorated with blue-and-white tile panels showing angels and the name of the hospital *Instituto P. Mata* painted in red lustre. Magnificent blue-and-white tile panels with angels holding holy vessels or playing musical instruments, reminiscent of

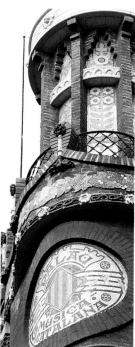

Edward Burne-Jones and William Morris, can be seen on the exteriors of the various buildings throughout the compound. Polychrome tiles with stencilled decorations by the ceramic artist Lluís Bru, made by the Barcelona firm Pujol i Bausis, cover the walls and ceilings of many rooms in the hospital.

However, Domènech's most prominent achievement is the Palau de la Musica in central Barcelona which is an extravagant exercise in Catalan Art Nouveau ornament and structure. Built between 1905 and 1908 it represents one of the highlights of Catalan Modernista architecture. Much of the upper part of the facade facing Carrer Sant Père Mes Alt is accentuated by tall, round columns crowned by ornate glazed capitals. The shafts of all the columns are decorated with tile mosaic by the ceramic artist Lluís Bru. The coloured mosaic decorations not only cover the columns but are also extensively used on the exterior walls on the ground floor. They are made from small pieces of broken tile which have been assembled to form a rich and diverse range of floral shapes and abstract patterns. Square and rectangular tiles are also used and of particular interest here are the embossed glazed tiles, with designs of musical notes, used as a frieze along the side of the building adjoining Carrer d'Amadeu Vives. It is without doubt the world's most fanciful concert hall.

In a league of his own is Antoni Gaudí (1852-1926) whose unique creative inventiveness has often come to epitomize the Catalan Modernista movement, sometimes at the expense of Puig and Domènech. Gaudí was both a strong adherent of the Catholic faith and a fervent Catalan nationalist. His eccentric and fanciful architecture defies any attempt to place it firmly within a particular stylistic context. Most of his buildings are in Barcelona and tiles and tile mosaic play an important part in many of them. In this respect four creations stand out: Casa Vicens, Pavilions Güell, Casa Batlló and Park Güell.

Opposite, left: Detail of the tiled entrance to the Pere Mata Institute, Reus, constructed between 1897 and 1919 to designs by the architect Lluís Domènech. The name of the institute has been painted in red lustre.

Opposite, right: Top section of the exterior of the Palau de la Musica, Barcelona, designed by Lluís Domènech between 1905 and 1908, elaborately decorated with mosaic decorations by the ceramic artist Lluís Bru.

Right: Tiled dado in the portico of the main entrance of the Pere Mata Institute, Reus, built between 1897 and 1919 by the architect Lluís Domènech. The tiles are decorated with stencilled foliage designs showing the influence of the English Arts and Crafts Movement.

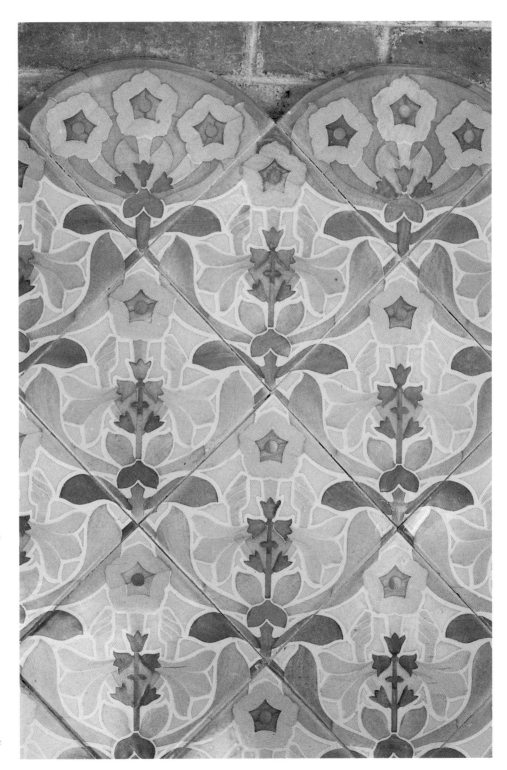

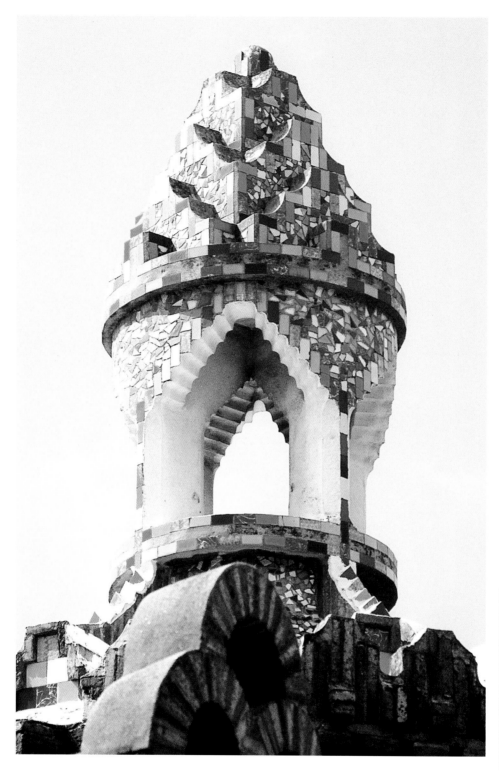

Left: Ventilation turret decorated with small pieces of broken tile on one of the entrance lodges to the Güell estate at 7 Avinguda de Pedralbes, Barcelona, built by Gaudí between 1884 and 1887. This is one of the first instances where Gaudí opted for the use of the tile mosaic that was to become a hallmark of so much of his later work.

Below: Detail of the exterior of Casa Vicens, 24 Carrer de les Carolines, Barcelona, built according to designs by Gaudí between 1883 and 1888. This is the first house where Gaudí used tiles on a large scale in combination with ornate ironwork and elaborately decorated ceramic vases.

One of his first commissions was the summer house for the ceramics manufacturer Manuel Vicens Muntaner. This house, known as Casa Vicens, was constructed between 1883 and 1888. It draws on both Moorish and medieval Catalan architectural traditions, in which tiles play a prominent part. Only one type of patterned tile, with a stencilled design of orange flowers and green leaves, together with plain white and green tiles, has been used to decorate the exterior. Yet with this limited range Gaudí has managed to create a striking and highly individual facade. The plain green and white tiles have been used in chequerboard fashion to accentuate the many eastern looking oriel windows and turrets of the top story, while the floral tiles have been employed to decorate the middle and lower half of the exterior. Striking wrought iron decorations in the form of window grills and railings enhance the idiosyncratic appearance of the house. Casa Vicens is also important as a building in which Gaudí used square tiles in an unbroken form (the other is Casa El Capricho, built in 1883-5 in Comillas, near Santander).

In Catalonia the use of broken tile fragments is known as *trencadis*. In Gaudí's work, an early application of this technique can be found in the decoration of the entrance pavilions at the Güell estate on the Avinguda de Pedralbes. One pavilion consists of a gatekeeper's lodge, while the other houses comprise a coach-house and stables. The ventilation turrets on the lodge and the little cupola over the stables are covered with multi-coloured tile fragments. It was necessary to break the tiles in order to follow the curved surfaces. This set an important precedent because from now on the exteriors of all Gaudí's tiled buildings utilize broken tile fragments as it was the only way to cover the increasingly complex curved and undulating wall and roof surfaces.

Casa Batlló on the Passeig de Grácia was built between 1904 and 1906 for Josep Batlló i Casanovas, a wealthy textile manufacturer. It was a conversion of an existing apartment house situated next to Puig's Casa Amatller. Because of the greatly contrasting styles of these two Modernista buildings, this particular block of apartment houses is known as Manzana de la Discordia or Block of Discord. However, Casa Batlló is clearly the most adventurous and unusual of all the houses in this block. The facade on the ground story is constructed of curvilinear stonework, and above this the undulating facade covered in colourful tile mosaic and small projecting balconies rises four stories up to the roof. The roof, formed like a dragon's back, is covered in variously shaped glazed roof tiles and has chimneys and a tower with tile mosaic. The meaning of this complex roof can also be interpreted on a symbolic level whereby it is seen to represent St George (patron saint of Catalonia) and the Dragon. The ceramic scaled roof is the dragon's body and the ceramic clad tower, which thrusts itself through the roof, is the lance of St George. This seems a conceivable interpretation given Gaudí's nationalist and religious convictions, but it is also consistent with the predominance given to the subject by other Modernista architects. Puig had used it on his Casa Terrades, and Domènech installed a tile mosaic panel of St George and the Dragon by Lluís Bru on the administration building of his Sant Pau Hospital.

If the tiles and tile mosaic on the exterior of Casa Batlló are both decorative and symbolic, they play a more functional part in the interior. The Art Nouveau entrance hall and staircase are lined with plain and embossed

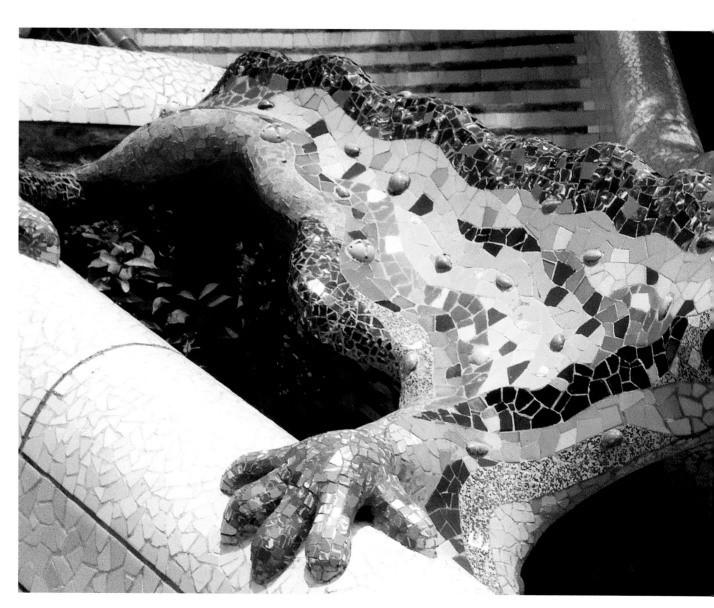

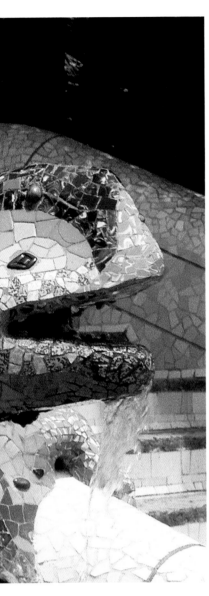

Above: A fountain in the shape of a colourful tiled dragon on the staircase of Park Güell.

Opposite: The entrance to Park Güell in Barcelona, built by Gaudí between 1900 and 1914. The large double staircase decorated with tile mosaic leads to a pillared hall and the viewing platform with the serpentine bench.

blue-and-white tiles, as are the light and ventilation shafts at the centre of the building. It is interesting to note that at the bottom of the light wells the colours of the tiles become lighter and the balconies and windows bigger in order to maximize the light for the lower part of the house.

In terms of tiled structures Gaudí's crowning achievement is Park Güell built between 1900 and 1914 and situated on the steep and barren slopes of Muntanya Pelada (Bald Mountain) to the north-west of Barcelona. Gaudí conceived the scheme in collaboration with his patron Eusebi Güell and the architect Josep M. Jujol. In the first instance it was meant to be a select and private development along the lines of English garden city schemes. The English influence can be seen in the name 'Park Güell', with the use of the English 'Park' instead of the Catalan 'Parc'. The ambitious residential project was eventually scaled down to only three houses, one for Güell, one for Gaudí, and one for the Trias family who were close friends of Güell. In 1923 it became a municipal park to be enjoyed by the local inhabitants but it is now also a major attraction for foreign tourists who flock from all over the world to see it. More recently its great cultural importance was recognized by UNESCO who declared it a world heritage site in 1984.

The main entrance of Park Güell is on Carrer d'Olot where the high perimeter walls are decorated with large round medallions with the words *Park Güell* in tile mosaic. The entrance is flanked by two stone gate lodges, with wondrous fairytale roofs and biomorphic towers and turrets covered with a skin of colourful tile mosaic. Once through the gate one enters an enclosed space that leads to a tiled staircase flanked on either side by curved and crenellated walls, all covered with broken tiles. In the middle of the staircase the visitor is greeted by a large tiled dragon which acts as a fountain. The staircase leads eventually to the market hall with its Doric columns and its ceiling covered in plain white tile mosaic interspersed with colourful tile mosaic roundels of great complexity. The columns of the market hall support the great platform that looks out over Barcelona. It is here that we find the famous serpentine bench that marks the perimeter of the platform.

The serpentine bench, to which the architect Jujol made important contributions, is an amazing structure combining function, decoration and symbolism into one. Since its ceramic surface reflects most of the heat of the sun it is an extremely pleasant and cool seat, while also providing a magnificent view over the park and Barcelona below. The bench seems to snake its way endlessly around the perimeter of the viewing platform and it is this sinuous, meandering line that links it so firmly to Art Nouveau. The bench is not only covered with broken pieces of tile, but also with fragments of ceramic plates, china dolls and glass wine jars. The great variety of colours and shapes provides visitors with an uplifting aesthetic experience but as in all Gaudí's work there is a deeper symbolic significance to be found. On close observation it becomes clear that the colours green, blue and yellow predominate. Following the colour symbolism employed in Gaudí's church of Sagrada Familia, one can see these as representing the Christian virtues of Hope, Charity and Faith. On closer inspection some of the tiles also reveal marks and inscriptions, with crosses, crowns of thorn and the letter *M* for the Virgin Mary. A kind of sacred graffiti that in the words of Conrad Kent and Dennis Prindle in their book *Park Güell* (1992) reflects 'one of the more

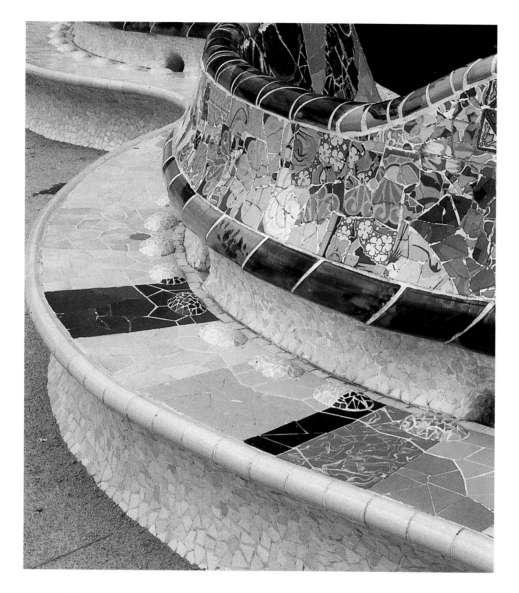

unusual but widely shared enthusiasms of the Catalan Catholic revival'. It is a testimony to Gaudí's creative genius that after almost a hundred years his tiled buildings still appear inspirational, fresh and modern and are still capable of engendering a sense of wonderment and amazement in those who visit them.

On a less exalted note, away from Gaudí's dazzling work, there are apartment blocks in the Eixample district in Barcelona with interesting tile decorations both on the exterior and in the entrance halls. In the Plaza De Toros les Arenes there is an apartment house with a curious gable in the form of a large butterfly covered in tile mosaic, while in the Carrer Gran de Grácia there are several apartment houses with stencilled Art Nouveau tiles in the entrance halls. These tiles were made by such as firms as Pujol i Bausis and Orsola, Solá i Comp. and were invariably executed in an in-glaze technique with colourful stencilled decorations in stylized floral designs. It was this type of tile that was also utilized on a grand scale in the broken tile mosaic of ceramic artists such as Lluís Bru and architects such as Gaudí.

Above, left: A section of the serpentine bench decorated with tiled mosaic in the Park Güell. The bench meanders around the perimeter of the viewing platform overlooking Barcelona.

Right: Stencilled Art Nouveau tiles in the vestibule of an apartment block dated 1905 at 77 Carrer Gran de Grácia, Barcelona.

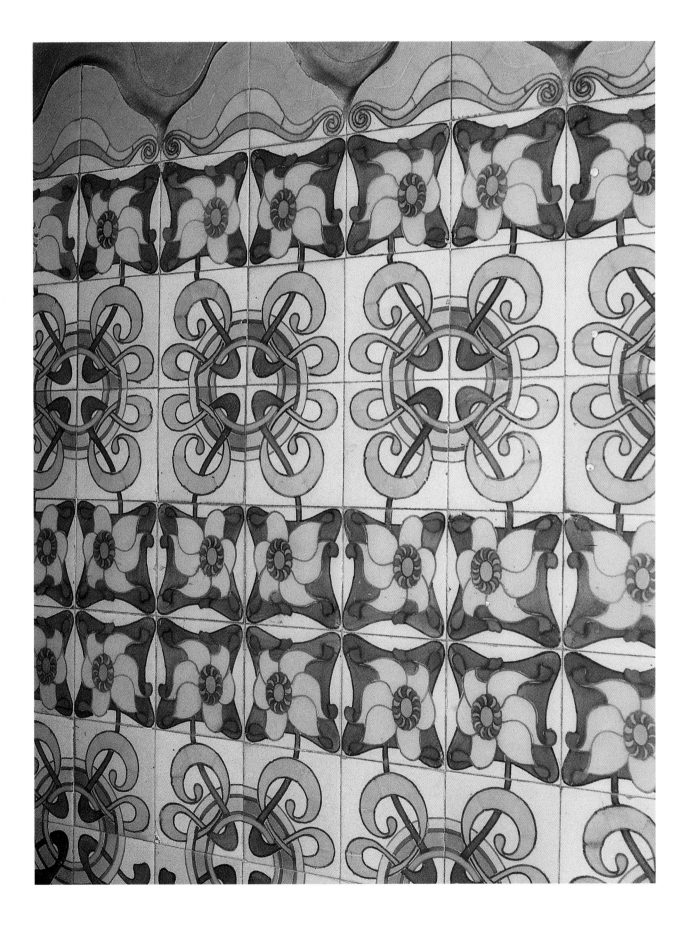

PORTUGAL

Art Nouveau tiles in Portugal are still commonly encountered on all kinds of domestic and commercial buildings of the period 1895-1920. They are often painted, but may also be stencilled, embossed or printed. Their production was centred in and around Lisbon and Oporto. In Lisbon we find factories like Constancia founded in 1836, Sacavém of 1850 and Desterro of 1889. In Oporto there was the Carvalhinho factory set up in 1840 and the Devezas factory founded in 1865 in Villa Nova de Gaya, just outside the city.

The Sacavém factory became a prominent producer not only of painted Art Nouveau tile panels by such artists as José António Jorge Pinto but also of Art Nouveau dust pressed tiles. Soon after its foundation in 1850 it was taken over by the Englishmen G.H. Howarth and J.S. Howarth. Business prospered and by 1898 they were employing up to 250 people. In 1904 Sacavém began a large scale production of dust pressed tiles with equipment and moulds acquired in England. Production of these tiles was also subcontracted to the firm of Desterro, which explains why there are Portuguese tiles with back marks by the Sacavém and Desterro factories but English Art Nouveau designs. Portuguese tiles of this type can still be encountered on the exteriors of several shops and houses.

The long and dominant history of naturalistic tile painting in Portugal affected how tile artists responded to Art Nouveau. In many cases tile panels show naturalistically painted central scenes set within an Art Nouveau border of plant tendrils and flowers. In these instances the artists failed to create central scenes in harmony with their Art Nouveau border. This failing can be seen in the work of José António Jorge Pinto whose panels of naturalistic sea goddesses decorate the upper story of a small kiosk in the Cais do Sodré, in Lisbon. A similar tendency can be seen in the painted panels by António Lluís de Jesus on the outside of a former paint store in the Largo do Corpo Santo in Lisbon. One of the panels shows a carefully composed naturalistic still-life with paint pots and brushes on a small table set within an elaborate border of sinuous Art Nouveau line work.

Better integrated Art Nouveau designs were painted by the artist Carlos Soares who worked at the Sacavém factory. His best work was done for a series of houses in Rua Dr Alvaro de Castro, Lisbon, executed in 1917. The gables of the houses and some of the porches have figurative designs of female heads, full length figures and other subjects. They are executed in monochrome blue or sepia and set within polychrome borders and compositions of flowers that show the influence of Art Nouveau. The monochrome colouring of the figures helps to play down excessive naturalism and this more decorative treatment makes them harmonize better with the surrounding border decorations.

Even more successful are the tile decorations found on a number of large apartment houses of the period 1900-10 along the main avenues in Lisbon, such as the Avenida de Republica and the Avenida Almirante Reis. Tiles appear in the form of flat stencilled floral Art Nouveau borders, or fairly flat painted scenes showing peacocks, swans or floral compositions with sunflowers. Used as friezes running below the roof or as panels above windows, they harmonize successfully with the shape and style of the buildings. Particularly impressive is

Opposite: Dust pressed Art Nouveau tile on the exterior of a shop in Rua da Lapa, Lisbon, made by the Sacavém or the Desterro factory of Lisbon, using metal moulds acquired in Britain, around 1905.

Right: Tile panel with an elaborate Art Nouveau border on the exterior of a former paint store at Largo do Corpo Santo in Lisbon, painted by António Lluís de Jesus, around 1910.

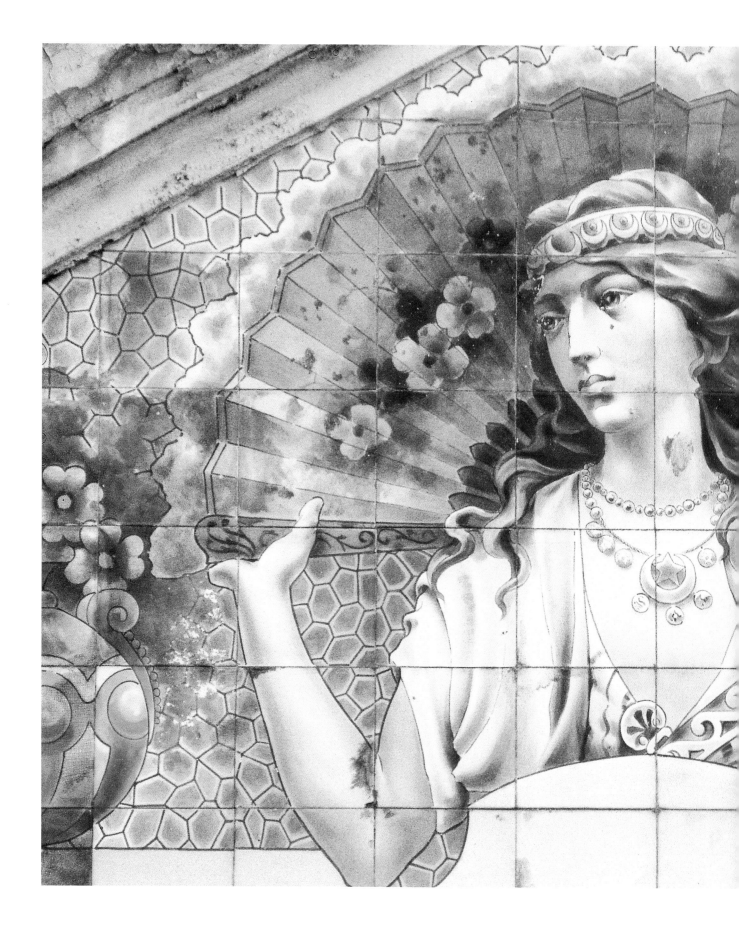

Detail of a Sacavém tile panel showing a woman with a fan on the facade of a house in Rua Dr Alvaro Castro, Lisbon, painted by the tile artist Carlos Soares in 1917.

Above: Detail of the bottom section of a painted tile panel flanking the entrance of the Tabacaria Mónaco in Rossio Square, Lisbon. The panel is signed by Rafael Bordalo Pinheiro and dated 1894.

Opposite, top: Detail of the extravagantly eclectic ceramic decoration above one of the windows of the house of the Count of Sacavém on Rua do Sacramento à Lapa, Lisbon, made by Campolide in Lisbon between 1897 and 1900.

Opposite, bottom: Panel of relief tiles with waterlilies and frogs by Rafael Bordalo Pinheiro on the exterior of a garage in Rua Ponte Delgade, Lisbon, around 1905.

the apartment building by the architect Adaes Bermudes of 1908 on the Avenida Almirante Reis. The building has a frieze of blue birds and flowers and in the spandrels above the windows on the top floor are painted scenes with blue peacocks set amongst red and pink flowers. There are also colourful water scenes with swans, ducks and ducklings with the airborne figure of Cupid aiming his bow and arrow at white doves. The block is virtually next to the Lamego tile factory so it is possible that the tile decorations were made there.

One of the most individualistic Art Nouveau tile makers was Rafael Bordalo Pinheiro (1846-1905). He began his career as an artist and caricaturist and during the 1870s became well known for his political and satirical illustrations. His interest shifted towards ceramics at the beginning of the 1880s. In 1883 he and his brother Feliciano founded a factory under the name Fábrica das Caldas da Rainha in the town of Caldas da Rainha, north of Lisbon, and their production of elaborately decorated pottery, figurines and tiles began in 1884. His talent as a caricaturist is revealed in the tiles he made for the tobacconist shop Tabacaria Mónaco, Rossio Square, Lisbon, in 1894. Slender vertical panels on either side of the narrow doorway flank humorous scenes of storks and cigar smoking frogs painted in blue. Inside the shop more painted decorations on the same subject can be found.

However, painted tiles were a rarity and Pinheiro's main output was polychrome relief tiles which fall into two basic categories. First there are those that show the influence of Hispano-Moresque tiles, many of them first made between 1884 and 1889. Here Pinheiro looked back in history and across the border to Spain for his inspiration. The second category produced between 1889 and 1905 is more original and shows the influence of Art Nouveau. The turning point may well have been Pinheiro's participation in the 1889 World Fair in Paris. Here he not only exhibited some of his wares, but he must also have seen the art pottery and tiles of other European and American ceramic manufacturers which by then were beginning to show the early stirrings of Art Nouveau. The tiles of Pinheiro's second phase show popular Art Nouveau subjects such as frogs sitting on the leaves of waterlilies, and insects such as butterflies and grasshoppers in which sinuous lines and colour are cleverly exploited.

Pinheiro's tiles can still be encountered in situ in some locations in Lisbon, for example on the exterior of the garage in Rua Ponte Delgade that has a number of vertical tiled strips between the windows as well as a tiled frieze below the eaves of the roof. There are tiles with Hispano-Moresque as well as Art Nouveau designs. The latter, depicting frogs and baby frogs on lily leaves, are the most charming. The other major example is the bakery in Campo de Ourique, Lisbon, where the interior is covered with tiles showing two butterflies perched on either side of a corn stalk, or a combination of corn stalks, poppies and butterflies. The esteem in which Pinheiro is held is signified by the museum devoted to his life and work situated in the Campo Grande in central Lisbon.

An unexpected piece of extreme extravagance in Lisbon is Count Sacavém's house in Rua do Sacramento à Lapa built between 1897 and 1900 by the architect H. Faria. It is decorated profusely with polychrome architectural ceramics made by the firm Campolide in Lisbon. These amazing decorations are conceived in an eclectic farrago of styles such as Renaissance,

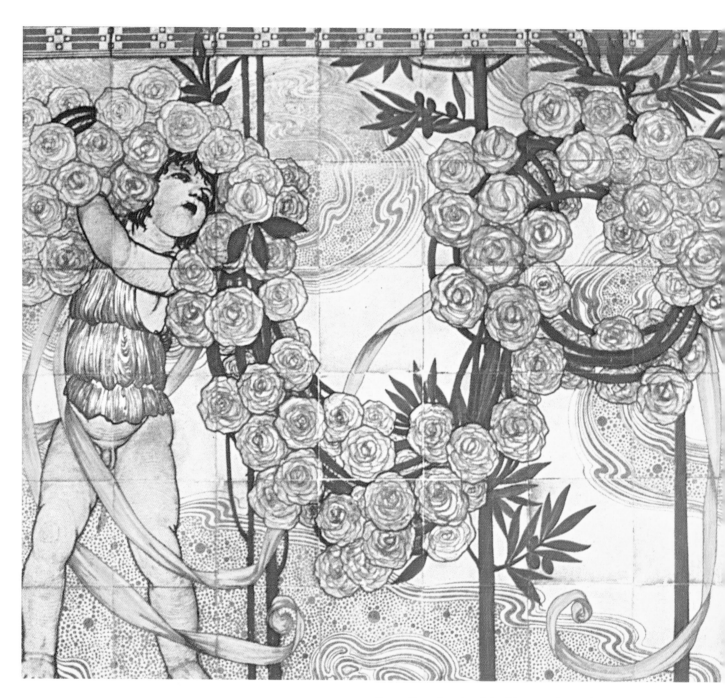

Above: Ornately painted Art Nouveau tile panel designed by the Italian ceramic artist Galileo Chini on a house in Via Gioberti in Milan built between 1910 and 1911.

Right: Detail of a door with Italian Art Nouveau tiles at a villa on the shores of Lake Maggiore, early twentieth century.

Manueline, Rococo and Art Nouveau. All the windows are covered with fantastic and grotesque heads, dolphins, dragons, leaves, fruit and flowers. Among the striking features on the ground floor are the ceramic dragons curling themselves around circular windows with their long tails ending in whiplash curves reminiscent of Art Nouveau. Although this is an idiosyncratic one off, these colourful architectural ceramic decorations were in keeping with the then growing European trend of polychrome ceramic facades.

ITALY

In Italy the Art Nouveau style manifested itself quite late because the country had always felt the weight of history more than its European neighbours. Even at the turn of the century Italy was still better known for its Roman antiquities and Renaissance art treasures than its contemporary architecture or industrial design – a fact that was bemoaned so strongly by the poet Marinetti in his famous manifesto of Futurism in 1909. The emergence of Art Nouveau in Italy was therefore an important attempt to break with the historical styles of the past.

The Italians referred to the Art Nouveau phenomenon as 'Stile Floreale' or

'Stile Liberty'. The latter name signifies the strong influence of English design which had been introduced into Italy via Liberty's of London whose progressive looking products were very much in vogue at that time. Italy lagged behind in the field of contemporary design, but an important boost to its efforts to catch up was provided by the First International Exposition of Modern Decorative Art held in Turin in 1902. This exhibition was the last great showcase for European Art Nouveau. France, Belgium, Holland, Germany, Hungary, England and Scotland were all represented, as countries that had already made important contributions to the movement.

One of the Italian buildings at the Turin Exhibition was Palazzina Lauro financed by the businessman Agostino Lauro and designed by the architect Giuseppe Velati-Bellini. Their aim was to create a unified architectural statement in the Italian equivalent of Art Nouveau. Ceramic tiles were part of the scheme, employed to add colour to the exterior. Tiles with floral decorations were used around the windows and a tile panel at the top of the facade showed two cockerels surrounded by poppies and ears of corn. The house attracted a lot of critical comment but the efforts made by Lauro and Velati-Bellini were sufficient for them to be awarded a gold medal.

The ceramic artist Galileo Chini (1873-1956) became of one of the principal exponents of Italian Art Nouveau tiles and pottery. In 1896 he was a co-founder of Arte della Ceramica in Florence where he became artistic director. In 1907 his firm amalgamated with the ceramics factory of Chini & Co. in Florence, which was owned by a member of his family, and moved to Borgo San Lorenzo where they set up under the name Fornaci di San Lorenzo. Tile designs by Chini vary from naturalistic floral relief tiles and semi-abstract stencilled floral patterns to exuberantly hand-painted figurative Art Nouveau panels.

Some fine examples of Art Nouveau tiling can still be seen on buildings in Milan, Florence and Viareggio. In Milan striking Art Nouveau panels depicting men and women decorate a large apartment block by the architect Giovan Battista Bossi at 3 Via Malpighi, built between 1902 and 1905. In Florence, Galileo Chini made the tiles for a large villa in Viale Michelangelo designed by the architect Giovanni Michelazzi in 1904. Late Art Nouveau tile work of a more restrained kind can be found in the seaside resort Viareggio. This town was developed at the beginning of the twentieth century as a leisure and spa resort for the *nouveaux riches* living in the expanding industrial towns of northern Italy. Cafés, hotels, cinemas and seaside villas were built to accommodate the growing tourist trade. An outstanding building in the town is Villa Argentina, 400 Via Fratti, built around 1910. Tile panels showing cupids carrying baskets of fruit on their heads decorate the entire length of the upper facade. The areas in between the cupid panels are filled with checkerboard patterns of dark and light tiles, strictly geometrical layouts that reveal the early stirrings of Art Deco.

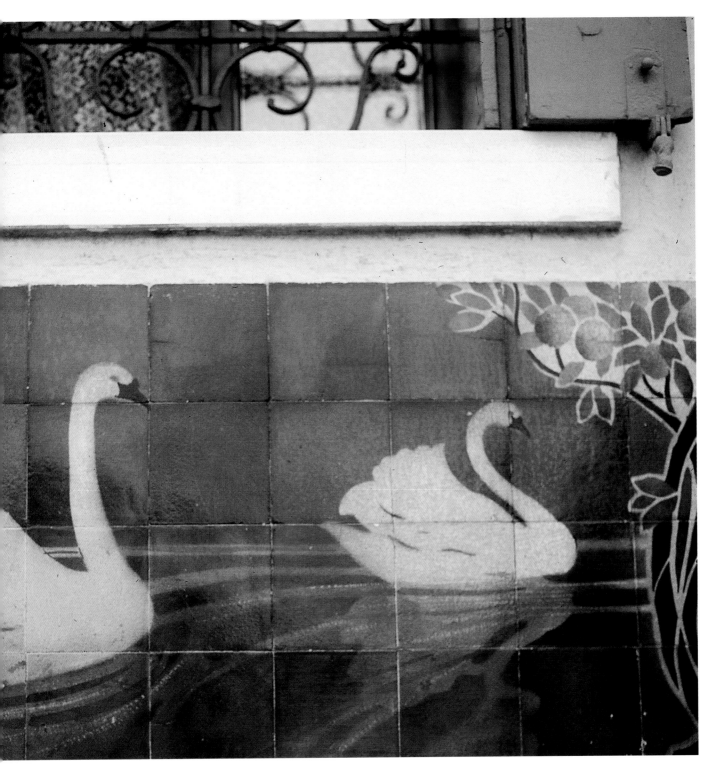

*Italian Art Nouveau tile panel with swans designed
by Arturo Martini and made by Ceramica Gregori, early
twentieth century.*

NEW WORLD EXPERIMENTS

DURING the first three quarters of the nineteenth century, the United States were dependent on the import of British tiles, but after 1870 they began to manufacture their own. Initially the industry relied on the skills of European immigrants from Britain and Germany, adopting mass production techniques such as the dust pressing process. This type of work can be seen in the output of firms like the American Encaustic Tiling Co., Low Art Tile Works and the Trent Tile Co. By the turn of the century some highly individual tile makers and manufacturers had come on the scene, for example Mercer, Batchelder, Grueby and Pewabic, who began to produce handmade tiles with matt glazes in the spirit of the American Arts and Crafts tradition. The impact of Art Nouveau was therefore less noticeable in America than in Europe, but it was nevertheless evident in the production of a few firms like Rookwood and Van Briggle and in the terracotta decorations of the architect Louis Sullivan. Early twentieth century American architects and tile makers showed an entrepreneurial spirit and a flair for individual experimentation. These endeavours resulted in buildings with faience tiles and terracotta decorations with their own unique character, many of which can still be seen in cities like New York.

THE RISE OF THE AMERICAN TILE INDUSTRY

E.A. Barber in his book *The Pottery and Porcelain of the United States* published in 1893 relates, 'It is a remarkable fact that, while the art of tile making in this country is practically not more than fifteen years old, the United States to-day excels the world in the manufacture of relief figure tiles and tile panels. True it is that we have had the benefit of the skill and knowledge of some of the foremost modellers of Europe, who have come to our shores, but we have also developed a number of American sculptors, whose work, in this direction, has fully equalled the best that has yet been accomplished.'

It remains a remarkable feat that the nineteenth century American tile industry managed to assert itself so quickly in competition with the major English manufacturers who had dominated the American market during the first three quarters of the nineteenth century. The legacy of English tiles by such firms as Minton & Co. and Maw & Co. can still be seen throughout the

Art Nouveau newel post at the bottom of the staircase in the New Amsterdam Theatre, New York, designed by the Norwegian architect Thorbjorn Bassoe and made by the Perth Amboy Terra Cotta Co. of New Jersey in 1902-3.

larger towns of the East Coast. The enormous Minton floor in the Capitol in Washington laid between 1856 and 1859, the beautiful Minton floor tiles in the entrance of Litchfield Mansion, Brooklyn, built in 1855, and the Maw tiles in the outer lobby of the apartment block The Gramercy, Gramercy Park, Manhattan, dating from 1883, are cases in point.

The Philadelphia Centennial Exhibition of 1876 is regarded by many as a turning point for the American tile industry. It came in the aftermath of the Civil War, which had ended in 1865, and within the 12 year Period of Reconstruction that followed it. The exhibition was visited by more than ten million people and in the Women's Pavilion visitors were introduced to fashionable ideas on how to decorate the home. There is no doubt that this helped to create a new interest in domestic interior decoration. It also coincided with the growth of the Aesthetic Movement in America which encouraged 'good taste' in the home, of which tiles were a part. Already in 1868 the Englishman Charles Eastlake had published his influential *Hints on Household Taste* which became very popular in America where no less than 12 editions were published between 1872 and 1886. He considered tiles for use in the home 'a means of decoration which, for beauty of effect, durability, and cheapness, has scarcely a parallel.' In a similar vein, the American writer on fashion and taste, Clarence Cook, published *The House Beautiful* in 1878. It is illustrated with a frontispiece by the English artist Walter Crane that shows a woman pouring tea in a tastefully decorated room. The large fireplace has blue-and-white tiles that match the oriental porcelain on the mantelpiece. To reinforce the Aesthetic message, Oscar Wilde began a lecture tour of America in 1882 to extol the pursuit of beauty. All this created an interest in decorative art, to the extent that a Tile Club was formed in New York in 1877 which existed until 1887. A group of 12 artists, including Winslow Homer, began to meet weekly on Wednesday nights to paint on 20 centimetre (eight inch) white tiles. Clearly, fine artists took tiles seriously as an aesthetic medium and so helped to promote a taste for tiles.

The Philadelphia Centennial Exhibition also made clear to any would-be entrepreneur that there was a serious lack of suitable home-produced tiles and hence considerable scope for American expansion in this field. In this way the Exhibition may have acted as a catalyst for the boom in American tile making during the last quarter of the nineteenth century.

One of the first great pioneering firms was the American Encaustic Tiling Co. set up by Benedict Fischer and George R. Lansing in Zanesville, Ohio, in 1875. After tentative beginnings under the direction of the general manager George A. Stanberry, large scale commercial production took off in the early 1880s and the firm became one of the major producers of encaustic floor tiles and dust pressed wall tiles in America. Initially it depended on the skills of German ceramicists like Herman Mueller and the glaze chemist Karl Langenbeck. They helped to establish one of the specialities of the firm, dust pressed relief tiles decorated in translucent glazes with classical figures and portraits, as well as naturalistic animal and floral designs.

In 1892 the American Encaustic Tiling Co. built a completely new factory in Zanesville to expand production. To commemorate this event a special dedication tile designed by Herman Mueller was brought out showing the head of a girl amid swirling ribbons. At the beginning of the twentieth century

Right, top: Relief tile with translucent glazes depicting an owl by American Encaustic Tiling, around 1890.

Right, bottom: American Encaustic Tiling dedication tile designed by Herman Mueller to celebrate the opening of the new factory at Zanesville, in 1892.

Far right: Relief moulded tile panel with translucent glazes depicting a rose made by Chelsea Keramic Art Works, Chelsea, Massachusetts, around 1885.

dust pressed and slip-trailed tiles were produced in abstract floral designs with the sinuous lines so characteristic of Art Nouveau. However, this was only one element among the multifarious output of the company, which continued production until 1935.

One of the most interesting companies amongst the larger firms was Low Art Tile Works of Chelsea, Massachusetts. The firm was set up in 1877 by John Gardner Low (1835-1907) with his father John Low, who provided some of the capital. Their early tiles were marked with the back stamp *J. & J.G. Low Patent Art Tile Works*. The artistically gifted John Gardner Low had spent some time studying painting and drawing in the studios of Thomas Couture and Constantine Troyon in Paris between 1858 and 1861. On his return he became an apprentice at the Chelsea Keramic Art Works where he was able to observe the decoration of vases with imprints of natural flowers. The Philadelphia Centennial Exhibition of 1876 opened his eyes to tiles and the following year he began his first experiments in the production of what he was to call 'natural tiles'.

Instead of copying existing figures or ornament he began to imprint natural objects such as leaves and grasses straight into the clay. In an interview

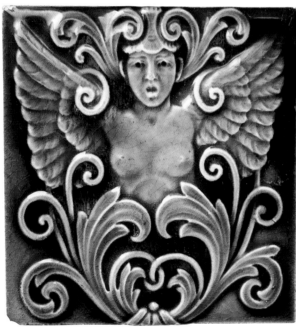

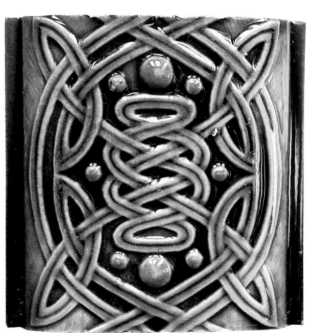

Above: A 'natural process' tile made at the Low Art Tile Works, Chelsea, Massachusetts, around 1880.

Opposite, top left: Relief moulded tile with translucent glazes and a girl's head, by Trent Tile, Trenton, New Jersey, around 1890.

Opposite, top right: Relief moulded tile with a monochrome translucent glaze showing a papyrus motif made by Low Art Tile Works, Chelsea, Massachusetts, around 1885.

Opposite, bottom left: Relief moulded tile with monochrome translucent glazes and a sphinx like creature, by Trent Tile, Trenton, New Jersey, around 1890.

Opposite, bottom right: Relief moulded tile with monochrome translucent glazes and a Celtic interlace design by Low Art Tile Works, Chelsea, Massachusetts, around 1885.

printed in the *Century Magazine* in April 1883 he said, 'It occurred to me that it might be possible to stamp a figure or a letter, or indeed, any form whatever, upon the face of the tile, just as the manufacturer's name is stamped on the back…. I naturally thought of leaves as the material nearest at hand, and rushing out of the shop, down behind there, towards the brickyard, I found a mullein leaf. I hurried back, put the dust in the press, flattened it down by light pressure of the screw, then laying on the leaf, gave the screw a hard turn. I pressed the juice all out of the leaf, but I got my imprint perfectly.' This account gives an idea of the excitement of the early experiments which initiated Low into the art of tile making.

By 1879 commercial production began and Low's tiles won a Silver Medal at the Cincinnati Industrial Exposition. The greatest glory however came the following year when Low entered an exhibition of English and American tiles at Crewe, near Stoke-on-Trent, England, which opened on 2 September 1880. After the judging, the firm received a cablegram saying: 'Low won Gold Medal'. This upstaging of the English tile industry was recalled in 1895 by the American C.T. Davis in his book *A Practical Treatise on the Manufacture of Brick, Tiles and Terra-cotta*: 'The development of tile making in the United States has been the most remarkable instance of rapid progress of an industry in any country or age, and our tile makers may be relied upon to hold the place they have gained against all the competition of Europe.'

Low Art Tile Works produced a considerable range of mainly dust pressed tiles, intended not only for fireplace surrounds, stoves, walls, ceilings and furniture panels, but also for soda fountains. They were marketed as 'Art Tiles', a term that clearly indicated that they were not merely functional products but were also meant to serve a higher aesthetic purpose. Much of Low's success in this field was due to his employment of a talented designer from the 'old country', Arthur Osborne, who had studied at South Kensington School of Art in London. He may have met Owen Jones there and certainly knew his book *The Grammar of Ornament*, judging by the Low tiles that show Persian, Moorish, Egyptian and Celtic patterns. The firm stopped making tiles in 1902 and went into liquidation in 1907.

The Trent Tile Co., in Trenton, New Jersey, was established in 1882 and by the beginning of the twentieth century had become a large company employing over 300 workers. The firm produced a standard range of dust pressed embossed tiles, many of them by their in-house artists William Wood Gallimore and Isaac Broome. They were beautifully decorated with plant and flower designs that showed a distinct feel for the organic and sinuous forms of nature. It was a firm that was willing to move with changing fashions in taste. After 1900 they began to produce tiles with matt glazes echoing the trend then established by Arts and Crafts ceramicists like William H. Grueby and Ernest Batchelder. A magazine of 1906, *The Craftsman*, shows various Trent Tile Co. advertizements for such things as faience mantels in Della Robbia glazes. They claimed these were 'obtained by having the modelled or embossed parts in dull glazes that have all the advantage of brilliant glazes as regards colour, yet they possess a charm of their own in the soft sheen of their surface.' In the February 1907 issue of *The Craftsman* is a large advertizement under the heading 'L'Art Nouveau Fire Place'. It shows a metal grate with Art Nouveau decorations and plain matt Trent tiles on either side, which

according to the advertizement 'are in exact accord with the movement mentioned above'.

Other tile firms of interest at that time were the Mosaic Tile Co. in Zanesville, Ohio, founded in 1894 by Karl Langenbeck and Herman Mueller who had both previously worked at the American Encaustic Tiling Co. They produced a large range of tiles in various styles, including some reminiscent of the Art Nouveau style.

Although some of the larger firms like the American Encaustic Tiling Co. and the Trent Tile Co. attempted to adopt the new American Arts and Crafts manner that began to emerge at the turn of the century, they could not deliver the real handmade product. With their large workforce and dust pressing machinery they were geared up for mass production and could not switch to hand manufacture. It fell to tile makers like Henry Chapman Mercer, Ernest Batchelder and William H. Grueby, and to firms like Rookwood, Pewabic and Van Briggle, to show what was possible in the field of American Arts and Crafts and Art Nouveau tiles.

ARTS AND CRAFTS AND ART NOUVEAU EXPERIMENTS

Towards the end of the nineteenth century the taste for dust pressed art tiles with modelled relief decorations and translucent glazes gave way to a different fashion trend under the influence of the Arts and Crafts Movement and French Art Nouveau. The essence of English Arts and Crafts ideals had already been transmitted to America during the last quarter of the nineteenth century by the writings of Ruskin and Morris and through visits by Arts and Crafts designers like Christopher Dresser, Walter Crane and C.R. Ashbee. There were strong responses to this in America as can be seen in the activities of the craftsman Gustav Stickley in Syracuse near New York. Stickley had made a trip to Europe in 1898, where he had met C.F.A. Voysey in London and Siegfried Bing in Paris. On his return he began publication of a magazine called *The Craftsman* of which the first issue came out in 1901. Early editions of the magazine paid homage to the work and ideas of Morris and Ruskin and in 1903 Stickley published an article by Bing on Art Nouveau. Siegfried Bing had already shown a lively interest in American design during his visit in 1894, when he saw the workshops of Louis Comfort Tiffany in New York and the Rookwood Pottery in Cincinnati. Also in Syracuse lived Adelaide Alsop Robineau, a ceramicist who in 1899 launched a magazine for the pottery trade called *Keramic Studio*. Apart from articles by ceramic artists like Charles Volkmar, Frederick H. Rhead and the French ceramicist Taxile Daot, she also published numerous designs of which many lean distinctly towards the Art Nouveau style.

The man to give American Arts and Crafts tiles their proper foundation was Henry Chapman Mercer (1856-1930). He was an educated gentleman of independent means with a professional interest in archaeology and anthropology who lived in Doylestown near Philadelphia. He had travelled extensively in Europe and South America to look at art and culture, the influence of which can be seen in his tiles. His interest in ceramic manufacture was aroused when he began collecting tools used by Pennsylvanian settlers,

Above: A line incised tile depicting a goose girl made by Henry Chapman Mercer, Moravian Pottery and Tile Works, Doylestown, Pennsylvania, on the exterior of a house at 141 East 19th Street, New York, around 1909.

Opposite: Fireplace with mosaic tiles representing St George and the Dragon, made by the Arts and Crafts tile maker Henry Chapman Mercer, Moravian Pottery and Tile Works, Doylestown, Pennsylvania, for a private residence in Syracuse, NY, installed in 1913.

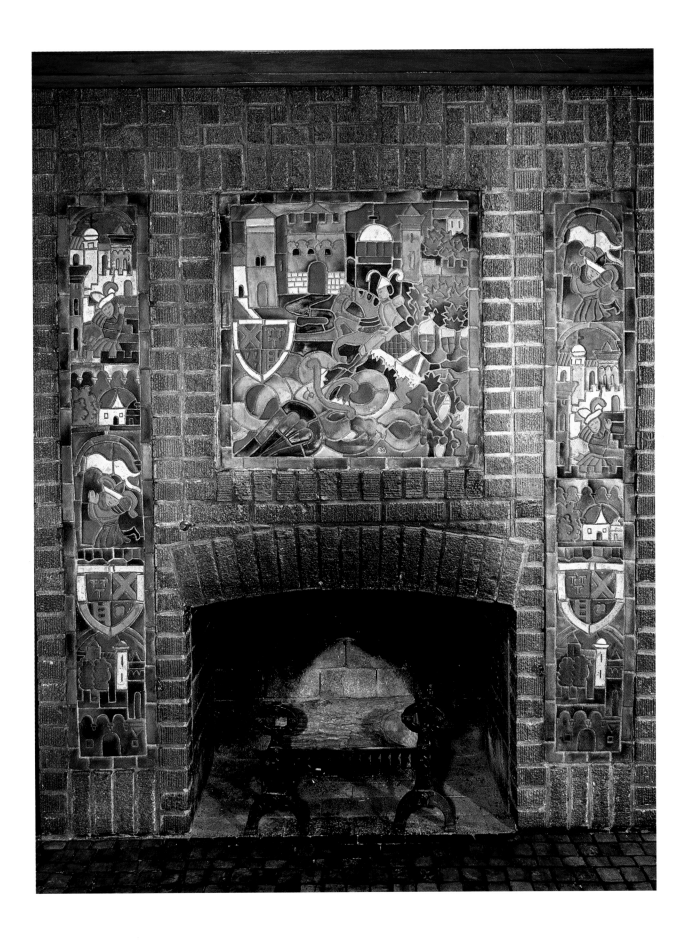

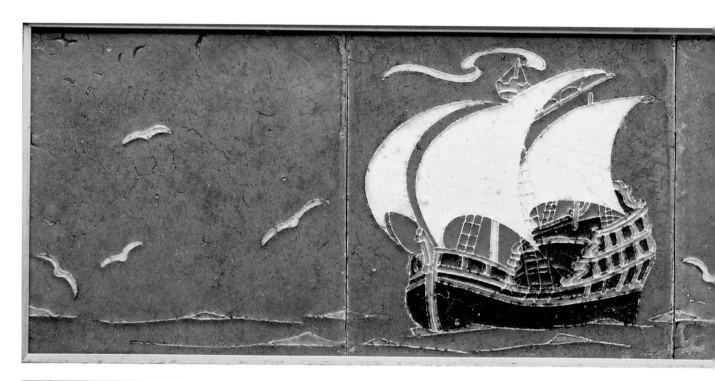

Top: Three ceramic tiles decorated with matt glazes depicting a ship with billowing sails made by Grueby Faience, South Boston, Massachusetts, around 1908, possibly by Addison B. LeBoutillier who designed many Grueby tiles after 1901.

Left: Mosaic brocade tiles with Biblical scenes in the sanctuary of Salem Church, Doylestown, Pennsylvania, donated as gift by Henry Chapman Mercer, Moravian Pottery and Tile Works, in 1928.

which to him illustrated the history of pre-industrial technology in America. In his searches he came across a disused pottery, which made him study more closely the manufacturing processes of pottery and tiles. He began to experiment with tile making during the years 1897-8, using local red clays, and after sufficient experimentation he felt confident enough to set up his own business under the name Moravian Pottery and Tile Works. Between 1908 and 1912 he constructed a purpose built pottery on a new site in Doylestown and next to it he built his own residence called Fonthill.

Mercer produced three types of handmade tiles: plain and moulded relief tiles, mosaic tiles, and brocade tiles. His plain tiles were cut from slabs of plastic clay and often used in combination with moulded relief tiles. The latter were hand pressed in moulds and coloured with slips and glazes. Mosaic tiles were composed of flat shapes of different sizes - not unlike stained glass - which after colouring and firing were assembled to make up a picture. The spaces between the variously cut pieces were filled with cement to create contour lines. The brocade tiles were three dimensionally modelled, individual units of such things as figures, animals, trees, letters, which were assembled into larger compositions and embedded in concrete. Mercer's own house, Fonthill, was a showcase for his tiles. The plain exterior belies the extraordinary interior, where every wall and ceiling is covered with various kinds of Mercer tiles with scenes drawn from medieval sources, the Four Seasons or the Bible. One of the most intriguing installations is the Columbus Room where the ceiling is covered with brocade tiles that depict the discovery of America.

It is difficult to categorize Mercer's tiles. They certainly do not fit the stylish conception of Art Nouveau. Instead there is a strong homespun and vernacular feel to his work which is unlike anything else done at that time. His creations are certainly original and must rank among the great tile experiments of the New World. Mercer also exercised considerable influence on other American Arts and Crafts tile makers such as Grueby, Batchelder and Pewabic.

William Henry Grueby (1867-1925) was a very different man from Mercer. If Mercer was a Harvard trained gentleman archaeologist turned tile maker then Grueby had come up through the ranks in the tile business with little formal education. He learned his trade at Low Art Tile Works but eventually became dissatisfied with the many machine made, dust pressed tiles with monochrome glossy glazes that he helped to produce. In 1894 he set up the Grueby Faience Co. in Boston and began to experiment in making tiles in a pseudo Chinese or Moorish style, some of which were exhibited at the Arts and Crafts Exhibition in Boston 1897. He also studied closely the tiles made by Mercer and it is a well known fact that in 1902 he ordered a batch of Mercer tiles for this purpose. Grueby tiles were made from plastic clay with hand pressed moulded designs which could be glazed or have their indentations filled with matt glazes. Tiles and panels with matt glazes were produced for the New York underground stations and for the waiting room of the D.L. & W. railway station in Scranton, Pennsylvania. The development of matt glazes, particularly matt green, for use on tiles and pottery is one of Grueby's great contributions to the history of American ceramics, one which won him acclaim not only in the States but also in Europe where Siegfried Bing in Paris was among his admirers.

The second important Arts and Crafts tile maker to take his cue from Mercer was Ernest Allan Batchelder (1875-1957). He was a trained art teacher

Above: A pair of troubadour tiles made by Batchelder Tile, Los Angeles, around 1920.

Opposite: Tile with two rabbits made by Rookwood Pottery, Cincinnati, Ohio, in 1911. Shown larger than actual size (15 x 15 cm, 6 x 6 ins).

who taught at the Throop Polytechnic Institute in Pasadena on the West Coast. It seems he employed Mercer tiles as teaching aids in the classroom and used some of them in his own house. This may have been the spur to try his own hand at tile making and his first tiles were produced in the studio behind his home in 1910. In 1912 he went into partnership with Frederick L. Brown and set up a small factory at South Broadway in Pasadena. In one of their early catalogues they set out their adherence to Arts and Crafts principles when they say: 'Our tiles are hand wrought, by processes peculiar to our own factory. They have slight variations of shape and size – just sufficient to relieve the monotony of machine pressed tiles.' The tiles were made from local clays, relief pressed by hand and decorated with mute coloured slips in tune with the vogue for tiles with matt surface decorations. They showed animals, birds and fruit, the Californian landscape or scenes from the American West. In 1920 the business was expanded and moved to Los Angeles.

Arts and Crafts potteries were not only active on the East Coast, the West Coast and in the south. Up in the far north in Detroit the Pewabic Pottery was set up by Horace J. Caulkins and Mary Chase Perry in 1903. Caulkins was a clay specialist and Perry an expert in glazes. They produced both tiles and pottery and their products soon gained national recognition for the quality of the clay bodies and matt glazes. They also developed unique iridescent and lustre glaze formulas. Tiles with such glazes, installed in 1910, are still to be found on the floors of the sanctuary of St Paul's Episcopal Cathedral in Detroit. Another unusual Arts and Crafts tile installation by Perry can be seen on the ground floor of the Detroit Public Library, in the form of a fireplace with ten, line incised handmade tiles depicting children's fairy tales made between 1918 and 1921.

The Art Nouveau style that had such a great impact on European tile design caused fewer reverberations in America. Perhaps in a young country like America there was less need for a new style. If anything Americans needed to keep their links with their European roots and hence the past, which may explain their preference for Arts and Crafts ideals rather than Art Nouveau. However, there were a few firms such as Rookwood and Van Briggle that show the influence of Art Nouveau in the tiles they made shortly after the turn of the century. Of these two firms the Rookwood Pottery in Cincinnati, Ohio, was the most important. It was founded by Maria Longworth Nichols in 1880 with financial support from her father Joseph Longworth. Between 1880 and 1900 they made high quality vases and bowls which became famous throughout America and Europe. Their fine underglaze hand painted pottery with exquisite floral designs attracted the attention of Siegfried Bing who visited Rookwood during his trip to America in 1894 and sold their ware in his shop in Paris.

Rookwood architectural faience and tiles were not made until 1902, when William Watts Taylor who was the company's business manager established the architectural and faience department. The tiles and faience products were painted with matt glazes which the firm had developed a few years earlier for their pottery; such was their success with these glazes that they had captured the Grand Prix at the World Fair International Exposition in Paris in 1900. An important early commission was the decoration of Fulton and Wall Street underground stations in New York in 1905. A promotional catalogue of 1907

Right: Panel of six tiles showing trees in a landscape made by Van Briggle Pottery in Colorado Springs, Colorado, around 1908.

Bottom, right: Fireplace with Rookwood Pottery Art Nouveau tiles depicting swans, in a house in Seattle which was originally a private residence built for John and Eliza Leary by the English architect Alfred Bodley, constructed between 1903 and 1905.

Opposite: Detail of a fireplace with line incised tiles showing children's fairy tales in the Detroit Public Library, made at the Pewabic Pottery, Detroit, by Mary Chase Perry between 1918 and 1921.

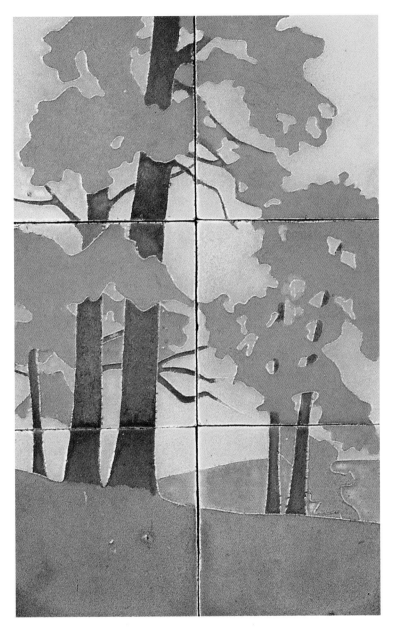

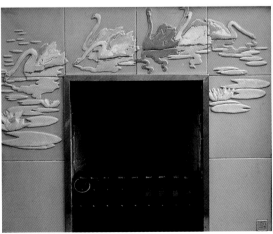

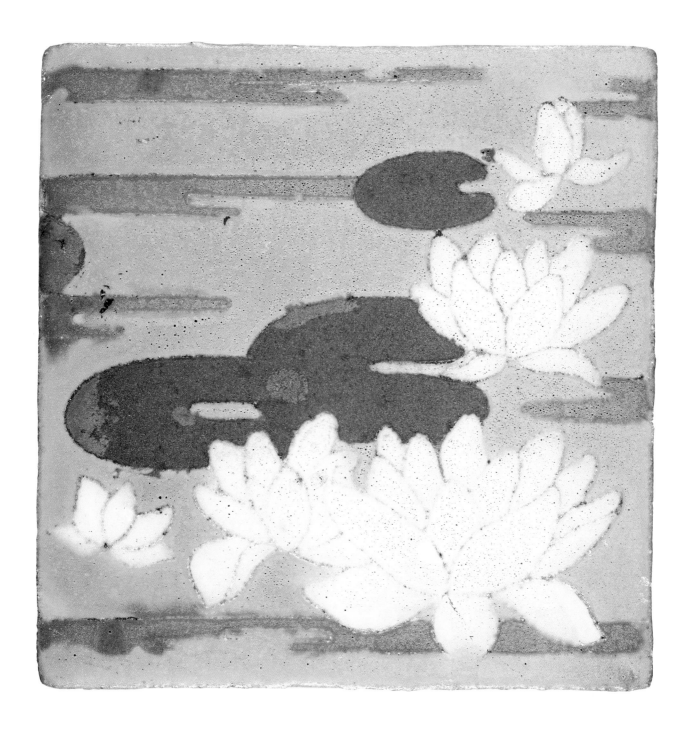

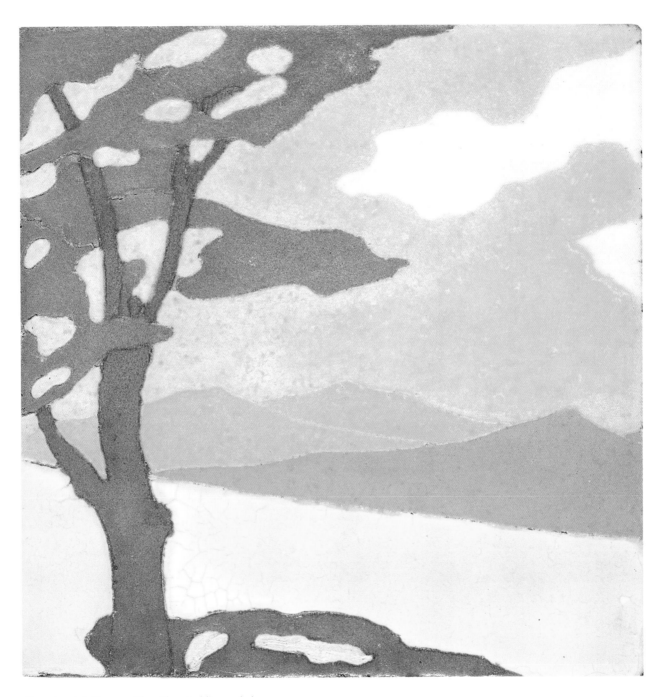

Opposite: Art Nouveau tile with waterlilies made by
Van Briggle Pottery in Colorado Springs, Colorado,
around 1908.

Above: Art Nouveau tile with a tree set against a
lake made by Van Briggle Pottery in Colorado Springs,
Colorado, around 1908.

shows Rookwood tiles with flowers, plants, birds and landscapes with the sinuous lines characteristic of the Art Nouveau style.

Another company that produced Art Nouveau tiles was Van Briggle. The firm was founded by Artus van Briggle (1869-1904) who had worked for Rookwood between 1887 and 1899. During his years at Rookwood he was given the opportunity to study for some time in Paris at the Julienne Art School. His poor health made him move to Colorado Springs where he established his own pottery. Like so many others at that time he developed matt glazes, which were ready for commercial use in 1901. He died young of tuberculosis in 1904 and the pottery was continued by his wife Anne. It was under her direction that the first Van Briggle tiles were made in 1906. The production focused on panels rather than individual tiles and shows delicate compositions of floral motifs, landscape elements and birds executed as relief tiles painted with matt glazes. Anne van Briggle made the many beautiful Art Nouveau tiles and panels that still adorn the Van Briggle Pottery built in 1907 in memory of her husband.

Also worth a mention is the J.B. Owens Pottery Co., founded in Zanesville, Ohio in 1891. Between 1909 and 1923 they traded as J.B. Owens Floor & Wall Tile Co., producing some interesting faience tiles with highly stylized flat organic designs decorated with matt glazes.

TILE AND TERRACOTTA APPLICATIONS IN NEW YORK

W. Zelinsky in his book *The Cultural Geography of the United States*, published in 1973, attempts to identify the factors that led to a distinct American identity. One aspect of this identity according to Zelinsky is 'an irresistible urge to achieve - and proclaim - the quantifiable superlative - the biggest, highest, costliest, loudest or fastest - frequently without any dollar and cents justification.' In many ways the American skyscraper and apartment building, as well as the subway systems, can be regarded as major symbols of this attitude, which manifested itself on a large scale in New York from the late nineteenth century onwards. The city's geographical situation as one of the main points of entry for European immigrants, its rise as the cultural and commercial centre of America, and its many artistic links with Europe helped to shape a rich architectural legacy in which tiles and terracotta feature prominently.

Susan Tunick in her *Terra Cotta - Don't Take It For Granite* remarked, 'The largest and most spectacular collection of terracotta structures anywhere in the United States can be found in New York City.' It is beyond question that New York is still remarkably rich in diverse tile and terracotta installations by many prominent American tile makers, terracotta manufacturers and architects. Even the great architect Louis Sullivan (1856-1924), who normally worked in places such as Chicago, St Louis and Buffalo, created one of his finest terracotta decorated office blocks, the Bayard Building, in New York.

Sullivan was one of the first architects to passionately believe in the use of terracotta ornament. It is his highly individual and idiosyncratic use of terracotta decoration, which often covers the whole exterior of his buildings with sinuous organic forms, that links him to Art Nouveau. This ornamentation

Opposite: Art Nouveau tile with sinuous lines depicting trees in a landscape, made by J.B. Owens Pottery, Zanesville, Ohio, around 1910.

was carefully designed to suit the character and needs of each building, a point that is emphasized in his *Ornament in Architecture* published in 1892:

> It follows then, by the logic of growth, that a certain kind of ornament should appear on a certain kind of structure, just as a certain kind of leaf must appear on a certain tree. An elm leaf would "not look well" on a pine tree - a pine-needle seems more "in keeping". So, an ornament or scheme of organic decoration befitting a structure composed on broad and massive lines would not be in sympathy with a delicate and dainty one. Nor should the ornamental systems of buildings of any various sorts be interchangeable as between these buildings. For buildings should possess an individuality as marked as that which exists between men, making them distinctly separable from each other, however strong the racial or family resemblance may be.

His approach to ornamentation can best be seen on the facade of the Bayard Building, constructed in 1897-8 on Bleecker Street, New York and decorated with terracotta by the Perth Amboy Terra Cotta Co. On the ground level there is a richly decorated entrance while the facade is characterized by tall vertical mullions with very slim subsidiary mullions in between. These vertical mullions subdue the horizontal bands with terracotta decorations between the windows and make the building appear taller than it is. The real glory is at the top of the building, where the plain mullions terminate in ornate vegetation-like capitals which were richly sculpted and undercut when the clay was still soft. Below the projecting cornice, between the spandrels of the bays, are terracotta angels with outstretched arm and wings set amid a rich background of curvilinear tendril-like foliage. However, the intricate ornamentation does not in any way detract from the form of the exterior but has been used to enhance and enrich the overall shape of the building, giving it its own individual aesthetic identity.

Sullivan's unique contribution to American Art Nouveau terracotta decoration is summed up concisely by M. Stratton in *The Terracotta Revival* published in 1993: 'Sullivan spurned Renaissance forms as having been developed for the European aristocracy. Instead he elevated nature and organic forms as representing freedom, individuality and moral virtue, and prompting an immediate response from people who were surrounded by drab, soot-laden buildings and divorced from fields, trees and hills.'

Two other architects, the brothers George and Edward Blum, also made a remarkable contribution to the design and decoration of buildings with terracotta ornamentation. Their speciality was apartment houses in New York and their architectural tour-de-force the monumental apartment block The Dallieu, built in 1912-13 in West End Avenue. It is a massive 12 story block with much terracotta ornamentation at the top as well as on ground level. This consists mainly of flowers, fruit, buds and leaves modelled in a strong and bold manner. However the ornamentation is not allowed to run riot but is kept in check by a framework of geometric lines which run over as well as behind the foliage and floral decoration. There seems to be a French influence here, which is not surprising as the Blum brothers were of French extraction and returned to France to study at the Ecole des Beaux-Arts in Paris between 1901 and 1908. There they must have seen buildings by such architects as Guimard,

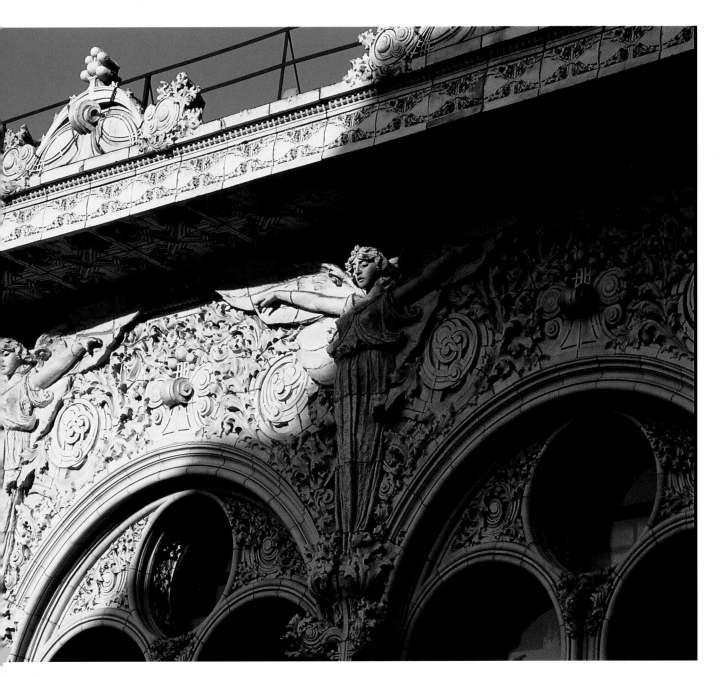

Above: Detail of the top of the Bayard Building in Bleecker Street, New York, by Louis Sullivan, constructed in 1897-8, showing terracotta angels with outstretched wings made by the Perth Amboy Terra Cotta Co. of New Jersey.

Left: Detail of the terracotta decorations made by the Perth Amboy Terra Cotta Co. of New Jersey, on the facade of the Bayard Building, Bleecker Street, New York, designed by Louis Sullivan, 1897-8.

Far left: Detail of the terracotta decorations on The Dallieu, an apartment block in West End Avenue constructed in 1912-13 by the brothers George and Edward Blum.

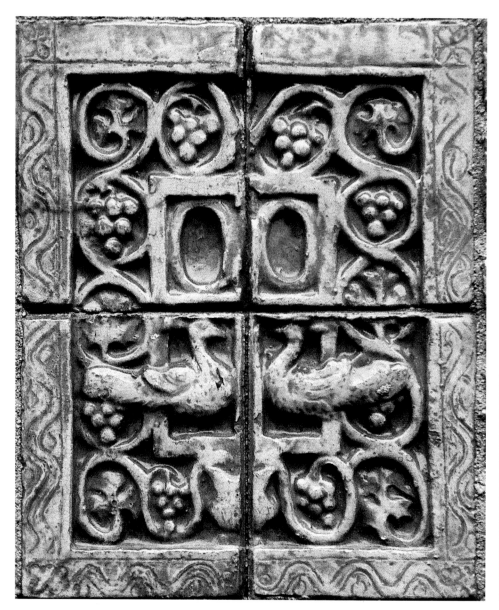

Baudot and Perret as well as buildings decorated with Art Nouveau tiles and faience by such French manufacturers as Bigot.

Apart from terracotta, tiles and faience decorations have also left a rich legacy in New York. Tiles made by the great Arts and Crafts practitioner Henry Chapman Mercer have survived in large as well as small apartment buildings. The architects Blum used Mercer tiles in the large fireplace in the lobby of their Vauxhall apartment in Riverside Drive built in 1914. The tiles are used as insets in the brick fireplace and their glazed surface contrasts nicely with the matt brick and cement work. But Mercer's tiles were also utilized on the exterior. A rather fine example is still extant over the entrance of a house in East 19th Street, where two large *Ravenna Peacock* panels are set above the door among a range of other Mercer tiles.

The well known Rookwood Pottery obtained some important commissions in New York. One of them can still be seen in what used to be the Vanderbilt Hotel, built in 1910-13, where Rookwood supplied faience ornament for what was then known as the Della Robbia Room. Handmade relief moulded tiles with floral ornaments were set within the plain tiled ceilings made by Guastavino, a company that specialized in vaulted tiled ceilings. Their work had earlier been used with great success in the building of the City Hall subway station in 1904.

A rather special and unusual Art Nouveau faience installation can be found in the New Amsterdam Theatre. It has a superb green glazed Art Nouveau ceramic staircase designed by the Norwegian architect Thorbjorn Bassoe and manufactured by the Perth Amboy Terra Cotta Co. in 1902-3. The staircase newel shows the heads of women with long hair emerging from among birds and vegetation. Other sections of the staircase show heads of old men crowned with leaves and with long flowing beards. There are also peacocks set among trees and vegetation. Altogether this is one of the most striking examples of pure Art Nouveau to be found in New York.

Other important examples of early twentieth century American tiles can be found in the many subway stations of the New York underground system. The first phase was started in 1904 under the direction of the architects George L. Heins and Christopher G. La Farge. The first line ran from City Hall in downtown Manhattan to Grand Central Station, and then up north to 96th Street where it divided and ran into the Bronx. About 50 stations were built along the line and in each of them, Heins and La Farge made extensive use of tiles and faience decoration for both functional and aesthetic reasons. They were also used to create a station identity with name panels and pictorial images.

The early stations are the most interesting because they used tiles in a variety of ways. At Bleecker Street, built in 1904, there are prominent white Art Nouveau style letters *B* set against a blue background of swirling tulips in the subway entrances. On the platforms are large tile panels with the full name *Bleecker Street* set within an oval shaped cartouche with ornamental tiled borders made by the Boston firm Grueby. The Grueby Faience Co. also made the well known pictorial plaque showing a beaver at the station Astor Place. The plaques, executed in matt glazes, depict a beaver gnawing through a tree to be used for dam building. On a symbolic level this image of the 'industrious beaver' can also be read as a sign of the hard working industrious Americans who built Manhattan.

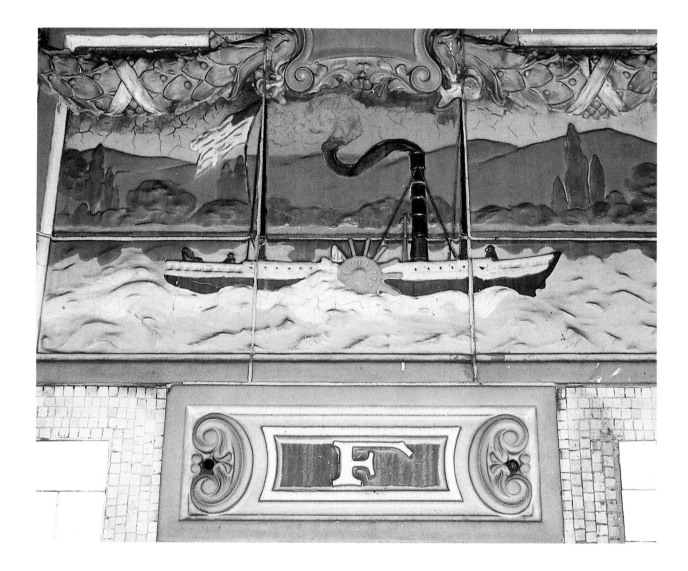

Not only Grueby was involved in the lucrative contracts of supplying tiles for subways. Rookwood, which at one time was better known for its art pottery, supplied pictorial panels for Fulton Street Station and Wall Street Station in 1905. The Fulton Street panels show the early steamship *Clermont*, while the Wall Street plaques depict the wooden wall that used to demarcate the northern edge of the New Amsterdam settlement in the seventeenth century. All the panels are modelled in relief and painted with thick matt glazes.

A second phase of building new lines and subway stations began under the direction of the architect Squire J. Vickers in 1913 and was largely completed by 1920. Although Vickers acknowledged the contributions of Heins and La Farge and their utilization of tiles and faience, he streamlined the decoration of his stations by doing away with large, dust catching relief plaques. The walls in his stations are flat with mainly plain tiles inset with station name panels. The tiles and mosaics were probably made by the New Jersey manufacturer Herman Mueller. This format was repeated uniformly and consistently for each station, of which Canal Street, Chamber Street, Cortlandt Street and Borough Hall are cases in point.

Ceramic panel with matt glazes showing the steamship Clermont, *on the platform of Fulton Street subway station, made by Rookwood Pottery, Cincinnati, Ohio, in 1905.*

Not only American manufacturers obtained major contracts in New York. In one instance the Dutch firm De Porceleyne Fles of Delft was commissioned to make two metre (six foot) high friezes for a number of buildings and pavilions at Seaview Hospital on Staten Island. They were manufactured and installed in the period 1909-11. The hospital had been designed by the American architect Raymond F. Almirall and the tiled friezes were to run along the entire length of the exterior, near the top of the facades and just below the overhanging roofs. The total area to be covered with tiles was in the region of 589 square metres (6,400 square feet). Seaview was a tuberculosis hospital and the friezes show doctors and nurses treating patients against a background of gold glazed tiles decorated with green cockle shells. The tiles and figurative scenes were partly moulded in relief and executed in the colourful matt and glossy glazes that appealed to the American Arts and Crafts taste of that time.

ART NOUVEAU
AND BEYOND

THE First World War is often regarded as the water-shed between Art Nouveau and Art Deco. By 1914 Art Nouveau had run its course and some of the elements that were to characterize Art Deco were already discernible. Whether Art Deco is a continuation of Art Nouveau or a direct opposite to it is still a matter of debate. However it is beyond doubt that the machine aesthetic of contemporary avant garde groups like the Dutch De Stijl, the German Bauhaus and the Russian Constructivists had a considerable influence on the architecture and design of the inter-war period and the emergence of Art Deco. When Art Deco is regarded in that light, it may be seen as a step towards Modernism proper. Tiles were not exempt from this process and Art Deco tiles are often characterized by the use of streamlined figures or bold angular forms instead of the more organic motifs of Art Nouveau which it replaced. There was also a sharp decline in the use of decorative tiles at this time as modern architecture was driven by the dictum 'less is more' and extensive decoration was no longer fashionable. During the inter-war period many factories had to close or merge in order to survive. However since the 1970s there has been a marked revival of past styles including Art Nouveau. This has been particularly noticeable in Britain where re-makes and copies of original Art Nouveau tiles are again being produced in considerable numbers.

Before the advent of the First World War there were already various artistic forces at work, notably Expressionism, Cubism, Futurism and the revival of exotic styles. These movements developed in different directions from Art Nouveau. Cubism experimented with the fragmentation of naturalistic form, Futurism became infatuated with the machine aesthetic, while Expressionism attempted to explore and express inner states of mind. There were also voices advocating a rejection of the excessive ornamentation that had been a major characteristic of so much Art Nouveau design and early twentieth century eclecticism. In 1908 Adolf Loos published an essay *Ornament and Crime* in which he equated the use of ornament with degeneration. He wrote: 'Evolution of culture is equivalent to the removal of ornament from utilitarian objects.' To prove his point he built the Steiner House in Vienna in 1910 marked on the outside by plain stuccoed walls and greatly reduced ornamentation. The drive against excessive ornament also became one of the hallmarks of the newly emerging avant garde groups after the First World War.

Opposite: Belgian Art Deco panel designed by Joseph Roelants showing the goddess Minerva, made by Gilliot & Cie, Hemiksem, around 1935.

T 99/DI

T 16/DI

4 x 4 T 100/DI

T 82/DI

T 54/DI

4 x 4 T 75/DI

T 98/DI

T 97/DI

*Detail of a 1936 tile catalogue by the British
firm Richards Tiles Ltd., with a range of geometric Art
Deco tiles.*

T 123 / D1

T 74 / D2 4 x 4

T 79 / D3 4 x 4

The German Bauhaus, the Dutch De Stijl Group, and the Russian Constructivists all advocated the use of geometric forms and primary colours in architecture and design, a philosophy that was to crystallize by the late 1920s into the International Style with its unadorned glass, stone and concrete surfaces.

Another important event in the history of inter-war design was the emergence of Art Deco. This term is an abbreviation of the French 'Arts Décoratifs' borrowed from the influential *Exposition Internationale des Arts Décoratifs et Industriels Modernes* held in Paris in 1925. However Art Deco as a style phenomenon was in evidence long before the exhibition, which can be regarded as its apotheosis rather than its beginning. This point of view is argued by Alistair Duncan in his book *Art Deco* where he says: 'The First World War has generally been taken as the dividing line between the Art Nouveau and Art Deco eras, but the Art Deco style was actually conceived in the years 1908-12, a period usually considered as transitional. Like its predecessors, it was an evolving style that did not start or stop at any precise moment.'

Art Deco drew on a myriad of different sources such as the inter-penetrating lines and planes of Cubism, the aerodynamics of Futurism, and the geometric forms of Bauhaus design, but it also found inspiration in Classicism, African art, Mayan art and Egyptian art. The latter had become particularly popular in America after the great discovery of Tutankhamun's tomb in 1922. Art Deco can be both highly ornamental or extremely simple and severe. Figurative forms are usually highly stylized and streamlined, while abstract forms are often geometric, bold and colourful. Handwork and craftsmanship were important aspects of Art Deco and although the bulk of inter-war tiles were machine made, the decorative tiles were often executed by hand methods such as tube lining, painting, stencilling and in the case of architectural ceramics, hand moulding and modelling. Generally speaking the inter-war fashion for tiles in architecture was for plain tiles with occasional insets of decorative tiles. Art Deco tiles could show abstract motifs or streamlined figurative designs executed in brightly coloured glazes, sometimes with additional silver or gold lustre, but how this manifested itself differed from country to country.

The changed economic circumstances after the First World War meant that tile manufacturers had to modernize their production processes and sometimes merge with other manufacturers in order to survive. Factories in Britain, Germany, Belgium and France began to feel the growing competition from tile manufacturers in southern and central Europe. The Czech firm Rako in particular was successful in the export of their good quality tiles. Factories in northern Europe tried to put up barriers against under-pricing by the formation of cartels and the international protection of brand names. On 27 and 28 November 1922 a conference was held in Cologne attended by the major German, Belgium and British manufacturers. The participating firms from Britain were H. & R. Johnson, Sherwin & Cotton, Alfred Meakin, Maw & Co. and Pilkington's; from Belgium there were the Manufactures Céramiques d'Hemixem and Gilliot & Fils; and from Germany there were such firms as Boizenburg, Servais Werke, Villeroy & Boch, Wessel, Tonwerk Witterslick and Tonwerk Offstein. These members of the Glazed and Floor Tile

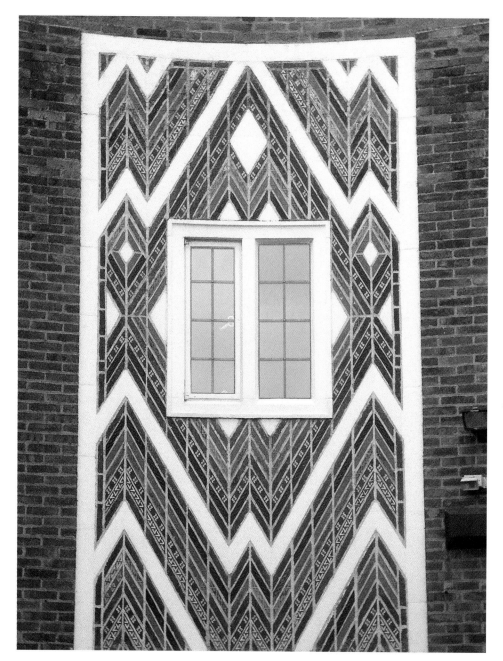

Left: Tiles arranged in zigzag shapes on the facade of the home of the English architect Edgar Wood in Hale near Manchester, built between 1914 and 1916. The strict geometry foreshadows the Art Deco style of the 1920s and 1930s.

Below: Ceramic panel above one of the windows at the St Pancras Housing Association apartment blocks in Euston, London, made by Doulton, with a scene from 'The Goose Girl' designed by the sculptor Gilbert Bayes in 1930.

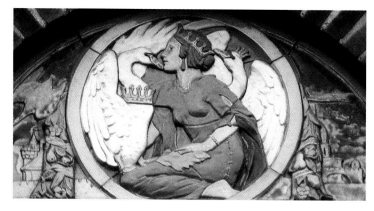

Manufacturers Association agreed on fixed prices for the individual export countries. The German manufacturers maintained that British tiles were most widely preferred and therefore the British tile manufacturers agreed on a surplus of one shilling per 100 tiles as compensation. This agreement stimulated the German export market.

FROM ART NOUVEAU TO ART DECO

In Britain, as in most European countries, the change from Art Nouveau to Art Deco was already in evidence before the First World War. A remarkable architectural example that seems to foreshadow the emergence of Art Deco is the front elevation of Royd House, Hale, near Manchester designed by the architect Edgar Wood between 1914 and 1916. A large area of tiling has been placed above the front door in the centre of the brick facade, its tiles arranged in bold zigzag shapes that anticipate the best of Art Deco tiling. Within the realm of fine art there were the Vorticists who under the direction of Wyndham Lewis created abstract and semi-abstract paintings, prints and sculptures influenced by Cubism. Members from this group became part of the Omega Workshop set up by the art critic Roger Fry in 1913 in London. Here artists like Wyndham Lewis, Vanessa Bell and Duncan Grant were given an opportunity to earn a living by designing and decorating interior furnishings including pottery and tiles. The Omega Workshops were not a commercial success and had to close in 1919 but their expressive and formalistic designs can be seen as a bridge between pre-war Art Nouveau and post-war Modernism. Their pottery and tiles had a particular influence on the products of Carter & Co., with whom they had some commercial dealings.

Carter & Co. of Poole, Dorset, were one of the most prominent firms during the inter-war period. They produced an interesting range of figurative tiles by such artists as Harold Stabler, Dora M. Batty and E.E. Stickland. These consisted of series depicting themes like nursery rhymes and farm animals. They were often hand-painted through stencils, which resulted in a flat and stylized effect in line with the Art Deco fashion for streamlining. Harold Stabler also created a series of relief moulded tiles with decorations symbolic of the City of London for a number of London Underground stations in the 1930s. Other firms like H. & R. Johnson and Maw & Co. produced striking sets of Art Deco tiles in the 1930s with abstract patterns of zigzags, circles and rising-sun motifs executed in bright colours. On a different note, Doulton in London used the services of sculptors like Gilbert Bayes (1872-1953), a contemporary of Jacob Epstein and Eric Gill. During the 1920s and 1930s Bayes designed figurative friezes for Doulton which were made in polychrome stoneware and used in various architectural projects like the St Pancras Housing Association apartment blocks in Euston, London, constructed in 1930. His largest and most famous creation was the frieze for the factory's own Doulton House in London which was completed in 1939 and depicted the history of pottery through the ages. Doulton House was demolished in 1978, but the frieze was rescued and is now on display in the Victoria and Albert Museum.

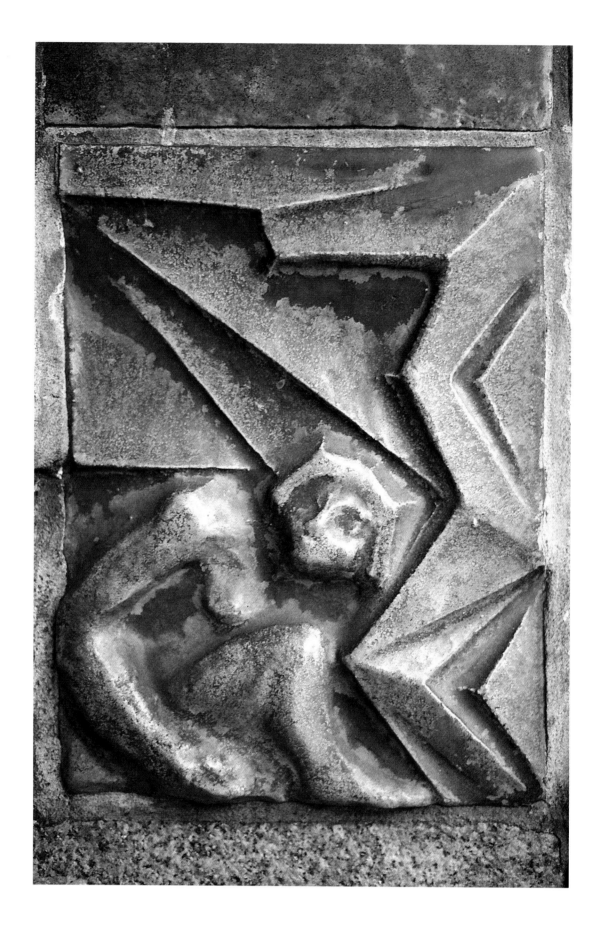

*Above: Colourful cloisonné tile by Westraven of Utrecht
with the heraldic arms of the Dutch town of IJsselstein,
around 1935.*

*Opposite: Detail of the ceramic decoration on the exterior of
the Tuschinski Theatre, Reguliersbreestraat, Amsterdam,
designed by H.L. de Jong between 1918 and 1921. The
faience decorations were made by Plateelbakkerij Delft in
Hilversum. The strong angularity of the fragmented shapes
is reminiscent of German Expressionism and Cubism.*

In Holland inter-war developments took a different direction. One of its special features was the remarkable use of Expressionist architectural ceramics. In Amsterdam there was a specific group of architects known as the Amsterdam School who favoured idiosyncratic form, handwork and ornament in contrast to the universalism and abstraction of the De Stijl group. This found expression in brick buildings of distinct individual quality which were at times decorated with architectural ceramics. Several striking examples of this kind of Expressionist architecture can still be found in Amsterdam. Of particular interest is the marine office building Het Scheepvaarthuis built between 1912 and 1916. The architect J.M. van der Mey was responsible for the expressive sculptural decorations on the building which are mostly in red-brown terracotta made by the ceramic artist Willem Brouwer. Brouwer held lectures for architects in which he promoted the use of unglazed terracotta, which in his opinion harmonized better with traditional brickwork. The other startling example is the Tuschinski Theatre built between 1918 and 1921 according to designs by the architect H.L. de Jong. The facade is covered in brown-grey glazed ceramics made by Plateelbakkerij Delft, Hilversum, with expressive decorations showing the influences of Cubism and German Expressionism. When the facade is seen as a whole it becomes a remarkable early manifestation of Art Deco.

New kinds of picture tiles were also developed by De Porceleyne Fles in Delft and the firm Westraven in Utrecht. Both firms began to market a kind of cloisonné tile during the 1920s and 1930s. In this technique the design is impressed into the soft clay, leaving hollows demarcated by raised edges that help to separate the various coloured glazes. A large range of subject matter was produced ranging from ships, landscapes, animals and birds to various sets of commemorative tiles. Although they could be used in an architectural context, they were mainly produced as single tiles to be hung on the wall like a picture and for this purpose two little holes were made at the top of each tile for a wire or string attachment. The tiles were also popular abroad and were exported to Britain and America.

In France, too, the first signs of Art Deco were already noticeable before the First World War. This can be seen in one of the houses built in 1910 by the architect Henri Deneux at 185 Rue Belliard in Paris. The whole facade is covered with various arrangements of square tiles which form striking geometric patterns. The wide cement joints become decorative features in their own right. Above the main entrance of the house is an interesting ceramic panel showing an architect at his drawing table. The First World War had a disastrous effect on the French economy and many tile firms had to close, but one that managed to survive the upheavals was Fourmaintraux & Délassus in Devres, Pas-de-Calais. Around 1925 they produced a catalogue with a good range of Art Deco designs, most of which were exhibited at the important Exposition Internationale of 1925. A fine example of their Art Deco tiling can still be seen on the facade of the mineral water factory of Sté Française des Eaux Minérales, Source Vals, Perle, at 30 Rue de Londres in Paris built in the 1920s.

In Belgium Art Deco tiles were made at the Manufactures Céramiques d'Hemixem where the chief designer Joseph Roelants created some outstanding panels in a convincing Art Deco style. The firm actively promoted

Detail of the tiled facade of the mineral water factory of Sté Française des Eaux Minérales, Source Vals, Perle, at 30 Rue de Londres in Paris, dating from the 1920s. The tiles were made by Fourmaintraux & Délassus in Devres, Pas-de-Calais.

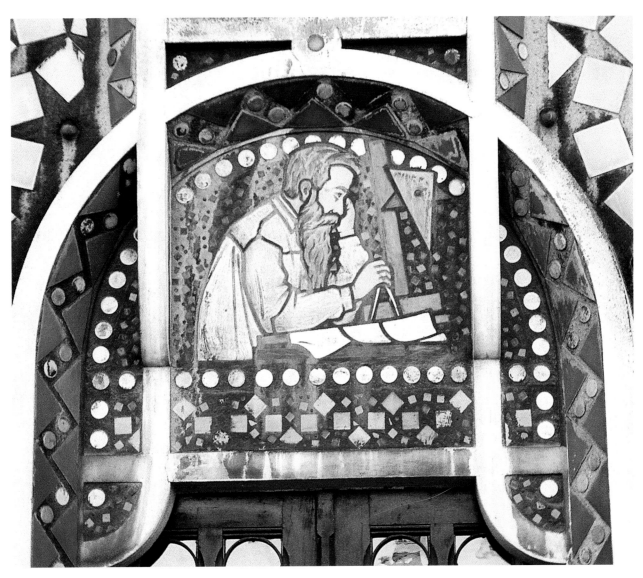

*The doorway of a house at
185 Rue Belliard in Paris
by the French architect
Henri Deneux, built in
1910. The striking geometric
patterns created by the
square tiles can be regarded
as a precursor to Art Deco.*

their tile panels at various international exhibitions. At the World Fair of
1935 in Brussels they had their own pavilion which sported an extraordinary
tiled tower showing a large Art Deco panel of Minerva, the goddess of Trade
and Peace.

In Germany the most interesting developments took place in the field of
Expressionism, in sculptural building ceramics. A good example is the
Chile House office building in Hamburg, designed by Fritz Höger and built
in 1923-4. One of its most outstanding features is the sculptural terracotta
border around the jeweller's shop window, with small children and animals in
Gothic-style niches executed by the sculptor Richard Kuohl. In Berlin there
is also the remarkable Expressionist Kreuzkirche (Church of the Cross) by
the architects Ernst and Günther Paulus, built in 1927-9 in the Hohen-
zollerndamm, Schmargendorf. It has a striking triangular entrance porch
decorated with blue glazed architectural ceramics showing streamlined
religious figures.

Art Deco became a particularly powerful element in American architecture
and design and many manufacturers produced tiles in response to the style. The
use of faience tiles with matt glazes continued in the inter-war period and
good examples in this line were made by the Mosaic Tile Co. of Zanesville,
Ohio. Their catalogues of 1929 and 1930 show tiles with bold colourful
designs, while their advertizements in the magazine *House Beautiful* of 1930
show interiors with suggestions as to how Mosaic Tile Co. products could be
used in domestic settings. Some of these interiors show the impact of the
Neo-Egyptian style which had swept across America at that time. Exotic
schemes were also advertized by Batchelder Tiles in Los Angeles. An
advertizement in *Architectural Form* of December 1927 showed one of their
Mayan fireplace surrounds; it was aimed at the designer 'who dares stray from
the easy path of accepted styles'. The upsurge in the American construction
industry in the early 1920s meant that new firms came onto the scene. In
Malibu, California, the Malibu Potteries began operating in 1926 and Catalina
Tile on Catalina Island, just off the coast, made their first tiles in 1927. They
were shortlived concerns that went bankrupt, like so many others, during the
Depression of the 1930s. Malibu Potteries were liquidated in 1932 while
Catalina Tile went out of business in 1937. The Franklin Tile Co. of Lansdale
in Pennsylvania fared better and managed to survive the stock market crash of
1929. They had been founded in 1923 and produced high quality Art Deco
tiles with flowers, butterflies and birds.

Some of the most spectacular examples of Art Deco tiling in America
are found on skyscrapers, commercial buildings and large apartment blocks
in New York. It is without doubt the Art Deco tile capital of America, with
a diverse range of styles. Mainstream Art Deco can be seen in the Fuller
Building (1928-9) at 41 East 57th Street which has striking black-and-white
geometric ceramic decorations, or on the facade of Gramercy House
(1929–30) at 235 East 22nd Street which has colourful tile bands with
triangular decorations along its entire brick facade. But there are also more
exotic examples such as the Pythian Temple (1926-7) on 135 West 70th Street,
which is a Masonic temple with brightly coloured Neo-Egyptian ceramic
ornament covering the whole facade. The F. Cossitt Memorial Building
(1928–30) on 5 West 63rd Street is clad in brightly glazed terracotta ornament

*Expressionist style ceramic
figure on the facade of the
Kreuzkirche (Church of the
Cross) by the architects
Ernst and Günther Paulus,
built in 1927-9 on the
Hohenzollerndamm,
Schmargendorf, Berlin.*

Right: Detail of the Neo-Egyptian ceramic decoration above the entrance of the Pythian Temple built in 1926-7 on 135 West 70th Street, New York, by the architect Thomas Lamb. It reflects the interest in all things Egyptian at the time of the discovery of Tutankhamun's tomb in 1922.

IF FRATERNAL LOVE
HELD ALL MEN BOUND
HOW BEAUTIFUL
THIS WORLD WOULD BE

A superb Art Deco tile with
the head of a Mayan Indian
in the entrance hall of the
Fisher Mansion, 383 Lenox
Avenue, Detroit, 1927.
It was built by the architect
Albert Kahn for
Lawrence Fisher, president
of Cadillac Motors.

GRAMERCY HOUSE

The Art Deco facade of Gramercy House with striking geometric tile arrangements by the architects George and Edward Blum, 235 East 22nd Street, New York, built in 1929-30.

with a hint of the Neo-Byzantine, while the apartment block at 81 Irving Place (1929-30) has medieval-style ceramic gargoyles and other fantastic elements.

It is not only New York that can boast of great Art Deco examples. In the 1920s the motor barons of Detroit had money to spend, which in some cases resulted in tiles becoming a spectacular feature of their homes. A celebrated instance is the Fisher Mansion in Detroit (1927) built by Albert Kahn for Lawrence Fisher, president of Cadillac Motors. The entrance hall is completely decked out with tiles including a wall fountain with the head of a Mayan Indian. It also has elaborately tiled bathrooms and tiled basins in the garden, but its startling variety shows perhaps that Fisher had more money than taste. Also in Detroit is the imposing Guardian Building which was completed in 1929. It is a tall skyscraper with a huge lobby full of plain, colourful tiles made by Rookwood and arranged in striking geometric patterns reminiscent of Aztec design.

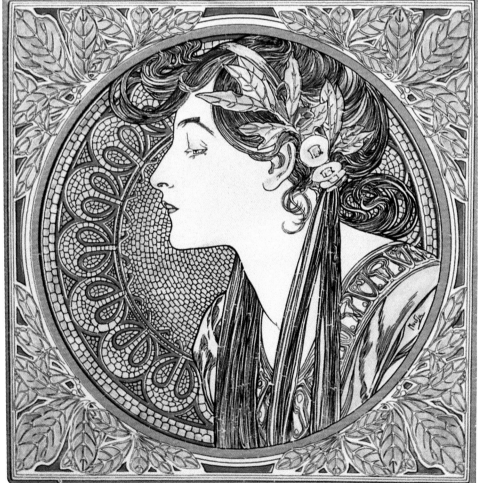

Left, top: The German tile artist Lothar Scholz at work in the Märkischer Künstlerhof, Brieselang, near Berlin, in November 1997. The tile panel shows the head of a women with long flowing hair and roses, reminiscent of the Art Nouveau style.

Left, bottom: Printed Art Nouveau tile with a reproduction of a design by the Czech artist Alphonse Mucha originally made in 1901. Marketed by Original Style, Stovax Ltd, Exeter, 1993.

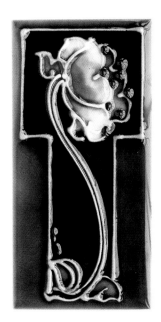

Art Nouveau tile by the Scottish artist Douglas Hunter made in 1998.

ART NOUVEAU REVIVAL

Reactions against Modernism set in from the 1950s onwards. An early manifestation of this was Laura Ashley Ltd, founded in London in 1953, which marketed all kinds of interior furnishings in the English country house look that proved popular in Britain and America. During the past 20 years this return to ornamentation and figuration has accelerated as part of the so-called Post-Modernist trend in architecture and design. One feature of Post-Modernism is the conscious revival of past styles. In the case of tiles this has led to a renewed interest in the Arts and Crafts Movement, Art Deco and Art Nouveau. This has been particularly strong in Britain where several large and small firms have been active to satisfy the new trend. Decorative tiles are again being used in homes, shops, offices, hospitals, schools and restaurants. An interesting new feature is the 'theme pub' constructed in a pseudo 'belle époque' style in an attempt to re-create the opulent splendour of turn-of-the-century pubs. Newly made copies of original Art Nouveau tiles can often be seen as part of the general decor. Another factor in the expanding revival of Art Nouveau tiles is the growing heritage industry. The repair and refurbishment of late nineteenth and early twentieth century buildings often includes the restoration of tiles. Replacement tiles can now be made to order by a range of firms.

One of the first British enterprises to produce Art Nouveau replacement tiles in the early 1980s was John Burges & Co. operating in a crafts centre set up in the former Maw & Co. tile works at Jackfield, Shropshire. Nearby, also in Jackfield, is the former Craven Dunnill tile works, which was turned into a tile museum in 1985 but also houses the Decorative Tile Works which since 1989 has been making all kinds of reproductions, including Art Nouveau ones. Although the original firm of Maw & Co. closed in the late 1960s, it was reestablished in Tunstall, Stoke-on-Trent. During the 1980s they specialized in a large range of tube lined tiles among which was a series of Art Nouveau designs representing The Months and The Seasons, inspired by the Czech artist Alphonse Mucha. Designs by Mucha were also the catalyst for a range of printed tiles marketed throughout the 1990s by Original Style, a member of the Stovax group, operating in Exeter, Devon. The great age of Scottish Art Nouveau has been revived by the Hunter Art & Tile Studio in Ancrum, Roxburghshire, where Douglas Hunter creates exquisite tube lined Art Nouveau tiles according to his own designs or inspired by the work of Charles Rennie Mackintosh. It is not only in Britain that the revival of Art Nouveau tiles is evident. In Germany still existing factories such as Grohn (formerly N.S.T.G.) and Stenler Fliesen in Mühlacker have added reproduction Art Nouveau tiles to their collection.

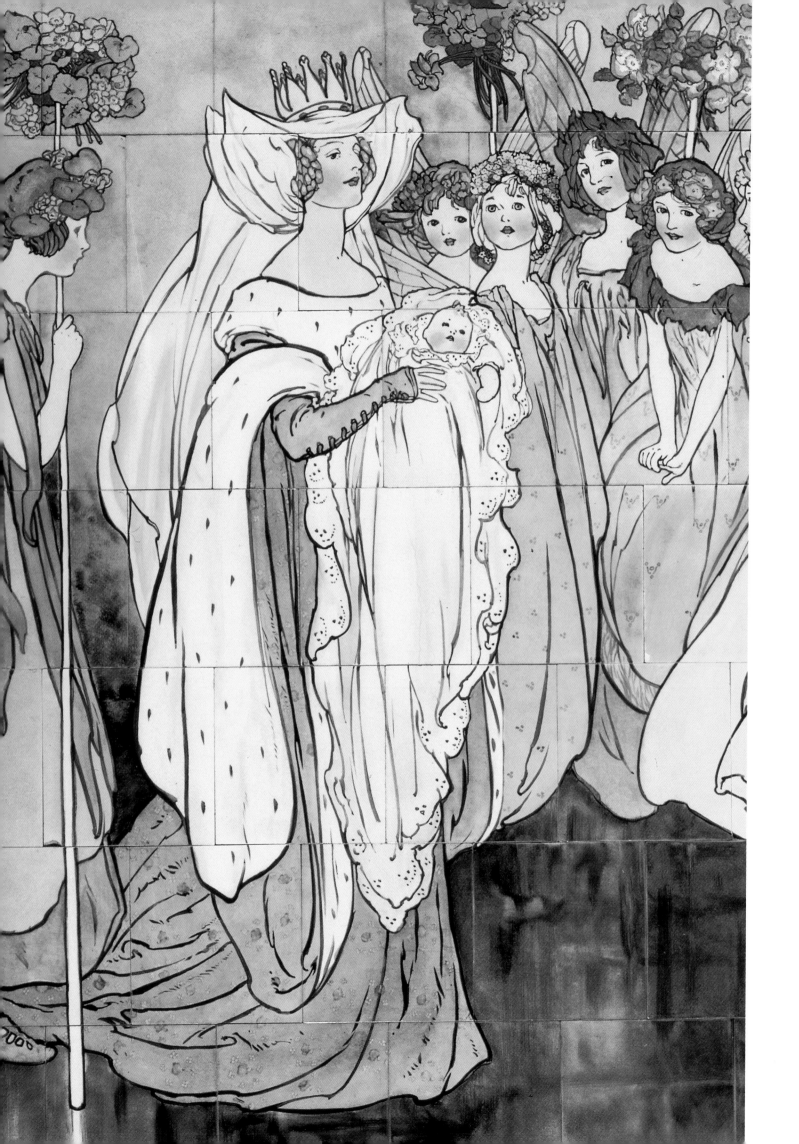

COLLECTING ART NOUVEAU TILES

ART Nouveau tiles are now eagerly sought after throughout Europe and the United States and their striking visual designs make them coveted items in many collections. They are still freely available at antique fairs, antique shops, architectural salvage places and tile auctions. Once a tile has been acquired, most collectors want answers to a number of basic questions. Who was the manufacturer? Who was the designer? When was it made? How was it made? What does the design represent? The answers can often be found by studying the tiles themselves and consulting specialist literature on the subject. In order to care for a collection effectively it is also necessary to follow certain basic rules and guidelines which will display tiles to their best advantage and help to preserve them in good condition.

COLLECTING AND STUDYING TILES

Tiles repay careful study. The front can reveal how the tile was decorated but the back can be even more interesting, with information about the manufacturer and dates of production. For example, many late nineteenth century and early twentieth century tiles have the name or trademark of the manufacturer stamped on the back as well as the place of manufacture. There are now several specialist publications on British, American, German and Belgian tiles that provide useful information on tile backs and their markings. Some British tiles also show design registration numbers and letters, which with the help of a relevant guide can give the day, month and year in which the design was registered with the patent office in London.

Although in most cases it is not difficult to establish the name of the manufacturer, many tile designers have unfortunately remained anonymous, particularly in the case of mass produced tiles. Occasionally the initials or the name of a designer can be found on a tile but these are exceptions rather than the rule. Tiles can be attributed to certain designers on the basis of style but much of this depends on informed knowledge of the work of the designers in

Opposite: Doulton panel with a scene from 'The Sleeping Beauty' painted by Margaret E. Thompson around 1900. This panel was sold by Phillips in London in 1989 for £3,600.

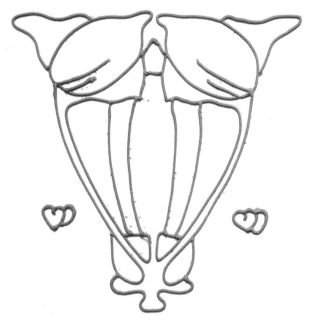

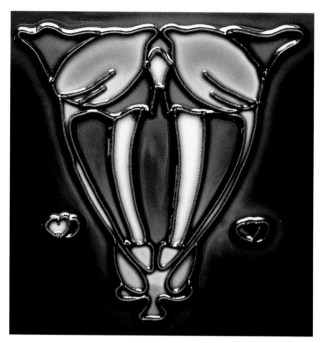

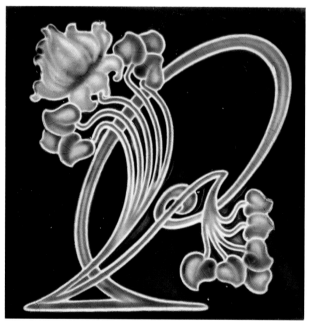

question and the manufacturer they worked for. However, research in this area can be very rewarding and lead to new insights.

The dating of European Art Nouveau tiles depends on the approach adopted. Roughly speaking most were made between 1890 and 1914. However, there are ways and means of narrowing down the dates within this timescale. In the case of British tiles, the aforementioned registration marks can help, but it must be borne in mind that tile designs could be kept in production long after their initial registration. Manufacturers' catalogues can be useful in establishing a more accurate date particularly if the date of the catalogue itself is known. Catalogues of tile sales at auction houses may be helpful since the descriptions of the items for sale will usually include a date. If tiles were acquired from a certain building, the date of the building can give an indication of when the tiles were made. In many cases therefore an approximate date can be established.

More problematic is the dating of American tiles, particularly those made from the beginning of the twentieth century onwards. If in Europe the First World War was a clear watershed between the Art Nouveau of the early twentieth century and the Art Deco of the 1920s and 1930s, there is no such clear dividing line in American design during this period. The dating problem is compounded by the fact that hardly any publications on American tiles, not even recent ones, attempt to set up a clear chronology that would be helpful to the collector. The only broad guidelines that can be offered are that most American tiles made between 1875 and 1900 are dust pressed with moulded relief designs showing such themes as classical figures, portraits, children, animals and floral motifs, decorated with monochrome translucent glazes. After 1900 the fashion changed to handmade Arts and Crafts tiles with relief designs decorated with matt glazes and depicting stylized trees, landscapes, birds, medieval sailing ships, horsemen and floral designs. Some of these motifs were kept in production well into the 1920s and 1930s.

The decoration and manufacture of a tile can be revealed by studying the tile body and the decorated surface. Tile bodies come normally in two varieties: plastic clay and dust pressed clay. Plastic clay is ordinary damp clay which is rolled flat and from which differently shaped tiles are cut. Plastic clay tiles were much favoured by Arts and Crafts potters both in Europe and America. They often look slightly uneven and no two tiles are exactly the same which is a clear sign of the handwork processes involved. Dust clay is finely powdered with a low moisture content; it is compacted into the shape of a tile in a press. All the big manufacturers in Europe and America used the dust clay method because it allows for rapid production and more regular thickness and size. Dust pressed tiles look very even and straight and the imprint of die marks of the press can often be seen on the back. Once the handmade or dust pressed tile has been fired for the first time it is known as a 'biscuit'. Biscuit tiles can be decorated in a number of ways.

The majority of Art Nouveau tiles were decorated according to four main processes: hand-painting, tube lining, machine pressing and stencilling. Hand-painting can be done directly on the biscuit tile and then covered with a transparent glaze, a process that is known as 'underglaze' decoration; or by painting on a glazed tile, as 'on-glaze' decoration. A third option, which was

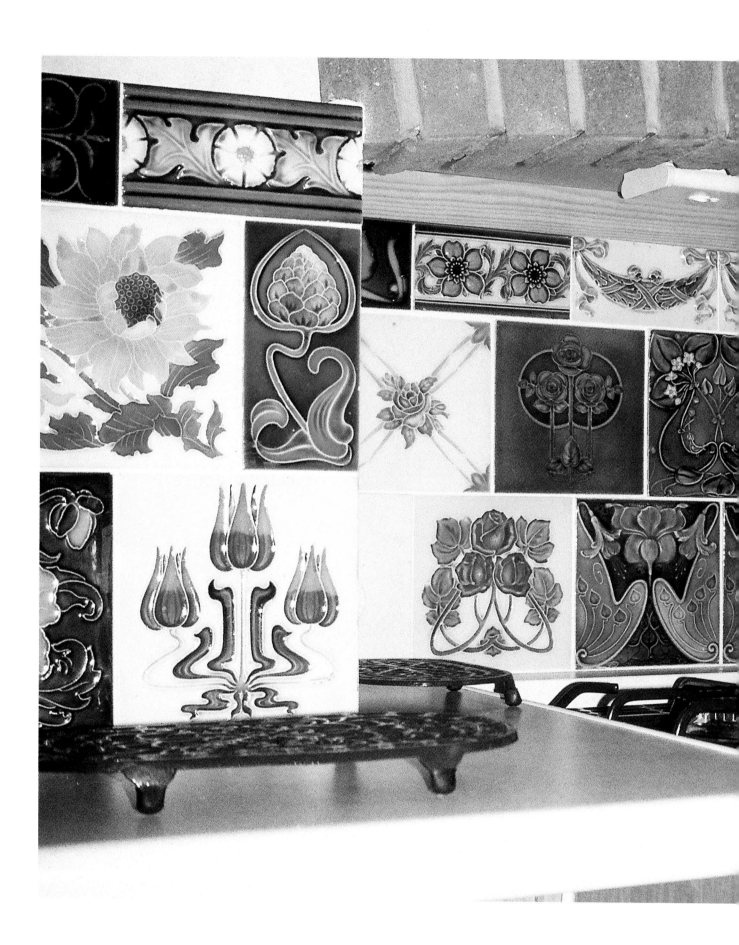

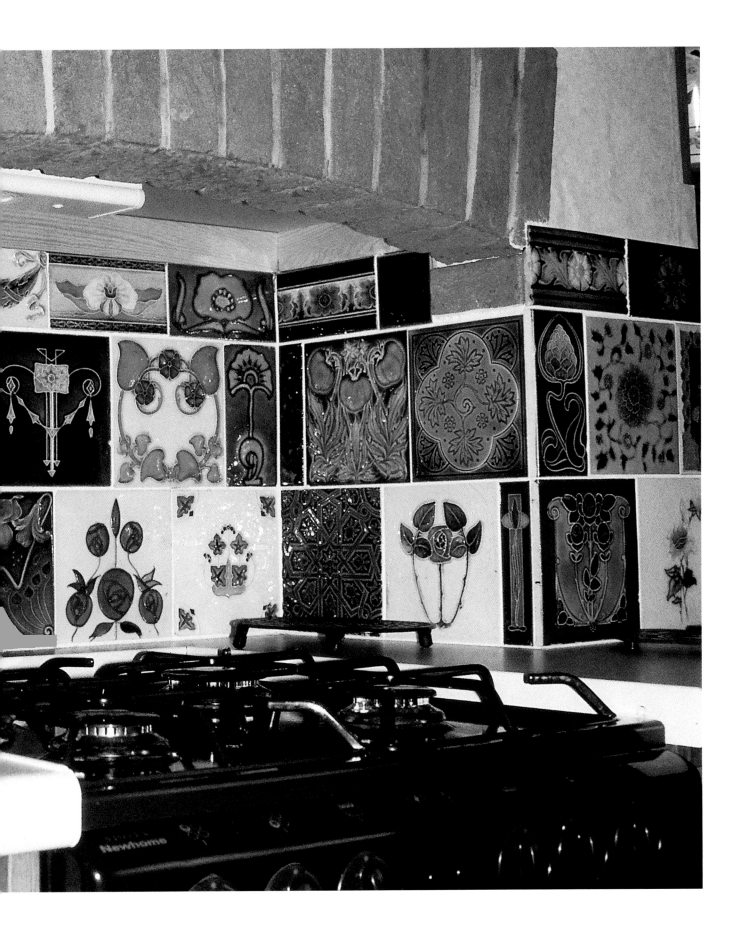

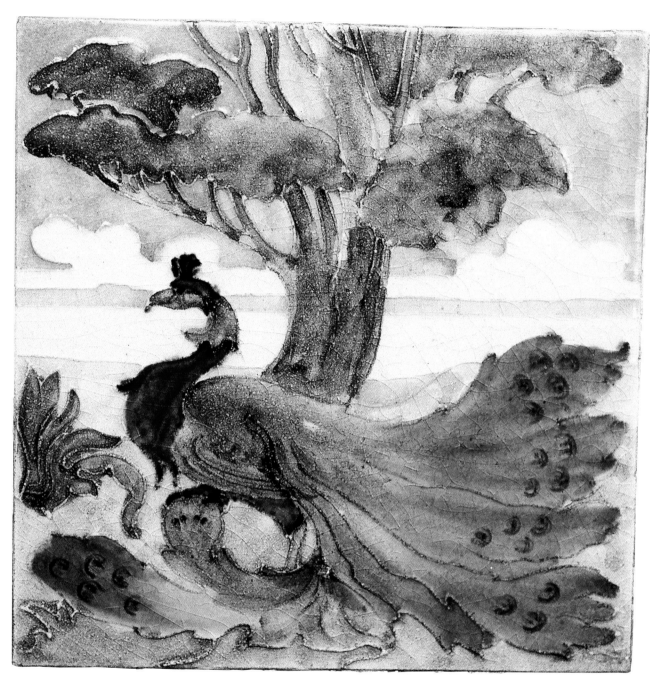

Above: A beautifully designed English Art Nouveau tile with a peacock, around 1905.

Previous page: Art Nouveau tiles installed as a part of a new kitchen arrangement in a house in Littlehampton, West Sussex.

used in countries like Holland and Portugal, is known as 'in-glaze' decoration. The paint is applied on top of a white unfired tin glaze and then sinks into the glaze during the firing.

Tube lining was a method of decoration used for many Art Nouveau tiles. It involved piping delicate lines of slip onto the surface of the tile to form raised lines that separated areas of colour. A telltale sign of this technique is the little blobs that form at the end of each drawn line where the nozzle of the slip applicator was lifted off. Tube lining is the technique par excellence for Art Nouveau tiles since the fluid sinuous line, which is often seen as a hallmark of the style, could be manipulated so well in the hands of a skilled tile decorator.

Machine pressing undulating areas and lines onto the face of a tile was one of the most common methods for mass produced tiles. It was also one of the most cost-effective methods of decoration as the design is impressed onto the tile during the same operation as the dust pressing of the tile body. All that is needed is a metal or plaster die with the required design at the bottom of the mould of the tile press. Decorated dust pressed tiles can be made at a rate of several hundred an hour. Once the tile has been biscuit fired it is painted with one or more translucent glazes and fired again. Even the tube line method could be simulated in this way as many British, Belgian and German Art Nouveau tiles show. It is this type of mass produced Art Nouveau tile that collectors are most likely to come across in antique shops.

The stencil method is simply one of cutting out the required design in a piece of thin metal or waxed paper and brushing or spraying the ceramic pigment through the openings. The Dutch firms De Porceleyne Fles, De Distel, Holland and Rozenburg made some striking Art Nouveau tiles in this technique. It was also much used in Spain where the stencilled tiles by the firm Pujol i Bausis are a case in point.

The collector can find a wealth of attractive subject matter on Art Nouveau tiles, where floral designs, animal themes and the female form dominate. Flowers like poppies, lilies, roses, pansies, honeysuckle, tulips, sunflowers and irises were popular and their sensitively abstracted forms grace many tiles. Birds like flamingos, storks, herons, pelicans, swans, birds of paradise and peacocks were exploited for their graceful long legs and necks or their colourful array of feathers. The peacock was a particularly popular motif because of the splendour of its long tail feathers. The subject was made famous in the Peacock Room designed by the artist James McNeill Whistler for the London home of the shipping magnate F.R. Leyland in 1876.

The human figure was represented most often as the maiden with soft and sensuous body contours and long flowing hair that appealed so strongly to many Art Nouveau designers; the male figure, which can be more muscular and angular, did not fit the Art Nouveau design idiom as well. The artists Dante Gabriel Rossetti and Edward Burne-Jones created a certain female type with a long gown and an elegant neckline, strong sensuous lips and flowing hair, which became an icon of Pre-Raphaelite painting and exerted great influence on Art Nouveau artists such as Alphonse Mucha. However, with the exception of single tiles by the German Johann von Schwarz, the female figure is more likely to be found on tile panels rather than on single tiles which makes them more difficult and expensive to collect.

THE CARE AND MANAGEMENT OF A TILE COLLECTION

Tiles need looking after and there are a great many things a collector can do in relation to display, storage, conservation, photographing and cataloguing. How tiles are displayed is always a matter of personal taste and dependent on available space and financial means. They can be effectively displayed on shelves and ledges or hung on the wall with wire or adhesive hangers. Some collectors prefer to frame each individual tile in a wooden or metal frame, which gives a homogenous and professional finish to the display. Whichever display technique is adopted, it should allow for tiles to be arranged in groups to show specific types of subjects, manufacturers or decoration techniques. Fixing tiles more permanently as part of interior fittings such as fireplaces, kitchen or bathroom walls should be considered with care. The standard rule is that the process should be reversible and that the tiles when necessary can be taken off without damage. Therefore such adhesives as Portland cement should never be used as the bonding is permanent and the tiles cannot be separated from it. Polyfilla, which can be easily removed, is more suitable.

Most collectors will eventually meet a point when they have more tiles than display space. Surplus tiles should be stored with care in strong cardboard or plastic boxes and kept in a dry, accessible place. It is best to place the tiles in an upright position wrapped in acid free tissue paper with a piece of cardboard or thin polystyrene between each one. Do not store the boxes on top of each other as downward pressure could crack the tiles at the bottom of the pile. Mark the boxes clearly on the outside with information about their content. This will avoid having to look through all the tiles when a particular example is needed: flicking through tiles in boxes can cause impact damage.

When tiles are dirty and need to be cleaned do not use ordinary tap water which can cause salt growths and damage between the body and the glaze. Always use distilled water and a non-ionic detergent. Do not use abrasive cleaning pads which can score the glaze, but cotton wool dipped in a cleaning solution. When the tile is clean rinse it with distilled water and leave it to dry naturally. When the tile is dry it can be gently buffed with dry cotton wool. Organic stains can often be successfully removed by hydrogen peroxide which is commonly available from chemists. Soak the tile first in distilled water and apply a poultice soaked in hydrogen peroxide to the stained area and leave to sit for a few days. Never use bleach or acidic cleaners as they can damage the clay body and the glaze. Tiles with brown films of smoke deposits can be cleaned with methylated spirit.

Tiles that have been painted over can easily be cleaned with paint stripper and a soft plastic scraper, but care should be taken not to use metal implements as they will inevitably scratch the glaze surface. Tiles that have been used on damp walls and have absorbed salts may have a bloom of white salt crystals. This can be removed by putting the tiles in a bath of de-ionized water and leaving them to soak, changing the water several times. The tiles should then be left to dry naturally before displaying them.

Damaged tiles can be restored up to a point with simple means. Broken tiles can be mended with a synthetic glue such as Uhu. Only tiny amounts of glue are needed to ensure close and strong bonding. Missing glaze areas can be

Above: Photocopy stand with a SLR camera attached ready for tile photography.

Opposite: A corner of a comprehensive English private collection of Arts and Crafts and Art Nouveau tiles hung individually on a wall.

Previous page: A collection of German tiles featuring waterlilies, seascapes and Dutch style landscapes. This a good example of focusing on specific subjects.

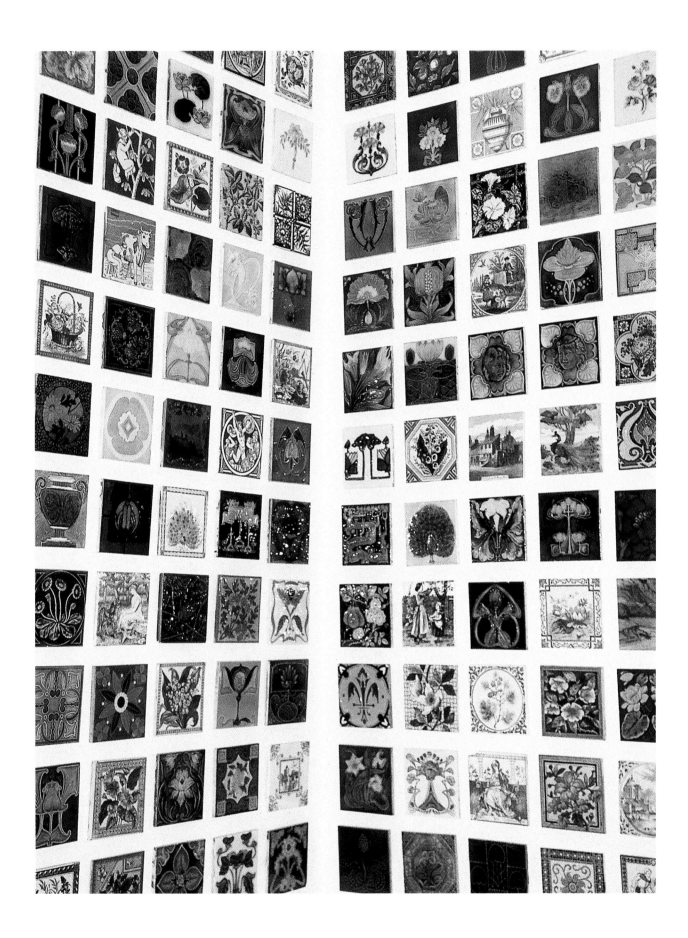

filled with the use of a fine plaster-based filler which can then be painted to match the colour of the tile. It is always difficult to reproduce the effect of a glossy glaze but a final application of clear varnish or lacquer over the painted areas will go some way to matching the glaze of the tile. The point of restoration is not to make the tile look as new but to enhance its design and colour without the obvious distraction of missing pieces. However, if the tile is particularly valuable, it is better to seek professional help before commencing any restoration work.

Cataloguing tiles is another feature of effective management. The easiest way is to number each tile on the back with a small adhesive label and then to write the tile number, colour, size, manufacturer, designer, subject matter, place of acquisition and price paid on standard sheets of loose paper which can be kept in a ring folder. The entries can be made more extensive when additional information is found. A useful addition to a written catalogue is a photograph of the tile alongside each entry. It is best to photograph tiles in daylight to avoid the use of flash, which often bounces off the glazed surface of the tiles and creates blurred photographs. For those who want more professional photographs, a single lens reflex (SLR) camera and copy stand are recommended. In this way tiles can be photographed close-up and the pictures used in conjunction with a catalogue or just kept in an album for reference purposes.

Responsible collectors are aware of the vanishing heritage of Art Nouveau tiles. In Britain, Germany, Holland, Belgium and America where the demand for tiles is high, they are sometimes removed unnecessarily or illegally from their original architectural locations. Such removal of Art Nouveau tiles not only robs us of already scarce installations, but often results in much breakage and damage so that not even the tile collectors' market profits from this kind of activity. Many collectors are now members of societies that both serve the interests of collectors and encourage and support conservation. The latter can only be achieved by making people more aware of the fact that Art Nouveau tiles were made for buildings and that is often the best place for them to be seen.

Opposite: German Art Nouveau tile made by the manufacturer Johann von Schwarz of Nürnberg, around 1900.

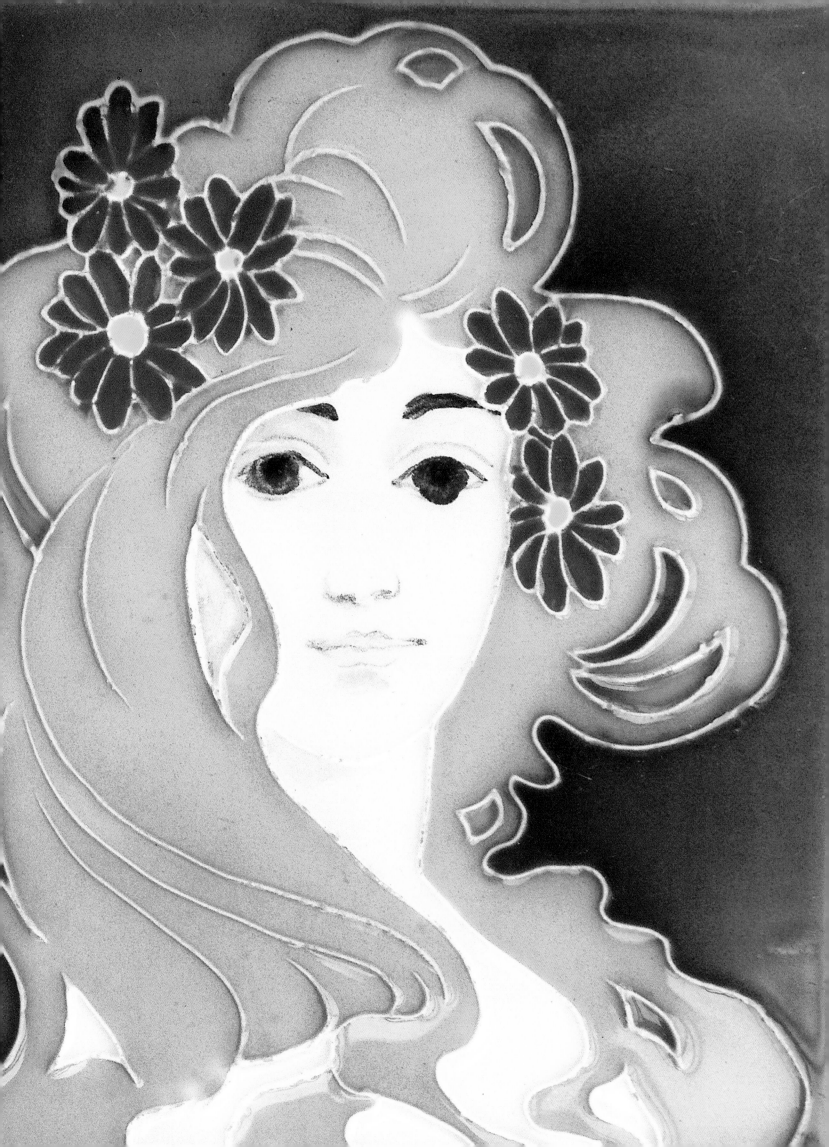

GLOSSARY

Aerography	Tiles decorated with ceramic colour sprayed through stencils with the aid of an airbrush.
Architectural ceramics	Generic term for all kinds of moulded architectural ceramic ornament, whether glazed or unglazed.
Art tiles	Tiles with special aesthetic qualities showing the influence of the Arts and Crafts Movement or of Art Nouveau. In America the term is used in connection with dust pressed tiles with moulded decorations and glossy translucent glazes made during the last two decades of the nineteenth century. In Germany these are tiles used as individual decorative objects meant to be placed or hung on their own.
Barbotine	Tiles painted with coloured slip and covered by a transparent glaze.
Biscuit	The body of a tile that has been fired once. It is the biscuit that is glazed and decorated.
Block printing	A form of transfer printing from flat metal plates introduced by Minton & Co. and based on an invention by Collins and Reynolds in 1848. The technique is well suited for printing large areas of flat colour.
Body	The clay body of a tile but not the glaze surface.
Ceramic colours	Pigments that will withstand the fierce heat of the kiln at high temperatures.
Chamotte	Ground and pulverized, pre-fired clay that is added to reduce shrinkage and make a stronger ceramic.
Cloisonné	French term for enamel work on metal but also used for tiles where the design has been delineated by raised edges. Different coloured glazes can be introduced into each cavity and kept apart by the ridges.
Cuenca	A Spanish word meaning 'bowl'. See Cloisonné for technical description.
Cuerda seca	'Dry-cord' in Spanish. The tile is first painted in outline using a compound of iron oxide and grease. Different coloured glazes can then be painted on because they retreat from the greasy lines and do not run into each other. The outlines show after firing as matt black.
Delftware	Tile covered with a tin glaze at the biscuit stage and then painted or stencilled by hand. This decoration is called 'in-glaze' because it sinks into the tin glaze during the firing. The term 'delftware' is derived from the Dutch town of Delft.
Dust pressing	The compressing with great force of powdered clay in a press, based on an invention by the Englishman Richard Prosser in 1840. Most mass produced tiles are dust pressed.
Earthenware	A tile made of ordinary clay fired at a temperature of not more than about 1000°C. The biscuit is porous and admits water readily in contrast to stoneware or porcelain which is impervious to water.
Enamels	Ceramic colours which can be painted or printed on a glazed tile and permanently fixed by means of a low temperature firing in a muffle kiln.
Encaustic tiles	Ceramic tiles in which a pattern or figurative motif is inlaid with coloured clays into the main body of the tile.
Faience	The word probably derives from the Italian town Faenza. Originally a term used for tin glazed ware but during the nineteenth century it was used to indicate moulded and glazed architectural ceramics. In France *faience fine* is used to indicate a fine quality earthenware. In America it has acquired a special meaning in relation to 'faience tile', by which is meant a tile with a handmade look decorated with matt glazes.
Grès	French term for stoneware. See Stoneware for technical description.
Glaze	Glassy substance used to decorate tiles and architectural ceramics in order to make them impervious to water as well as for aesthetic and decorative effects. Glaze can be transparent, translucent, opaque, glossy or matt. Glaze is added to a biscuit tile by dipping, painting or spraying, after which the tile is fired for a second time.
In-glaze	Decorations painted on the unfired tin glaze which, during the glaze firing, sink into the tin glaze and fuse permanently with it. Much used in the production of delftware and maiolica.
Lave émaillée	A mixture of volcanic rock and clay fired at a high temperature invented by the Frenchman Joseph Mortelèque in 1828. Only used in France mainly by the Gillet & Hachette factory, especially for exterior architectural decorations.
Lead glaze	A transparent glaze made from lead oxide used since ancient times to cover tiles and pottery. Common

until the beginning of the twentieth century when leadless transparent glazes were formulated to combat the high level of lead poisoning in the ceramics industry.

Lustre Ceramic colour that through the introduction of reduction gases into the kiln during the last phase of the firing turns into a thin film of metal. Copper and silver lustre are the most common.

Maiolica / Majolica Originally earthenware with white tin glaze painted in bright colours as produced in Italy and Spain. The term spelled as 'majolica' is also used in the nineteenth century for relief moulded tiles and pottery with colourful opaque glazes.

Muffle kiln A kiln with an interior totally enclosed and separated from the flames of the main kiln, allowing only the heat to enter. It is used for glaze firings as well as for fixing enamel colours to glazed surfaces.

On-glaze Decoration executed on the glaze with enamels and then fired in a muffle kiln.

Opaque glazes Coloured glazes that cover the body of the tile completely without allowing the surface to show through. They are made by adding coloured oxides to transparent glazes.

Pâte-sur-pâte French term meaning 'paste-on-paste'. A delicate form of low relief decoration built up by layer on layer of usually fine white slip on a contrasting ground. Louis Marc Solon who worked for Minton's China Works between 1870 and 1904 was the great master of this technique.

Plastic clay Ordinary wet clay.

Porcelain A vitreous ceramic material of high quality which in the case of tiles is characterized by a dense, fine grained and smooth body. During the firing the body and glaze are fused together at a high temperature of 1350-1500°C.

Pyrogranit A frost resistant stoneware, fired at a high temperature, intended for use on facades, produced by the Zsolnay factory in Pécs, Hungary. It was made from refractory clay, fine grained quartz and ground chamotte. The tiles were either pressed or made in moulds, and the first firing was between 1200°C and 1300°C. It could be unglazed, coated with salt glaze, covered with coloured majolica glazes or decorated with the special Zsolnay lustrous metallic Eosin glazes.

Relief tiles Tiles with low or high relief decorations moulded onto the surface. Many Art Nouveau tiles have their relief decorations directly pressed onto the surface during the dust pressing process. After the biscuit firing they are decorated with translucent or opaque glazes.

Sgraffito Scratching through two or more layers of clay to reveal an underlying layer. From the Italian *sgraffito* meaning 'scratching'.

Slip Thin liquid clay used for tube lining, *pâte-sur-pâte* and barbotine decorations.

Stencilling Applying a decoration onto a flat tile by brushing or spraying the glaze through a piece of thin metal with the design cut out of it.

Stoneware Tiles or architectural ceramics fired to a high temperature of 1200-1250°C resulting in a vitrified body which is water and frost proof and therefore well suited to the outside of buildings. Known as *grès* in French.

Terracotta Italian for 'fired earth'. The term is normally reserved for unglazed architectural ceramics but in America it is more widely used for all kinds of glazed and unglazed architectural ceramic decoration.

Tin glaze A glaze made by adding tin to a lead glaze which, when fired, becomes an opaque white. It is often used in combination with in-glaze decoration in the production of maiolica and delftware.

Transfer printing The transfer of a printed image from a metal, woodblock or lithographic stone to the surface of pottery and tiles by means of thin paper or gelatinous 'bats'. Transfer printing can be on-glaze or underglaze. The technique was first used for tiles in 1756 in Liverpool by the printer John Sadler.

Translucent glazes Transparent glazes to which small amounts of ceramic colour have been added, still allowing the surface to show through. Commonly used in the production of 15 centimetre (six inch) dust pressed Art Nouveau tiles.

Transparent glazes Clear glazes used to cover tiles and pottery in order to make them impervious to water and dirt.

Tube lining Delineating the outline of a design by piping delicate lines of slip onto pottery and tiles to form raised lines that separate areas of coloured glazes. A technique particularly well suited to the making of Art Nouveau tiles.

Underglaze A printed or painted decoration under a transparent glaze. Because the decoration is covered by a glaze it is completely durable.

PLACES TO VISIT

All the museums listed below have Art Nouveau tiles as part of their collection, on show or in store. It is advisable to check the opening times before visiting. Also included below are the addresses of tile societies in Britain and the United States.

BELGIUM

Joseph Roelants Museum
Hemiksem (near Antwerp)
Tel. 03-887 0213
*Tiles and documentary material of the firm
Manufactures Céramiques d'Hemixem,
Gilliot & Cie*
Visits by appointment only via the Chairman
(A. Leroy) of the Heemkundige Kring
'Heymissen', who administer the museum.

BRITAIN

Jackfield Tile Museum
Jackfield, Ironbridge, Shropshire, TF8 7AW
Tel. 01952-882030
Tiles by Maw & Co. and Craven Dunnill

Minton Museum
Minton House, London Road, Stoke-on-Trent,
Staffordshire, ST3 1PQ
Tel. 01782-292292
Minton archives and Minton tiles

The Potteries City Museum and Art Gallery
Bethesda Street, Hanley, Stoke-on-Trent,
Staffordshire, ST1 3DE
Tel. 01782-232323
Tiles and pottery from Staffordshire factories

Tiles and Architectural Ceramics Society
Decorative Arts Department, Liverpool Museum
William Brown Street, Liverpool, L3 8EN

Victoria and Albert Museum
Cromwell Road, South Kensington, London,
SW7 2RL
Tel. 0171-938 8500
Large collection of European tiles

World Wide Web Tile Image Gallery
http://www.derbycity.com/michael/tile-cd.html
*Many examples of tiles including Arts and Crafts and
Art Nouveau tiles*

FRANCE

Musée d'Orsay
62 Rue de Lille, 75343 Paris
Tel. 01-4049 4814
Tiles by Bigot and other French ceramicists

Musée Municipal
Rue de la Manutention, 54400 Longwy
Tel. 0382-238519
Longwy pottery and tiles

Musée Municipal, 15-17 Rue Raymond-
Poincaré, 57322 Sarreguemines
Tel. 0387-981990
Sarreguemines pottery and tiles

Musée de la Céramique Architecturale
432 Avenue du Maréchal Foch, 60390 Auneuil
Tel. 0344-477847
*Encaustic tiles by the firm Boulenger and documentary
material on French tile manufacturers from the
Beauvais area and other parts of France*

Musée Paul Charnoz
32 Avenue de la Gare, 71600 Paray-le-Monial
*Encaustic tiles and factory material from Carrelage
Céramique de Paray-le-Monial*

GERMANY

Erstes Deutsches Fliesenmuseum
Reichenstrasse 4, 19258 Boizenburg
Tel. 038844-21430

Boizenburg tiles
Kachelofen Museum
Wilhelmstrasse 32, 16727 Velten
Tel. 03304-502324
Stoves and tiles

Villeroy & Boch Museum
Schloss Ziegelberg, 6642 Mettlach
Tel. 06864-811294
Villeroy & Boch pottery and tiles

HUNGARY

Museum of Applied Arts
33-37 Ulloí ut, 1091 Budapest
Tel. 01-217 5222
Zsolnay tiles and ceramics

Zsolnay Keramia
2 Kaptalan ut, 7621 Pécs
Tel. 72-324822
Zsolnay tiles and ceramics

The Zsolnay Tile Museum Web Site
http://www.drawrm.com/ztilemus.htm
*Information about Zsolnay and examples of
their tiles*

HOLLAND

Nederlands Tegelmuseum
Eikenzoom 12, 6731 BH Otterlo
Tel. 0138-591519
Dutch tiles

Keramiekmuseum Het Princessehof
Grote Kerkstraat 11, 8911 DZ Leeuwarden
Tel. 058-212 7438
*Important collection of pottery and tiles from all over
the world*

De Porceleyne Fles
Rotterdamseweg 196, 2628 AR Delft
Tel. 015-256 0234

Porceleyne Fles pottery, tiles and architectural ceramics
Keramisch Museum Royal Goedewaagen
Glaslaan 29a, Nieuw Buinen
Tel. 0599-616090
*Small permanent exposition of pottery, tableware and
tile panels of De Distel and Goedewaagen factories*

ITALY

Exhibit and Library of the Italian
Ceramic Industry
Palazzina della Casiglia,
Viale Monte Santo 40, 41049 Sassuolo
Tel. 0536-818111
Italian tiles and archive material

The International Museum of Ceramics
Via Campidori 2, 48018 Faenza
Tel. 0546-21240
Italian tiles of all periods

PORTUGAL

Museu da Cidade,
Campo Grande 245, Lisbon
Tel. 01-757 1725
Portuguese tiles

Bordalo Pinheiro Museu
Campo Grande 382, Lisbon
Tel. 01-759 0816
Pottery and tiles by Bordalo Pinheiro

Museu Nacional do Azulejo,
Rua Madre de Deus 4, Lisbon
Portuguese tiles

SPAIN

Casa Museu Gaudí
Park Güell, Carrer d'Olot,
08024 Barcelona
Tel. 93-284 6446

Architectural drawings by Gaudí
Museu de Ceramica,
Palau Reial de Pedralbes
Avinguda Diagonal 686, 08034 Barcelona
Tel. 93-280 1621
Spanish pottery and tiles

USA

Cincinnati Art Museum
Eden Park, Cincinnati, Ohio 45202
Tel. 513-721 5204
American tiles

Colorado Springs Pioneers' Museum
215 South Tejon Street, Colorado Springs,
Colorado 80903
Tel. 719-578 6650
Van Briggle tiles

Cooper-Hewitt Museum
2 East 91st Street, New York, NY 10128
Tel. 212-860 6868
European and American tiles

Fonthill
Swamp Road, Doylestown, Pennsylvania 18901
Tel. 215-345 6722
*Arts and Crafts tiles by Henry Chapman Mercer's
Moravian Pottery and Tile Works*

National Museum of American History
Smithsonian Institution, Constitution Avenue,
Washington, D.C. 20560
Tel. 202-357 2700
American tiles

Tiles on the Web
http://www.aimnet.com/~tcolson/webtiles.htm
*Largest and most extensive American web site dealing
with tiles*

Tile Heritage Foundation
PO Box 1850, Healdsburg, California 95448
Tel. 707-431 8453

BIBLIOGRAPHY

GENERAL BOOKS

Barnard, J., *Victorian Ceramic Tiles*, Studio Vista, London, 1972

Fahr-Becker, Gabriele, *Jugendstil*, Könemann, Cologne, 1997

Forrer, R., *Geschichte der Europäischen Fliesen-Keramik von Mitteralter bis zum Jahre 1900*, Schlesier und Schweikart, Strasburg, 1901

Foy, J. *La Céramique des constructions, briques, tuiles, carreaux, poteries, carrelages céramiques, faiences décoratives*, Paris, 1883

Furnival, W.J., *Leadless Decorative Tiles, Faience, and Mosaic*, W.J. Furnival, Stone, 1904

Herbert, Tony, and Huggins, Kathryn, *The Decorative Tile*, Phaidon, London, 1995

Howard, Jeremy, *Art Nouveau*, Manchester University Press, Manchester, 1996

Lemmen, Hans van, *Tiles in Architecture*, Laurence King, London, 1993

Riley, N., *Tile Art*, Quintet, London, 1992

Schmutzler, Robert, *Art Nouveau*, Thames and Hudson, London, 1978

Sembach, Klaus Jürgen, *Art Nouveau*, Taschen, Cologne, 1991

ARTS AND CRAFTS INSPIRATIONS

Banham, Joanna, MacDonald, Sally, and Porter, Julia, *Victorian Interior Design*, Crescent Books, New York, 1991

Catleugh, Jon, *William De Morgan Tiles*, Trefoil Books, London, 1983

Durant, Stuart, *Christopher Dresser*, Academy Editions, London, 1993

Greenwood, Martin, *The Designs of William De Morgan*, Richard Dennis and William E. Wiltshire III, Shepton Beauchamp, 1989

Lambourne, Lionel, *The Aesthetic Movement*, Phaidon, London, 1996

Lemmen, Hans van, 'De invloed van William Morris op laat negentiende eeuwse Nederlandse tegeldekors', *Tegel*, no. 12, 1984

Myers, Richard and Hilary, *William Morris Tiles*,

Richard Dennis Publications, Shepton Beauchamp, 1996

Parry, Linda (ed), *William Morris*, Victoria and Albert Museum, London, 1996

Spencer, Isobel, *Walter Crane*, Studio Vista, London, 1975

THE RISE OF ART NOUVEAU

100 Ans de création et de tradition faiencières: Boch-Kéramis, La Louvière, 1841-1901, La Louvière, 1991

Aa, J. van der, *Josef Roelants en het keramisch paneel van de firma Gilliot*, n.p., 1988

Baeck, Mario, and Verbrugge, Bart, *De Belgische Art Nouveau en Art Deco wandtegels, 1880-1940*, Ministerie van de Vlaamse Gemeenschap, Brussels, 1996

Brossard, T., and Jacob, A., 'Faiences et porcelaines de Sarreguemines', numéro trimestriel hors-série, *ABC Décor*, October 1975

Cartier, Jean, and Morisson, Henri, *La Céramique architecturale des années 1900 dans le Beauvaisis*, Musée Départemental de l'Oise, Beauvais, 1980

Declève, Chantal, *Guide des décors céramiques à Bruxelles de 1880 à 1940: 7 Firmes de céramiques Belges*, Brussels, 1996

Dierkens-Aubry, F., and Vandenbreeden, J., *Art Nouveau in België: Architectuur & Interieurs*, Lannoo, Tielt, 1991

Girveau, Bruno, *La belle Epoque des cafés et des restaurants*, Guides Paris/Musée d'Orsay, 1995

Lambert, G., *Art céramique: Déscription de la fabrication des faiences fines et autres poteries en Angleterre, avec indication des ressources que présente La Belgique pour ce genre d'industrie*, Brussels, 1865

Mahaux, Monique, 'Les Boutiques à décor de céramique: La Céramique s'affiche', Reinharez, Claudine, and Chamarat, Josselyne, *Boutiques du temps passé: Décors peints des boulangeries, charcuteries et crèmeries*, Paris, 1977

Maillard, Anne, *La Céramique architecturale, 1880-1930: Paris, Normandie, Beauvaisis*, Septima, Paris, 1995

De Meester, M., *Les Industries céramiques en*

Belgique, J. Lebègue & Cie, 1907

Meyer, Ronny de, and Bekaert, Geert, *Art Nouveau in België*, Hadewijch, Antwerp-Baarn, 1989

Tunick, Susan, and others, *Paris and the Legacy of French Architectural Ceramics*, The Friends of Terra Cotta Press, New York, 1997

Verbrugge, Bart, 'N.V. Manufactures Céramiques d'Hemixem, Gilliot & Cie: A Major Tile Manufacturer in Belgium, 1896-1977' *Glazed Expressions*, no. 34, spring 1997

NORTHERN EUROPE

Atterbury, Paul, and Irvine, Louise, *The Doulton Story*, Royal Doulton Tableware Ltd, Stoke-on-Trent, 1979

Austwick, J. and B., *The Decorated Tile*, Pitman, London, 1980

Barnard, Julian, 'Some Work by W.J. Neatby', *Connoisseur*, November 1970

Catalogue Jakob Julius Scharvogel: Keramiker des Jugendstils, Arnoldsche, n.p., 1996

Cross, A.J., *Pilkington's Royal Lancastrian Pottery and Tiles*, Richard Dennis, London, 1980

Dittmar, Monika, *Märkische Ton-Kunst - Veltener Ofenfabriken*, Deutsches Historisches Museum, Berlin, 1992

Euler, Margrit, *Studien zur Baukeramik von Villeroy & Boch, 1869-1914*, inaugural dissertation, Rheinischen Friedrich-Wilhelms Universität, Bonn, 1994

Jones, Joan, *Minton: The First Two Hundred Years of Design & Production*, Swann-Hill Press, Shrewsbury, 1993

Kessler-Slotta, Elisabeth, *Max Laeuger*, Saarbrücker Druckerei und Verlag, Saarbrücken, 1985

Lemmen, Hans van, 'Nederlandse Jugendstiltegels', *Mededelingenblad Nederlandse Vereniging van Vrienden van de Ceramiek*, vol. 117/118, 1985

Ludwig, Hannah, *J. van Hulst: Sporen van een Friese tegelbakker*, Leeuwarden, 1992

Maenen, A.J.Fr., *Petrus Regout*, 1801-1878, Nijmegen, 1959

Thomas, Thérèse, *Villeroy & Boch*, 1748-1930, Rijksmuseum, Amsterdam, 1977

Verbrugge, Bart, 'Keramiek in de Amsterdamse Architectuur, 1880-1940: Tegeldecoraties', *Amsterdamse Monumenten*, no. 1, mei 1984

Verbrugge, Bart, 'Keramiek in de Amsterdamse Architektuur, 1880-1940: Bouwaardewerk', *Amsterdamse Monumenten*, no. 2, juli 1984

Weisser, Michael, *Kacheln & Fliesen im Jugendstil*, F. Coppenrath Verlag, Münster, 1980

Weisser, Michael, *Wessel's Wandplattenfabrik Bonn*, Rheinland Verlag, Cologne, 1979

CENTRAL EUROPE

Csenkey, Éva, *Zsolnay Szecessziós kerámiák*, 1992

Éri, Gyöngi, and Zsuzsa, Jobbágyi, *A Golden Age: Art and Society in Hungary, 1896-1914*, Budapest, n.d.

Gerle, Janos, Kóvacs, Attila, and Makovečz, Imre, *A századforduló Magyar építészete*, 1990

Kallir, Jane, *Viennese Design and the Wiener Werkstätte*, New York, 1986

Powell, Nicolas, *The Sacred Spring: The Arts in Vienna, 1898-1918*, Studio Vista, London, 1974

Rubovskey, Andras, *Hotel Gellert*, Artunion/Szechenyi Publishing House, Budapest, 1988

Santi, Federico, 'The Zsolnay Tile Museum', *Glazed Expressions*, no. 34, spring 1997

Svoboda, Jana E., Lukeš, Zdeněk, and Havlová, Ester, *Praha, 1891-1918: Kapitoly o architektuře velkoměšta*, Prague, 1997

Vitochová, Marie, Kejr, Jindřich, and Všetečka, Jiří, *Prague and Art Nouveau*, V Raji Publishing House, Prague, 1995

SOUTHERN EXTRAVAGANZA

Bossaglia, Rossana, 'The Protagonists of the Italian Liberty Movement', *The Journal of Decorative and Propaganda Arts*, no. 13, summer 1989

Carboni, Elena, 'Ceramiche per architettura di Galileo Chini', *Ceramica per l'Architettura*, no. 9, 1990

Loyer, François, *Art Nouveau in Catalonia*, Taschen, Cologne, 1997

Meco, José, *The Art of Azulejo in Portugal*, Bertrand Editora, Amadora, 1988

Petriconi, Renate, 'English Moulds for Relief Tiles of the Fábrica de Louça de Sacavém, Portugal', *Glazed Expressions*, no. 33, autumn 1996

Petriconi, Renate, 'Die Entwicklung der Fliesenmotive vom Hispano-Maurischen zum

Jugendstil bei Rafael Bordalo Pinheiro und der Fábrica de Faianças das Caldas da Rainha, Portugal', *Keramos*, no. 154, October 1996

Pitarch, Antonio José, and Dalmases Balañá, Nuria de, *Arte e industria en España, 1774-1907*, Editorial Blume, Barcelona, 1982

Pujadas, M.P.S., *Pujol i Bausis*, Ajuntament d'Esplugues, Barcelona,1989

Saporiti, T., *Lisbon Tiles of the 20th Century*, Edicoes Afrontamento, Oporto, 1992

Weisberg, Gabriel P., *Stile Floreale: The Cult of Nature in Italian Design*, The Wolfsonian Foundation, Miami, 1988

Zerbst, Rainer, *Antoni Gaudí*, Taschen, Cologne, 1991

NEW WORLD EXPERIMENTS

Anscombe, Isabelle, and Gere, Charlotte, *Arts & Crafts in Britain and America*, Academy Editions, London, 1978

Dolkart, Andrew, S., and Tunick, Susan, *George & Edward Blum: Texture and Design in New York Apartment House Architecture*, The Friends of Terra Cotta Press, New York, 1993

Fehr, Beulah B., 'Arts & Crafts Tiles in Berks County, PA', *Tile Heritage*, vol. iv, no. 1, summer 1997

Koehler, Vance A., 'The Arts and Crafts Tile', *Flash Point*, vol. 6, no. 4, October-December 1993

Koehler, Vance A., 'American Decorative Tiles, 1880-1950', *American Art Tile, 1880-1950*, David Rago Arts & Crafts Movement Gallery, Lambertville, 1994

Reed, Cleota, *Henry Chapman Mercer and the Moravian Pottery and Tile Works*, University of Pennsylvania Press, Philadelphia, 1987

Stookey, Lee, *Subway Ceramics*, Lee Stookey, Brooklyn, NY, 1992

Taylor, Joseph A., 'Ernest Allan Batchelder: Craftsman Turns Entrepreneur', *Flash Point*, vol. 5, no. 4, October-December 1992.

Trapp, Kenneth R., 'Tiles of the Rookwood Pottery', *Flash Point*, vol. 6, no. 4, October-December 1993

Tunick, Susan, *Terra Cotta - Don't Take It For Granite*, The Friends of Terra Cotta Press, New York, 1995

Tunick, Susan, *Terra-Cotta Skyline*, Princeton Architectural Press, New York, 1997

White Morse, Barbara, 'Low Art Tiles', *Flash Point*, vol. 3, no. 2, April-June 1990

ART NOUVEAU AND BEYOND

Anscombe, Isabelle, *Omega and After: Bloomsbury and the Decorative Arts*, Thames and Hudson, London, 1993

Bayer, Patricia, *Art Deco Architecture*, Thames and Hudson, London, 1992

Buehl, Olivia B., and Dennis, L., *Tiles: Choosing, Designing, and Living with Ceramic Tile*, Clarkson Potter Publishers, New York, 1996

Duncan, Alistair, *Art Deco*, Thames and Hudson, London, 1995

Hayward, Lesley, *Poole Pottery: Carter & Company and their Successors, 1873-1995*, Richard Dennis Publications, Shepton Beauchamp, 1996

Hillier, Bevis, *The World of Art Deco*, E.P. Dutton, New York, 1971

Lemmen, Hans van, and Blanchett, Chris, *Twentieth Century Picture Tiles*, Shire Publications, Princes Risborough, 1999

COLLECTING ART NOUVEAU TILES

Karlson, Norman, *American Art Tile*, Rizzoli, New York, 1998

Lemmen, Hans van, and Malam, John, (eds), *Fired Earth: 1000 Years of Tiles in Europe*, Richard Dennis Publications, Shepton Beauchamp, 1981

Lemmen, Hans van, *Tiles: A Collectors' Guide*, Souvenir Press, London, 1990

Lockett, Terence, A., *Collecting Victorian Tiles*, Antique Collectors' Club, 1979

Padwee, Michael, *A Guide to the Patterns and Markings on the Backs of United States Ceramic Tiles*, The Whatnot Shop, Brooklyn, NY, 1997

Purviance, Evan and Louise, *Zanesville Art Tile in Color*, Wallace Homestead Book Co., Des Moines, 1972

Sigafoose, Dick, *American Art Pottery*, Collector Books, Paducah, Kentucky, 1998

Weisser, Michael, *Jugendstilfliesen*, Fricke Verlag, Frankfurt, 1983

ACKNOWLEDGEMENTS

The authors would like to thank the following individuals and institutions for their generous help: Mario Baeck, Chris Blanchett, Michael Blood, Piet Bolwerk, Douglas Hunter, Wilhelm Joliet, Prof. Dr Wolfgang König, Helen Kornblau, Leeds Metropolitan University – School of Cultural Studies for research support, Anne Maillard, Michael Padwee, Renate Petriconi, Dr Thomas Rabenau, Cleota Reed, Lothar Scholz, Joseph Taylor, Susan Tunick, Dr Richard Tyler.

PICTURE CREDITS

The numbers refer to page numbers. The following abbreviations have been used: HVL: Hans van Lemmen

Frontispiece: HVL. 6 Ironbridge Gorge Museum Trust. 7 Wolfgang König/photo HVL. 8 HVL. 10 Bridgeman Art Library/Lincolnshire County Council, Usher Gallery, Lincoln. 11 HVL. 12 HVL. 13 Musée de la Céramique Architecturale, Auneuil, (Oise), France/photo Francis Dubuc. 15 Wolfgang König/photo HVL. 16 Victoria and Albert Picture Library, London. 18 *both* HVL. 20 HVL. 21 *both* HVL. 22 HVL. 23 HVL. 24 *left* Richard Dennis Publications from *Fired Earth: 1000 Years of Tiles in Europe.* 24 *right* HVL. 25 HVL. 26 HVL. 28 HVL. 29 HVL. 30 HVL. 31 HVL. 32 *top left* HVL. 32 *top right* HVL. 32 *bottom left* Michael Blood/photo HVL. 32 *bottom right* HVL. 34 Vlaamse Gemeenschap - Monumenten en Landschappen/photo Oswald Pauwels. 37 Musée de la Céramique Architecturale, Auneuil, (Oise), France/photo Francis Dubuc. 38 HVL. 39 HVL. 40 *both* HVL. 41 *top right* HVL. 42 HVL. 43 HVL. 44 *top* HVL. 44 *bottom* Bart Verbrugge. 46 HVL. 47 HVL. 48 *both* HVL. 50 HVL. 51 Bart Verbrugge. 52 Mario Baeck/photo Oswald Pauwels 53 *top* HVL. 53 *bottom* Bart Verbrugge. 55 Vlaamse Gemeenschap - Monumenten en Landschappen/photo Oswald Pauwels. 56 Vlaamse Gemeenschap - Monumenten en Landschappen/photo Oswald Pauwels. 57 Vlaamse Gemeenschap - Monumenten en Landschappen/photo Oswald Pauwels. 58 HVL. 60-61 HVL. 62 *both* HVL. 63 Vlaamse Gemeenschap en Landschappen/photo Oswald Pauwels. 64 Hotel Jan Luyken, Amsterdam. 67 HVL. 68 HVL. 69 HVL. 70 Nederlands Tegelmuseum, Otterlo/photo HVL. 72 HVL. 73 *top left* HVL. 73 *top right* Chris Blanchett/photo HVL. 74 *top* HVL. 74 *bottom* Chris Blanchett. 76 *both* HVL. 77 *both* HVL. 78 HVL. 79 *both* HVL. 80 *top* Wolfgang König/photo HVL. 80 *bottom* HVL. 83 HVL. 84 *top left* Chris Blanchett/photo HVL. 84 *right* Wolfgang König/photo HVL. 84 *bottom* Villeroy & Boch Museum, Mettlach. 85 HVL. 86 Wolfgang König/photo HVL. 87 Thomas Rabenau/photo Bart Verbrugge 88 Nederlands Tegelmuseum/photo HVL. 89 Villeroy & Boch Museum. Mettlach. 90 Villeroy & Boch Museum, Mettlach. 91 Villeroy & Boch Museum, Mettlach. 92 Villeroy & Boch Museum, Mettlach. 93 *top* Wolfgang König/photo HVL. 93 *bottom* Ofen und Keramikmuseum, Velten. 94 Bart Verbrugge. 95 *both* HVL. 96 *top* Bart Verbrugge. 96 *bottom* HVL. 99 Maarten Brinkgreve, Amsterdam. 100 HVL. 101 HVL. 102 HVL. 103 HVL. 104 Bart Verbrugge/photo Calmann & King. 105 HVL. 106 Hotel Jan Luyken, Amsterdam. 107 HVL. 108 HVL. 109 Bart Verbrugge. 110 Janos Kalmar, Vienna. 111 HVL. 112 *both* Janos Kalmar, Vienna. 113 *both* HVL. 115 HVL. 116 Ben Klaverweide. 118 HVL. 119 *left* Janos Kalmar, Vienna. 119 *right* HVL. 121 HVL. 122 Janos Kalmar, Vienna. 125 Janos Kalmar, Vienna. 126-7 Janos Kalmar, Vienna. 128 Janos Kalmar, Vienna. 129 *left* Janos Kalmar, Vienna. 129 *right* Bart Verbrugge. 130 HVL. 132 HVL. 133 HVL. 134 *both* HVL. 135 HVL. 136 *both* HVL. 137 HVL. 138 *both* HVL. 140 *both* HVL. 142 HVL. 143 HVL. 144 HVL. 145 HVL. 146 HVL. 148 *both* HVL. 149 HVL. 150-51 Studio Giancarlo Gardin, Milan. 151 Studio Giancarlo Gardin, Milan. 152-3 Studio Giancarlo Gardin, Milan. 154 Peter Mauss/Esto. 157 *top left* and *right* Collection Cleota Reed. 157 *bottom left* Michael Padwee/photo HVL. 158 *top left* Collection Cleota Reed. 158 *top right* Private Collection, courtesy of the Tile Heritage Foundation, Healdsburg. 158 *bottom left* Helen Kornblau/photo HVL. 158 *bottom right* Michael Padwee/photo HVL. 159 Smithsonian Institution, National Museum of American History. 160 HVL. 161 Collection Cleota Reed. 162 *top* Christies Images. 162 *bottom* HVL. 164 *both* Perrault-Rago Gallery/photo Suzanne Perrault. 165 Private Collection, courtesy of the Tile Heritage Foundation, Healdsburg. 166 HVL. 167 *top* Perrault-Rago Gallery/photo Suzanne Perrault. 167 *bottom* Collection Cleota Reed. 168 Colorado Springs Pioneers Museum, Colorado. 169 Colorado Springs Pioneers Museum, Colorado. 170 Private Collection, courtesy of the Tile Heritage Foundation, Healdsburg. 172 *bottom* HVL. 173 *top* HVL. 173 *bottom* Peter Mauss/Esto. 174 *all three* HVL. 176 HVL. 177 HVL. 178 Vlaamse Gemeenschap - Monumenten en Landschappen/photo Oswald Pauwels. 180 Chris Blanchett/photo HVL. 182 *both* HVL. 184 HVL. 185 HVL. 186 HVL. 187 HVL. 188 HVL. 189 HVL. 190 HVL. 191 HVL. 192 *both* HVL. 193 HVL. 194 Philips, London. 196 all four HVL. 198-9 HVL. 200 Michael Blood/photo HVL. 202-3 Thomas Rabenau/photo Bart Verbrugge. 204 HVL. 205 Michael Blood/photo HVL. 207 Wolfgang König/photo HVL.

INDEX

Numbers in italics refer to captions.

Abington, Adwin 103
abstract designs 35, 36, 82, 85, 157, 181, 183
Aesthetic Movement 9, 25, 66, 75
 in America 156
allegorical figures 30, 31, 31, 36, 39, 42, 72, 73, 96, 98
Almirall, Raymond F. 177
American Encaustic Tiling Co., Zanesville 155, 156-57, 157, 160
American tiles see United States
Amsterdam:
 Admirael de Ruyterweg 101
 American Hotel, Leidseplein 95
 't Binnenhuis 98, 108
 Bols distillery 98
 Central Station 97
 Ferdinand Bolstraat 95
 Hotel Jan Luyken 65
 Leliegracht 102
 marine office building (Het Scheepvaarthuis) 186
 Nicolaas Witsenkade (porch) 107
 Van Eeghenstraat 105
 Vondelstraat (Oud Leijerhoven II) 97
 Rijksmuseum 97
 Stock Exchange 96, 98
 Sweelinck conservatory, Van Baerlestraat 108
 Tuschinski Theatre 185, 186
 Vondelpark dados 108
Amsterdam School 186
angels (motifs) 23, 29, 72, 72, 135
 terracotta 172, 173
animal and reptile designs 24, 29, 36, 75, 166, 183, 186, 197
 beaver 175, 175
 frogs 149, 149
 lizards 12, 54, 60
 rabbits 164
 squirrel 15
Antwerp, Belgium 36, 54
 World Fair (1894) 59
Architectural Form (magazine) 188
Arkay, A. 129
Arnoux, A. J. 45
Arnoux, Joseph François Léon 71
Art Deco 179, 179, 180, 181, 182, 183, 186, 187
 in America 188, 190, 191, 191
Art Decorator (magazine) 82
Art et décoration (magazine) 82
Art moderne, L' (magazine) 35
Arte della Ceramica, Florence 152
Arts and Crafts Movement 9, 17-33
 in America 155, 160
Ashbee, C. R. 113, 120, 160
Ashley, Laura 193
Austria 111, see Vienna

Bad Nauheim, Germany: swimming pools 89
Baes, Jean 54
Balšánek, Antonín 14, 117 117

Bankel, Georg 86, 92
Barber, E. A.: The Pottery and Porcelain of the United States 155
Barcelona, Spain 131, 132
 Casa Amatller 132, 132, 139
 Casa Batlló 131, 136, 139, 141
 Casa Ramon de Montaner 134, 135
 Casa Terrades 132, 134, 135, 139
 Casa Vicens 136, 138, 139
 Eixample district 142
 Palau de la Música Catalana 135, 136, 137
 Park Güell 136, 141, 141-42, 142
 Pavilions Güell 136, 138, 139
 Sant Augusti Hotel 132
 Sant Pau Hospital 135, 135, 139
Barnard, Bishop and Barnard, Norfolk Iron Works 10
Barrett (J. H.) & Co. 77
Bassoe, Thorbjorn 155, 175
Batchelder, Ernest Allan 155, 159, 160, 163, 166
Batchelder Tile Co., Los Angeles 164, 166, 188
Batty, Dora M. 183
Baudot, Anatole de 42, 46, 49, 50
Baudoux, Henri 54, 57
Bauhaus 179, 181
Bayes, Gilbert 182, 183
Bazel, K. P. C. de 94, 98
BBB see Barnard, Bishop and Barnard
Beauclair, René 82
Beauvais, France 50, 54
 Avenue Victor Hugo 37, 54
 Gréber's workshop (Rue de Calais) 12, 52, 54
beaver motif 175, 175
Behrens, Peter 14, 65, 81, 82, 84
Belga see N.V. Ceramiekprodukten De Dyle
Belgium 15, 54-63, see also Brussels
 Art Deco 186, 188
Bell, Vanessa 183
Bendorfer Wandplattenfabrik, Germany 86
Berlage, Hendrikus P. 14, 65, 94, 96, 98, 123
Berlepsch-Valendas, H. E. von 82
Berlin 81, 82
 Admiralsbad 94
 Kreuzkirche, Hohenzollerndamm, Schmargendorf 188, 188
Bermudes, Adaes 149
Bigot, Alexandre 41, 45, 46, 46, 48, 49-50
Billing, Hermann 94
Bing, Siegfried 7, 13, 35, 49, 160, 163, 166
birds (motifs) 13, 24, 75, 101, 166, 171, 186, 188, 197, 201
 cranes 31, 95
 flamingos 36, 201
 herons 36, 201
 owl 157
 peacocks 7, 36, 65, 70, 101, 144, 175, 175, 200, 201
 seagulls 52
 swans 24, 59, 92, 144, 153, 167, 201
 water birds 7, 103, 107, 108
biscuit tiles 197

Blizard, F. S. 66
block printed tiles 17, 18, 19, 31, 33
Blum, George and Edward 14, 172, 173, 175, 191
Boch, Anna 59
Boch, Jean-François 86
Boch Frères factory (Kéramis) 59, 60
Bodley, Alfred 167
Bohemia 114, see Prague
Boizenburger Plattenfabrik, Germany 85, 86, 181
Bonnerot, H. 57
Boote, T. & R., Stoke-on-Trent 77, 79
Bosch, Jac. van den 33, 65, 94, 97, 98, 107, 107, 108
Bosselt, Rudolf 82
Bossi, Giovan Battista 152
Boulenger, Hippolyte 44, 45
Boulenger tile factory, Auneuil 42, 44, 45, 52, 54
Bovy, Serrurier 36
Bracquemond, Félix: De Dessin et de la couleur 36
Briggle, Anne van 171
Briggle, Artus van 171
Bristol: Everard Building 72, 73
Britain 65-79
 see also Arts and Crafts; Glasgow; London
brocade tiles 162, 163
Brongniard, Alexandre: Traité des arts céramiques 39
Broome, Isaac 159
Brouwer, William 186
Brown, Ford Maddox 24, 27
Brown, Frederick L. 166
Bru, Lluís 132, 136, 139, 142
Bruges, Belgium 101
Brussels 35, 54, 59
 Avenue Jean Dubrucq 62, 63
 Grande Maison du Blanc, Kiekenmarkt 59
 'Maison d'Art' (gallery) 35
 Old England Store, Kunstberg 59
 Palais Stoclet 113
 Rôtisserie Vincent 63
 Tassel House 14, 33, 36
 Villa Marie-Mirande, Sint-Agatha-Berchem 59, 63, 63
 Waversesteenweg 59
Budapest, Hungary 111, 112
 Arkaden Basar 124, 129
 Evangelical Church, Gorkij fasor 129
 Ferenc Bárd music store 124
 Gellert Baths 124, 129
 Geological Institute 124
 Kobanya Church 124
 Liszt Music Academy 124
 Museum of Applied Arts 49, 120, 121, 123, 123, 124, 129
 Opera building 124
 Post Office Savings Bank 124
 Rákoskeresztír cemetery crypt 124
 Rózsavölgyi department store 124

Town Hall 124
underground 120
Vas utca school 129
Bürck, Paul 82
Burges (John) & Co. 193
Burmantofts, Leeds 73, 75
Burne-Jones, Edward 9, 17, 19, 23, 24, 97, 201
Burslem School of Art, Stoke-on-Trent 66
Burton, William 75
butterflies (motifs) 107, 149, 188

Cachet, C. A. Lion 108
Cambridge University: dining rooms 25
Campbell, Colin Minton 71
Campbell Tile Co., England 77
Capitol, Washington 156
'Carduus' tiles (De Distel) 107, 108
'Carraraware' 72
carreau-métro tile 45
Carter & Co., Poole, Dorset 27, 183
Carvalhinho factory, Oporto 144
Catalan Art Nouveau 131-2
Catalina Tile, Catalina Island, USA 188
catalogues 30, 37, 52, 57, 86, 107, 132, 166, 180, 188, 197
cataloguing tile collections 206
Catteau, Charles 59
Caulkins, Horace J. 166
Century Magazine 159
Ceramica Gregori 153
Chaplet, Ernest 39
Cheadle, Staffordshire: church 19
Chelsea Keramic Art Works, Massachusetts 157, 157
Chéret, Jules 50
children (motifs) 46, 103, 129, 197
Chini, Galileo 131, 150, 152
Chini & Co. 152
Christiansen, Hans: Neue Flachornamente 81, 82
Clapham Church, Sussex: reredos (Morris & Co.) 23
cleaning tiles 204
cloisonné tiles 39, 185, 186
Coalbrookdale School of Art, Shropshire 66
Coché factory, Brussels 59
Coilliot, Louis: ceramics showroom, Lille 41
collections, tile 14, 195, 204, 204
Collins and Reynolds (printers) 29
Cologne, Germany:
Werkbund exhibition (1914) 94
Conference (1922) 181, 183
Colozier, Saint-Just-des-Marais 54
Compton Pottery, Surrey 29, 29
Constancia factory, Lisbon 144
Constructivists, Russian 179, 181
Cook, Clarence: The House Beautiful 156
Corn Brothers, Stoke-on-Trent 77, 77
Cottancin system 49
Coutan, J. 42
Couture, Thomas 157
Craftsman, The (magazine) 159, 160
Crane, Walter 9, 17, 30, 31, 31, 66, 75, 76, 97, 120, 156, 160
Claims of Decorative Art 97
Craven Dunnill & Co., Shropshire 31, 33, 33, 66, 77, 193
Crespin, Adolphe 54
Crewe, Cheshire: Catherine Street 79

Cubism 179, 181, 183, 186
cuerda seca 39, 60
Cuypers, Edward 98
Cuypers, P. J. H. 97, 98
Czech Republic 111, see Prague
dados 57, 59, 76, 77, 82, 88, 94, 102, 107, 107, 108, 117

Daot, Taxile 160
Darmstadt, Germany 65, 81
Grossherzögliche Keramische Manufaktur 89
Mathildenhöhe art colony 81, 82
Olbrich's house 82, 83
railway station 89
dating tiles 197
Davioud (architects) 42
Davis, C. T.: A Practical Treatise on the Manufacture of Brick, Tiles, and Terra-cotta 159
Day, Lewis F. 9, 17, 31, 33, 33, 66, 75, 76, 77, 77
Every-Day Art: Short Essays on the Arts not Fine 33
Debenham's House, London 27
Deck, Théodore 39, 46
Decorative Tile Works, Jackfield, Shropshire 193
De Distel, Amsterdam 65, 95, 103, 105, 108, 201
'Carduus' tiles 107, 108
Dekorative Kunst (magazine) 82
Dekorative Vorbilder (magazine) 9, 82
Delaherche, Auguste 39
Delft: Polytechnic School 97
see De Porceleyne Fles
Della Robbia Pottery, Birkenhead 27
De Morgan, William 9, 10, 17, 17, 24, 25, 27, 29, 33
Deneux, Henri 186, 187
De Porceleyne Fles, Delft 96, 97, 98, 105, 107, 107, 108, 186, 201
Seaview Hospital, Staten Island 177, 177
'Sectile' 96, 98, 103
Deslignières, M.: Porte de la Céramique 42
De Sphinx v/h Petrus Regout & Co. N.V. 103
Desterro factory, Lisbon 144, 145
De Stijl movement 179, 181, 186
Detroit, Michigan 155, 160, 166
Fisher Mansion 190, 191
Guardian Building 191
Public Library 166, 167
St Paul's Episcopal Church 166
Deutsche Kunst und Dekoration (magazine) 88
Deutsche Werkbund 81, 88, 94
Devezas factory, Villa Nova de Gaya 144
Diffloth, Emile 59
Digoin, France 50
Distel see De Distel
Domains Royal de Laeken, nr Brussels: washroom tiles 35, 57
Domènech i Estapa, Josep 135
Domènech i Montaner, Lluís 14, 131, 132, 134, 135, 135-36, 137, 139
Doulton & Co. 66, 71-73, 72, 73, 75, 183, 195
'Doultonware' 13, 72

Cubism 179, 181, 183, 186
Doyleston, Pennsylvania 160, 160, 163
Fonthill 163
Salem Church 162
Drahoňovský, Josef 117
Dresser, Christopher 9, 17, 31, 33, 33, 71, 160
Principles of Decorative Design 66
Dressler, Conrad 17, 27, 29
D.T.A.G. see Düsseldorfer Tonwarenfabrik
Duncan, Alistair: Art Deco 181
Düsseldorf, Germany:
Gewerbe und Industrieausstellung (1902) 88
restaurant Jungbrunnen 82
Düsseldorfer Tonwarenfabrik (D.T.A.G.) 81, 86
dust pressed tiles 197
American 155, 160
British 10, 13, 29, 29, 31, 68, 71, 75, 76
Dutch 103, 105
French 35, 39
German 82, 86
Hungarian 123
Portuguese 144, 145
Dys, Herbert 81

Eastlake, Charles: Hints on Household Taste 156
Ebel & Gazet, Paris 46
Eckmann, Otto 65, 81, 82, 88, 91
Edwards (J. C.), Ruabon, Wales 33, 33
Egyptian influences 117, 119, 120, 181, 188, 189
Eisenloeffel, Jan 81, 108
encaustic tiles 13, 17, 19, 29, 31, 33, 54, 59, 71, 86, 97
Endell, August 81
Ensor, James 35
Eosin tiles 123, 124
Evans, Thomas F. 76, 79
Expressionism, German 179, 186, 188, 188

Fabiani, Max 113
faience 27, 42, 50, 155, 166, 171, 188
faience fine see dust pressed tiles
Fanta, Josef 116, 117
Faria, H. 149
Faulkner, Charles 19
Faulkner, Lucy 19, 23
female figures (motifs) 201
American 159, 160, 175, 177
Belgian 36, 62, 179
British 23, 24, 30, 31, 31, 70, 72, 73, 75, 79, 182
Czech (Bohemian) 111, 118, 119, 120, 192
Dutch 8, 95, 177
French 36, 39, 43, 45
German 86, 92, 94, 192, 206
Portuguese 147
Feure, Georges de 13
Finch, William 59
Findon church, Sussex 25
fireplaces 17, 24, 27, 50, 50, 71, 76, 77, 107, 156, 160, 166, 167, 175
Fischer, Benedict 156
fixing tiles 204
floral designs 7, 36, 197, 201
American 156, 157, 157, 159, 169, 171, 172, 173, 197

Art Deco 188
BBB *10*
Belgian *58*, 59, *59*
Burmantofts *73*
Walter Crane 76
Lewis Day *33*, 77
William De Morgan *17*
Dutch *frontis.*, 87, 103, 105, 107,
German 81, *84*, *85*, *92*
Douglas Hunter *193*
Italian 152
Marsden Tiles 77
Minton *29*, *68*
William Morris *17*, *20*
Alphonse Mucha 76, *79*
Portuguese 144, 149, *149*
A. W. N. Pugin *18*, 19
Sèvres *42*
Spanish 136, *137*, 142
sunflowers 24, *24*, *37*, 46, *65*, 117, 144
C. F. A. Voysey 75-76, 77
waterlilies 81, *84*, 88, *90*, 149, *149*, *169*,
204
Florence, Italy 152
Formigé (architect) 49
Fornaci di San Lorenzo, Florence 152
Forsyth, Gordon Mitchell 76
Foster, Birket 25
Fourmaintraux & Délassus, Devres, France
50, 186, *186*
fox head motif 88, *91*
France 39-54, *see also* Paris
Art Deco 186
Francis Joseph, Emperor 111
Franklin Tile Co., Lansdale, Pennsylvania 188
Freiburg, University of 94
frogs 149, *149*
frost-resistant tiles 13-14, 39, 72, 103, 123
Fry, Roger 183
Futurism 151, 179, 181

Gallimore, William Wood 159
Gallissà, Antoni 132
Gaudí, Antoni 14, 123, 131, *131*, 132, 136,
138, 139, *141*, 141-42, *142*
Geetere, Georges de 59
Geiger, Baron de 50
Gentil & Bourdet, Paris 45, 46
geometric designs 7, 81, 82, *84*, 97, 105, 111,
112, *182*, 183
Art Deco *180*, 181, 186, *187*, *191*
Germany 81-94
Ghent, Belgium 63
conservatory, Korte Meer *54*
facade, Prinses Clementinalaan *62*, 63
Gibbons, Hinton & Co. 77
Gien, Faiencerie de 45, 50
Gilardoni Fils & Cie, Paris 45, 46, 75, *75*
Gilbert, Alfred 66
Gillet, François 39, *41*, 45, 46
Gilliot, Charles 57
Gilliot, Georges 57
Gilliot & Cie, Hemiksem *15*, 45, 57, *57*, 59,
179
Gilliot & Fils, Hemiksem 181
Glasgow, Scotland:
713 Great Western Road 76, *79*
Scotland Street School 65-66, *68*

Glasgow Exhibition (1901) 76, *79*
'Glasgow Four' 65, 112
Glazed and Floor Tile Manufacturers
Association 181, 183
glazes 45
Eosin 123, 124
Läuger 89
lead 105, 108
lustre *24*, 25, 33, 37, 76, 135, *137*, 166,
181
majolica 29, 123
matt 108, 155, 159, *162*, 163, 166, 171,
175, *175*, *176*, 188
tin 33, 98
translucent 29, 75, 76, 89, 156, *158*
Zsolnay 129
see also grès flammé
Gödöllö artists colony 124
Goedewaagen factory, Gouda 105, 108
Goldie, George 75
Gouda, Netherlands *8*, 105, 108
Gradl, M. J. and E. 82
Grande Tuilerie d'Ivry-sur-Seine, La 42, 46
Grant, Duncan 183
Great Exhibition, London (1851) 13, 17, 29,
31
Gréber, Charles *12*, *13*, *37*, 46, *52*, 54
grès (ceramic stoneware) 46, 50, *50*
Rozenburg 105
grès flammé tiles *13*, 39, *41*, 45, 46, *46*, *48*,
49-50
Grohn (formerly N.S.T.G.), Germany 193
Groot, J. H.: 'Triangles for Designing
Ornament' 97
Gropius, Walter: Model factory 94
Grossherzöglichen Manufaktur, Karlsruhe 94
Grossmann, H. 94
Grueby, William H. 155, 159, 160, 163
Grueby Faience Co., Boston, Mass. *162*,
163, 175, *175*
Grundy, George Henry 77
Guadet, Paul 46
Guastavino (tile company), USA 175
Gudenberg, Baron Wolff von 105
Güell, Eusebi 141
Guillot: *Frise du Travail* 42
Guimard, Hector 14, 36, *41*, 45, 46, *48*, 49

Haarlem, Netherlands 97, *103*
Hachette & Gillet 13, 39
Hagen, Germany 81, 105
Hague, The 97, 98, 108
De Witte literary club 108
Ministry of Justice building 98
Municipal Gas Works *107*
Villa Henny 98
see also Rozenburg factory
Haité, George C. 66, 75
Hale, nr Manchester: Royd House *182*, 183
Halou (designer) 49
Hamburg, Germany 82
Chile House 188
Elbe tunnel 94
Hagenbeck Zoo Ostrich House 103
Museum for Art and Design 114
hand-painted tiles 17, 20, *20*, *24*, 25, *33*, 60,
71, *73*, *95*, *101*, 105, *105*, 132, 197, 201
Hankar, Paul 54

Harlingen, Netherlands *see* Hulst; Tichelaar;
Tjallingii
Hasselt tile factory (Manufacture de
Céramiques Décoratives) 54, 57
Haustein, Paul 89
Haviland factory, Limoges 50
Heins, George L. 175, 176
Helman, Célestin-Joseph 57
Helman Céramique, Sint-Agatha-Berchem,
Brussels *35*, 54, 57, 59
Hemiksem, Belgium *58*
see Gilliot & Cie; Gilliot & Fils;
Manufactures Céramiques d'Hemixem
Herminé, E. L. 50
Heystee, A. M. A. *70*
Heytze, J. C. 107
Hlavín, E. 117
Hoffmann, Josef 112, 114
Hoffmann (Julius) Verlag 82
Höger, Fritz 188
Holland 25, 94-108, 186, *see* Amsterdam
Holland tile factory, Utrecht *8*, 33, 97, 98,
102, 105, 107, *107*, 201
Hollins, Michael Daintry 71
Homer, Winslow 156
Horta, Victor 14, 33, 36, 54
hospitals 14, 73, 75, 135, *135*, 177, *177*
House Beautiful (magazine) 188
Houses of Parliament, London 19
Howard, Jeremy: *Art Nouveau: International
and National Styles in Europe* 9
Howarth, G. H. 144
Howarth, J. S. 144
Huart Frères factory, Longwy 50
Hulst, J. van (firm), Harlingen 33, *33*, *95*, 105
human figures *73*, 75, 82, *115*, *119*, *134*,
135, *164*
see also allegorical figures; female figures
Hungary 111, 120-129, *see* Budapest
Hunter, Douglas 193, *193*

Iles, Frank 27
in-glaze decoration *20*, 25, 142, 201
Indonesian art 97
Innendekoration (magazine) 9, 82
International Style 181
Islamic designs *24*, 25, 27
Italy 9, 66, 131, *150*, 151-52, *153*
Ivry, nr Paris 46
Iznik style ceramics 25, 76

'Jacoba' tiles *107*
Jakab, Desző 124
Janin & Guérineau, Paris 46, *52*
Janssens, Maison Guillaume *62*
Villa Marie-Mirande 59, 63, *63*
Japanese influences 9, 25, 31, 35, 39, 50, *52*,
81, 89, 97
Johnson (H. & R.), Stoke-on-Trent *180*,
181, 183
Jones, Owen 31, 36, 159
Grammar of Ornament 31, 66
Jong, H. L. de *185*, 186
Jourdain, François *41*, 45
Journal de la décoration 82, *105*
Journal of Design 31
Jouvé, Paul 49
Judaspenningen (Honesty) *frontis.*

Jugend (magazine) 81
Jugendstil 9, 46, 65, 81-94
Jujol, Josep M. 141

Kahn, Albert *190*, 191
Kamp, Johan Bernhard 98
Kareol House, nr Aerdenhout, Netherlands *88*, 89
Karlsruhe, Germany 94
Kecskemét, Hungary: Town Casino 124
Kelmscott Manor, Oxfordshire 25
Kent, Conrad, and Prindle, Dennis: *Park Güell* 141-42
Keramic Studio (magazine) 160
Kéramis *see* Boch Frères factory
Kesckemét, Town Casino *128*
Khnopff, Fernand 35
Kiel, Germany: Town Hall 94
Klimt, Gustave 112, 120
Knox, Archibald 66
Komor, Marcell 124
Korb und Giergl 124
Kós, Károly 120
Kriesch, Aladár Köröshfői 124
Kromhout, W. *95*
Kunst und Dekoration (magazine) 82
Kunst und Kunsthandwerk (magazine) 113
Kuohl, Richard 188

Labouchere, Abel 98
La Farge, Christopher G. 175, 176
Lajta, Béla 120, 123, 129
La Louvière, Belgium: Boch Frères 59, *60*
Lamare & Jurlin, Paris 46
Lamb, Thomas *189*
Lambert, Guillaume 103
landscapes 42, *54*, 63, 88, 166, 171, *171*, 186, 197, *204*
Langenbeck, Karl 156, 160
Lansing, George R. 156
Läuger, Max 81, *88*, 89
Lauro, Agostino 152
Lauweriks, Jan L. M. 81, 94
lave emaillée 13, 39, *41*, 45, 97
Lavirotte, Jules 46, 49
LeBoutillier, Addison B. *162*
Lechner, Ödön 14, 112, 120, *121*, 123-4
Le Comte, Adolf 94, *96*, 97, 98, *99*, 103, 107, *107*
Leeuwarden, Holland:
 Centraal Apothek *95*
 railway station 108
Leschhorn-Strassburg, P. 88
Leurs, J. K. 107
Leverhulme, Lord *26*, 27
Lévy, Emile 42
Lewis, Wyndham 183
Leyland, F. R. 25, 201
Liberty's, London 13, 66, 152
Libre Esthétique, La 36, 59
Lille, France: Rue de Fleurus *41*
Lily (Verneuil) 59
Lisbon, Portugal 144
 Avenida Almirante Reis apartment house 144, 149
 Avenida de Republica 144
 Cais do Sodré kiosk 144
 Campo de Ourique bakery 149

Largo do Corpo Santo store 144, *145*
 Rua da Lapa shop *145*
 Rua Dr Alvaro Castro 144, *147*
 Rua Ponte Delgade garage 149, *149*
 Count Sacavém's house, Rua do Sacramento à Lapa 149, *149*, 151
 Tabacaria Mónaco, Rossio Square 149, *149*
lithographic technique 59, 88, *91*
Livemont, Privat 36, 54, 59
Liverpool Museum 76
lizards *12*, 54, *60*
Lluís de Jesus, António 144, *145*
Loebnitz, Jules *39*, 42, 46
Löffner, Berthold 113
London:
 Debenham's House 27
 Doulton House 183
 Michelin Building, Fulham Road 75, *75*
 St Thomas's Hospital 73
 Harrods Meat Hall 73
 The Hill 25
 Houses of Parliament 19
 St Pancras Housing Association apartment block, Euston *182*, 183
 Sands End, Fulham 27
 Stanmore Hall 25
 Underground 75
'Longden' pattern (Morris & Co.) *20*
Loos, Adolf 179
 Ornament and Crime 179
Lotus tile factory, Amsterdam 105
Lovatelli-Colombo (designer) 45
Low, John Gardner 157, 159
Low Art Tile Works, Chelsea, Mass. 155, 157, 159, *159*, 163
Loyer, François: *Art Nouveau in Catalonia* 135
Luber, Carl Siegmund *92*, 94
Luksch, Richard *119*, 120
Luksch-Makowski, Elena 114
Lundberg, Anders 89
lustre tiles *24*, 25, 33, 37, 76, 135, *137*, 166, 181

Maastricht, Netherlands 57, 103, 105
Macdonald, Frances and Margaret 65
machine pressing 197, 201
Mackintosh, Charles Rennie 14, 57, 65, *68*, 82, 112, 193
MacNair, Herbert 65
Madiol, Jacques 54, 57
Magazine of Art 17, 33, 66
Maggiore, Lake: villa *150*
majolica glazes, Minton 29
Majorelle (architect) 49
Malibu Potteries, California 188
Mallet, Pierre 75
Manufacture de Céramiques Décoratives, Hasselt 54, 57
Manufactures Céramiques d'Hemixem 57, 181, 186, 188
Mará, A. 117
Marcel, Alexandre *35*
Marcks, Gerhard 94
Marinetti, Filippo: Futurist Manifesto 151
Marks, Murray 25
Márkus, Géza 124
'Marmo' 75

Marsden Tiles, Stoke-on-Trent 77
Martin, G. 45
Martini, Arturo *153*
Maus, Octave 35
Maw & Co., Jackfield, Shropshire 7, *30*, 31, *31*, 33, 66, *74*, 75, 155, 156, 181, 183, 193
Mazzioli, Paris 46
Meakin, Alfred 181
Medmenham Pottery, Marlow Common *26*, 27
Meinhold, Gebrüder, Schweinsburg 94
Meissen, Germany 86
Meissner Ofen and Porzellanfabrik (vormals Carl Teichert) 7, *81*, 86
Membland Hall, nr Plymouth 17, 27
Menier chocolate factory, Noisiel 46, 49
Mer, Cher-et-Loir, France 49
Mercer, Henry Chapman 155, 160, *160*, *162*, 163, 175, *175*
Merton Abbey, Surrey 27
Mettlach, Germay *see* Villeroy & Boch
Mey, J. M. van der 186
Michelazzi, Giovanni 152
Mijnlieff, Jan Willem 107, 108
Milan, Italy *150*, 152
Minton, Herbert 19, 29, 71
Minton & Co. 13, 29, *29*, 31, 71, 155-56
Minton, Hollins & Co. 19, 25, *68*, 71
Minton's Art Pottery Studio 31
Minton's China Works, Stoke-on-Trent 18, 19, 31, *33*, 66, 71
 trademark *197*
Moravian Pottery and Tile Works, Doylestown, Pennsylvania *160*, *162*, 163, 175, *175*
Morris, Jane 25
Morris, William 9, 17, *17*, 19, *20*, 24-25, 29, 33, 97, 135, 160
Morris & Co *20*, 23, 25, 27
Morris, Marshall, Faulkner & Co. 24
Mortelèque, Joseph 39
M.O.S.A. tile factory, Maastricht 103, 105
Mosaic Tile Co., Zanesville, Ohio 160, 188
mosaic tiles 88, 114, *115*, *116*, *119*, 120, 136, *137*, *138*, 139, 141, *141*, 142, *142*, *160*, *162*, 163
 brocade tiles *162*, 163
Moser, Koloman 112, 114
Mucha, Alphonse 36, *43*, 49, 76, *79*, 98, *192*, 193, 201
Mueller, Herman 156, *157*, 160, 176
Mügeln, Germany 86
Mühlacker, Germany 86
Müller, Emile 42, 46, 49
Müller, Louis 49
Müller-Breslau, Georg 88
Munich, Germany 81
Mutters, Johannes, Jr 107, 108

N.V. Ceramiekprodukten De Dyle, Belgium 59
Nagy, Sándor 124
Nancy, France: Majorelle House 50, *50*
Neatby, William J. *72*, 72-73, *73*, 75, 77
Neo-Egyptian style *see* Egyptian motifs
Netherlands, the *see* Holland
New York 156, 171, 188
 Bayard Building 171, 172, *173*

Cossitt Memorial Building 188, 191
The Dallieu 172, *173*
East 19th St *160*, 175, *175*
Fuller Building 188
The Gramercy, Manhattan 156
Gramercy House, East 22nd St 188, *191*
Irving Place 191
Litchfield Mansion, Brooklyn 156
New Amsterdam Theatre *155*, 175
Pythian Temple 188, *189*
Seaview Hospital, Staten Island 177, *177*
subway stations 163, 166, 175, *175*, 176, *176*
Vanderbilt Hotel 175
Nichols, Maria Longworth 166
Nienhuis, Lambertus *60*, 81, 94, 105, *105*, 108
Niermans brothers 42
Nieuwenhuis, Th. W. 108
Nikelsky, Géza 129
Noisiel, France 46
Norddeutsche Steingutfabrik, Bremen-Grohn 59, *84*, 86
Norden, W. van 108
N.S.T.G. *see* Norddeutsche Steingutfabrik

Obrovsky, Jakub *115*, 117
Ohmann, Friedrich 117
Olbrich, Joseph Maria 14, 81, 82, *83*, 112
Omega Workshop 183
on-glaze decoration *20*, *23*, 25, 29, 197
Original Style, Stovax Ltd, Exeter *192*, 193
Orsola, Solá i Comp., Barcelona 132, 142
Osborne, Arthur 159
Osthaus, Karl Ernst 81, 105
Otterlo, Netherlands: National Tile Museum *88*, 89
Ould, Edward A. *26*, 27
Owens (J. B.) Pottery Co., Zanesville, Ohio 171, *171*

Pankok, Bernard 81
Paris 35, 39, 45-46
 Avenue Rapp (No. 29) 46, *46*
 Aviatic Bar 45
 Boulevard Saint Martin (No. 8) *43*, 45
 Brasserie Mollard 42
 Castel Béranger (14 Rue de la Fontaine) 14, 46, *48*
 Ceramic Hotel (34 Avenue de Wagram) 46, *46*, *48*
 Galerie de l'Art Nouveau 7, 35, 36, 49
 Hôtel Jassedé 46
 Lux Bar 45
 Métro *44*, 45
 Ministère d l'Industrie 42
 Palace Bar 45
 Le Petit Zinc (L'Assiette au Beurre) *39*, 45
 Place Félix Desruelles 42, *42*
 Place Paul Langevin 42
 Place Rapp (No. 3) 46
 Royal Bar 45
 Rue Belliard (No. 185) 186, *187*
 Rue Eugène Flachat (No. 32) *41*
 Rue Franklin (No. 25) 46
 Rue Jouffroy (No. 103) *52*
 Rue de Londres (No. 30), mineral water factory 186, *186*

Rue de Paradis (No. 18) *44*, 45; (No. 28) 45, 50; (No. 38) 45
Rue des Petites Ecuries (No. 13) 49
Rue de la Pierre (No. 14) 42
St Jean, Montmartre 49, *50*
Samaritaine department store *41*, 45
La Table en Aquitaine 45
World Fairs *see* World Fairs
Passenger, Charles and Fred 27
'pastilles', ceramic 46, 49, *50*
pâte-sur-pâte 71
Paulus, Ernst and Günther 188, *188*
peacock designs 7, 36, *65*, 70, *101*, 144, 175, *175*, *200*, 201
Pécs, Hungary *see* Zsolnay factory
Perret, Auguste 46
Perry, Mary Chase 166, *167*
Perth Amboy Terra Cotta Co., New Jersey *155*, 172, *173*, 175
Pewabic Pottery, Detroit 155, 160, 166, *167*
Philadelphia Centennial Exhibition (1876) 156, 157
Photo Decorated Tile Co., Derby 77, *79*
photographing tiles *204*, 206
Picard, Edmond 35
Pichenot, Paris 39
Pilkington's Tile & Pottery Co., England *10*, 31, 33, 66, 75-76, 77, *79*, 181
Pinheiro, Rafael Bordalo 131, 149, *149*
Pinto, José António Jorge 144
plastic clay tile bodies 75, 197
Plateelbakkerij Delft (P.B.D.), Hilversum 107, *185*, 186
Pleyer (architect) 88
Polívka, Osvald 14, 112, 117
polychromatic tiles *26*, 27
Poole factory, England 59
 see also Carter & Co.
Porceleyne Fles *see* De Porceleyne Fles
Portugal 9, 131, 144-51
Post-Modernism 193
Powolny, Michael 113
Prague, Czech Republic 111, 112, 114
 Americko Česka bank *118*
 Central Station *111*
 Café Corso 117
 Central Station 117, *119*
 Hlalol Patriotic Choral Society building *116*, 117
 Imperial Hotel 117
 Kaprova street *119*, 120
 Municipal House (Obecní Dům) *115*, 117
 Pařiž Hotel 117
 Široká Street 117
 Vinohrady district 120
Pre-Raphaelite Movement 9, 24, 201
Prikker, Johan Thorn 81
Prindle, Dennis *see* Kent, Conrad
Prouvé, Jean 50, *50*
Pugin, A. W. N. 9, 17, 19, 29
 Floriated Ornament 18, 19, 66
Puig i Cadafalch, Josep 132, 131, 132, *132*, *134*, 135, 139
Pujol i Bausis of Barcelona 131, 132, *132*, 136, 142, 201
Pyrogranit tiles *see* Zsolnay

rabbits (motifs) *164*
Rako factory, Rakovník *111*, 112, 114, *115*, *116*, 117, *119*, 181
Ramsgate, Kent:
 The Grange 19
 St Augustine's 19
Rathbone, Harold Steward 27
Ravenna Peacock panels (Mercer) 175, *175*
Ravesteijn, Utrecht *20*, 25, 105
Red House, Bexleyheath 19, *20*, 24
Redgrave, Richard 31
Regout, Petrus 103
Regout tiles *101*, 103, 105
relief lines 29, 39
relief tiles:
 American 156, *157*, *159*, 163, 176
 British 71, 76
 French 45, 46, *46*, *48*, 54
 German *81*, 82, *86*
 Portuguese 149, *149*
 Viennese 114
restoring tiles 204, 206
Reus, Spain: Pere Mata Institute 135-36, *137*
Rhead, Frederick H. 160
Rheinische Wandplattenfabrik, Bendorf 86
Rhodes Tile Co., England 77
Ricardo, Halsey 14, 27
Richards (Henry) Tile Co., Stoke-on-Trent 77, *197*
Riemerschmidt (designer) 81
Risler, Ch. 42
Robineau, Adelaide Alsop 160
Roche, P. 49
Roelants, Joseph 54, 57, 59, *179*, 186
Rookwood Pottery, Cincinnati 155, 160, *164*, 166, *167*, 171, 175, 176, *176*, 191
Rossetti, Dante Gabriel 19, 24, 25, 201
Rotterdam, Holland 97, 108
 Vrouwe Groenevelt's Liefdegesticht *99*
Rowe, William 73
Rozenburg factory, The Hague *frontis.*, 105, 107, 108, 201
Rudder, Isidore de 59
Ruiter, D. P. J. de *frontis.*, 107
Ruskin, John 9, 17, 18, 135, 160
 The Stones of Venice 19

Saarinen, Eliel 129
Sacavém, Count: house 149, *149*, 151
Sacavém factory, Lisbon 131, 144, *145*, *147*
Sächsische Ofen und Chamottewarenfabrik (formerly Ernst Teichert Meissen) 86, *86*
Sadler, John 29
Saint Amand tile works 50
Salt, John 57
Sarreguemines factory *see* Utzschneider
Saulnier, Jules 46
Sauvage, Henri 46, 49, 50
Scala, Arthur 113
Scharvogel, Jakob Julius 81, 89
Scholz, Lothar *192*
Schöntal, Otto 113
Schwarz, Johann von *92*, 94, 201, *206*
Scottish Art Nouveau 65-66
Scranton, Pennsylvania: D.L. & W. station 163
Seasons, The (Crane) *30*, 31, *31*
Secession *see* Sezession, Viennese
'Secessionist Ware' (Minton) 71

'Sectile' (De Porceleyne Fles) *96*, 98, *99*, 103
Seddon, John Pollard 33, 75
Seder, Anton 82
Sédille, Paul 14, 39, *41*, 42
 Etude sur la renaissance de la polychromic
 monumentale en France 42
Sellers, Henry J. 76
Selmersheim, Tony 88
Servais Werke, Ehrang 57, 86, 94, 181
Sèvres, Manufacture de 39, 42, *42*
Sezession, Viennese 9, 57, 81, 82, 111, *112*,
 112-114, 120
sgraffito 108
Shaw, Richard Norman 113, 124
Sherwin & Cotton 77, 181
ships (motifs) 27, *162*, *176*, 186, 197
ships, passenger 27, 76, 108
Simas, E. M. 42, 50
Slovakia 111
Slovenia 124
Smit, Amp *105*
Smith, John Moyr 71
Soares, Carlos 131, 144, *147*
Société Anonyme des Carrelages
 Céramiques de Paray-le-Monial 45
Société Anonyme des Pavillons 59
Société Anonyme Faiencerie de Bouffioulx 59
Société Céramique, Maastricht 57, 103, 105
Société Générale de Produits Réfractaires et
 Céramiques de Morialmé 59
Soestdijk, Holland: railway station *107*
Solon, Léon V. 70, 71, 77
Solon, Louis Marc 71
Spain 9, 131-42, *see* Barcelona
spiral motifs 82, *83*, *84*
Spring Bank, Headingley, Leeds: fireplace *24*
Spruce, E. Caldwell 75
squirrel (motif) *15*
Stabler, Harold 183
Stanberry, George A. 156
Steindl, Imre 123, 124
Steingutfabrik Witteburg, Farge, nr Bremen 86
Steinlen, Théophile 50
stencilled tiles *frontis.*, 76, *102*, 105, 132, *132*,
 136, *137*, 139, 142, *142*, 144, 197, 201
Stenler Fliesen, Mühlacker, Germany 193
Stickland, E. E. 183
Stickley, Gustav 160
Stoclet, Adolphe 113, 114
stoneware, ceramic *see grès*
storing tiles 204
Stratton, M.: *The Terracotta Revival* 172
Studio, The (magazine) 9, 17, 33, 71, 72, 76,
 97, *107*, 123
Sturm, Georg 97
Subotica, Slovenia: Town Hall 124
Sullivan, Louis 14, 155, 171-72, *173*
 Ornament in Architecture 172
sunflowers (motifs) 24, *24*, *37*, 46, *65*, 117, 144
Sunlight Chambers, Dublin: frieze *26*, 27
swans (motifs) 24, 59, *92*, 144, *153*, *167*, 201

Taylor, William Watts 166
Teichert, Ernst *84*, 86, *86*
Temple, Charles Henry *74*, 75
Teplice (Teplitz), Bohemia 114
terracotta 29, *29*, 94, 155, 171-72, *173*, 186,
 188

Thistle (Verneuil) 59
Thompson, Margaret E. 73, *195*
Thooft, Joost 98
Tichelaar, Makkum, Netherlands 105
Tiffany, Louis Comfort 160
Tirgu Mureş, Romania: Palace of Culture
 124
Titanic, SS 76
Tjallingii (firm), Harlingen, Netherlands *101*,
 105
toadstools (motifs) *84*
Tonwerk Offstein, nr Worms 86, 181
Tonwerk Witterslick 181
Toorop, Jan 97, 98, *99*, 103
trademarks 195
transfer printing 29, *29*, 31, *31*, 71, 77, *79*,
 92, *101*, 105
Travemünde, Germany: Possehl House 82
trees (motifs) 73, *167*, *169*, *171*, 197
Trent Tile Co., Trenton, New Jersey 155,
 159, *159*, 159-60, *160*
troubadour tiles *164*
Troyon, Constantine 157
tube-lined tiles 7, *15*, *65*, *68*, *70*, 77, *88*, 105,
 108, 193, *197*, 201
Tunick, Susan: *Terra Cotta - Don't take It for
 Granite* 171
Turin, Italy: First International Exposition of
 Modern Decorative Art 152

underglaze techniques 76, 98, 105, 166, 197
United States 155 *ff.*, 197
 Art Deco 188, *190*, 191, *191*
Utrecht, Netherlands *see* Holland;
 Ravesteijn; Westraven
Utzschneider, Sarreguemines factory 39, 42,
 45, 50

Vágó, József 124, 129
Vágó, Lászlo 124, 129
Vallance, Aymer: 'Mr. W. J. Neatby and his
 Work' 72
Van Briggle Pottery, Colorado 155, 160,
 166, *167*, *169*, 171
Van Hulst, Harlingen *see* Hulst, J. van
Velati-Bellini, Giuseppe 152
Velde, Henry van de 13, 36, 49, 54, 65, 81-82
Verheul, J. *99*
Verneuil, Maurice P. 59, 88, *90*, 97
Vet, Cornelis 108
Viareggio, Italy 152
Vicens Muntaner, Manuel 139
Vickers, Squire J. 176
Victoria and Albert Museum, London 31,
 123, 183
Vienna 65, 111, 112-114
 Burgtheater 114
 Cabaret Fledermaus bar 113-114
 Kaiserbad lockhouse *112*
 Portois & Fix Building 113
 Steiner House 179
 Villa Vojcsik 113, *113*
 Wagner's Majolica House *111*, 113
Viennese Sezession *see* Sezession, Viennese
Villeroy & Boch, Mettlach 82, *83*, *84*, 86,
 86, 88, *88*, 89, *90*, *91*, *92*, 97, 181
Villers-sous-Saint-Leu, France *13*
Vingt, Les 35, 36, 59

Viollet-le-Duc, Eugène-Emmanuel 14, 39,
 97, 132, 135
Volkmar, Charles 160
Vorticists 183
Voysey, C. F. A. 9, 33, 66, 75-76, 77, *107*,
 108, 113, 160

Wadsworth, John 71
Wagner, Otto 14, *111*, 112, *112*, 113, 124
Ward, James: *Elementary Principles of
 Ornament* 66
Wärndörfer, Fritz 113, 114
Waterkip (Bosch) 33, *107*, 108
waterlilies 81, *84*, 88, *90*, 149, *149*, *169*, *204*
Watts, George Frederick 29
Watts, Mary 29
Webb, Philip 19, 24
Wessel Wandplattenfabrik, Bonn-Dransdorf
 86, 181
Westra, J., Jr *107*
Westraven, Utrecht *185*, 186
whiplash designs 36, 82, 151, *197*
Whistler, James McNeill 25, 201
White, Gleeson: *Practical Designing* 66
Wiener Keramik, Vienna 113
Wiener Werkstätte *81*, 94, 112, 113-114
Wienerberger Ziegelfabriks- and
 Baugesellschaft 114
Wiesbaden, Germany: swimming pools 89
Wilde, Oscar 156
Wise, William 71
women, representations of *see* female figures
Wood, Edgar *182*, 183
Working Men's College, London: Morris
 lecture 24-25
World Fairs 13
 Antwerp (1894) 59
 Barcelona (1888) 132
 Brussels (1935) 188
 Chicago (1893) 72
 Paris (1878) 35, 39, 42; (1889) 35, 39,
 42, 49; (1900) 36, 42, *42*, 49, 50, 72, 88,
 98, 120, 124, 166
World War, First 179, 181, 186
Wyatt, Matthew Digby 75

Ybl, Miklos 124

Zanesville, Ohio 156-57, *157*, 160, 171, 188
Zeist, Netherlands *85*
Zelinsky, W.: *The Cultural Geography of the
 United States* 171
zigzag designs *112*, *182*, 183
Znojmo, Bohemia 114
Zsolnay, Vilmos 123
Zsolnay factory, Pécs *111*, 112, *113*, 120,
 123, *128*, 129, *129*
 'Pyrogranit' tiles 14, 113, *121*, *123*, 123-
 24, *128*, 129
Zuid-Holland factory, Netherlands 105